Also by John Sacret Young

Gallitzen & Sons

The Weather Tomorrow

Remains: Non-Viewable

Pieces of Glass

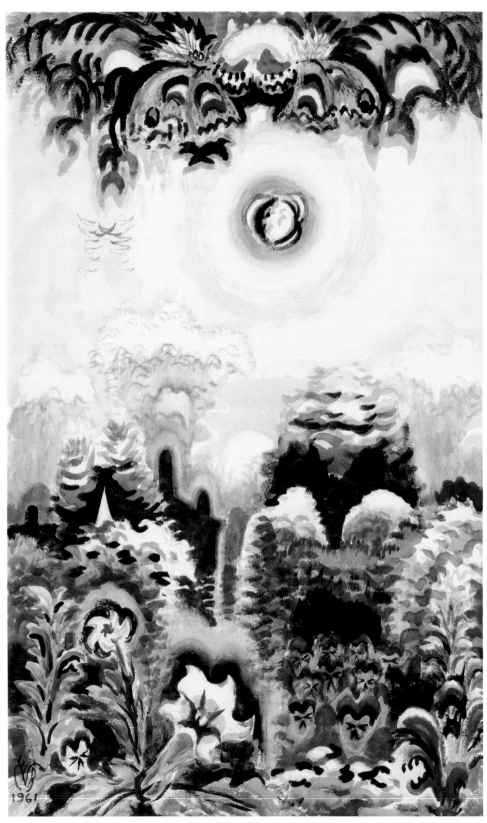

CHARLES BURCHFIELD, *MOONLIGHT IN THE FLOWER GARDEN*, 1961

Pieces of Glass

An Artoir

John Sacret Young

Tallfellow®Press

2016

Published by
Tallfellow® Press
9454 Wilshire Blvd.
Beverly Hills, CA 90212

Visit www.Tallfellow.com

ISBN 978-1-931290-97-5

Printed in the USA

10 9 8 7 6 5 4 3 2 1

to
C.F.S.
"the bearer of light"

TABLE OF CONTENTS

What do I ask of a painting?

I ask it to astonish, disturb, seduce, convince.

— Lucian Freud

INTRODUCTION

THIS IS A VIVID AND WINNING SELF-PORTRAIT of an aesthete, a man for whom reality cannot help but be understood and organized pictorially. John Sacret Young is a writer by calling, and like many of the best writers his memory is made up of "the things I saw or wished I saw." In this hypnotically involving story of his long and ongoing love affair with painting, he lets us look into his life through the windows that picture frames are: his stories about chasing, knowing, possessing, trading — and losing — artworks are beautifully cropped and focused compositions that have a lot in common with his favorite pictures.

One of the best things here is how Young developed his richly educated familiarity with the art he loves; his is an amorous taste that goes very deep. He particularly loves American painting. He especially loves Charles Burchfield, an artist I've learned to see much, much more in from reading John. He has also turned me on to artists I didn't know, such as John Koch. Like Koch, Young's involvement in painting is profoundly erotic. As John Updike knew, women and artworks have a great deal in common for a certain kind of sensibility, and like his fellow writer Young is an artistic gourmand. He is acquisitive; his relish for the art he loves is unreservedly appetitive. In Young's world, love is an active principle, and connoisseurship is an engaged and Protean adventure that is shared with the fellow fanatics he portrays so engagingly. Reading him, we become one, too.

One of Young's friends, who had passionately taken up watercolors in his retirement, said during his final illness, "When I'm painting, I don't have cancer." Like John, he had found a way of understanding and shaping his experience that was utterly engrossing and endlessly gratifying. We all should be so lucky.

This is one of the best books I know about why and how art—the creating but also the apprehending of it, which is the other, necessary half of the whole — gives meaning to life, becomes a way of living.

— Jonathan Galassi,
President and Publisher
Farrar, Straus and Giroux

PROLOGUE

For is not a work of art the most tantalizing — here — there — everywhere — yes and no — sort of thing on this Earth — the most vital and yet to all a mystery... it cannot be understood, it can be felt.

— John Marin

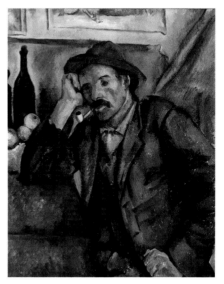

PAUL CÉZANNE, *THE PIPE SMOKER*, 1890

W HAT ERNEST HEMINGWAY CALLED "the perpendicular pronoun" — I — as opposed to that more sitting down, horizontal and passive fellow — me — may haunt these pages. It is only true because this book stems from my trying, not without foolishness, to hold up light and a lens, my lens, to the remarkable characters and their art that, in most instances, precedes my existence and, even more, will outlive my own. I am no wide or deep art expert, only a baby-stepping lover, but I hope within this my own perpendicular pronoun — that stand-tall fellow — there is some insight into the art that has moved and altered me.

I have searched my conscious and unconscious self after where such interest and passion was born and arose. How (as John Updike wrote) "when a painter acts upon a flat surface, harmonies and balances,

congruences flock into being out of thin air." I think I uncovered clues, to my delight and surprise, that yet were stirringly tangled with far more emotions of both beauty and contradiction than simple words imply.

There may be others still.

Only in looking back and over these brief chapters did I fully realize that my amateur foraging into this world tended to sniff and circle particularly, if haphazardly, about a remarkable time in American Art and Letters. What I think was a second American Revolution — this one not about independence or a Constitution or Bill of Rights, rather one that ripped anew our novels, our fiction, our poetry, our very language, and equally our music and painting.

I think of two book titles that have stayed with me and do a dance around this sort of a book, *Pentimento* and *Palimpsest*. Two words used by two very different authors, Lillian Hellman and Gore Vidal. Two words about layers and what lies underneath as well as on the surface for a gathering of their memories. Both words wonderful, complicated — the very sound of them — with wonderful, complicated meanings.

They reflect the great gift paintings have given to me: a walk through time and lives, including my own, dolloped with discovery, some comfortable and some not. There are regrets, some sad and hard, and some revelatory. But it is a walk that, wherever it has wandered, is rich with art and memory, and tied full with all the mystery they enfold within them.

Come walk with me.

THE BEGINNING
LESCAUX PAINTINGS

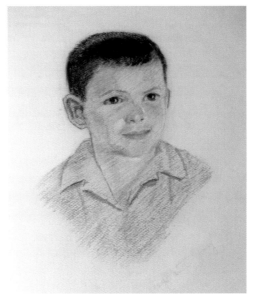

MARGARET YOUNG, *PORTRAIT OF JSY*, 1955

M<small>Y MOTHER, PAST 90 NOW</small>, lives these days in an apartment in what is called a village. The village is senior citizen friendly with a mini-bank, mini-store, mini-gym, mini-library, mini-cafe, and a dining room. A place that is yours, but where you can push a button or pull a cord and help will be on the way, door locked or not. The village sprawls with long corridors and low ceilings and there's a busy schedule of activities. Nearby, contiguous, is an assisted living section, and down the street not so far is a nursing home. The village has added town houses and fresh amenities and has to. Other such complexes are cropping up — newer, smarter, and better built — and will continue to in the next decades.

My mother's on oxygen and the cord to the tank trails through her apartment, right to the living room, left to the bedroom that she shared with my father before he died, and is hers alone now and has been for more than a decade. There are twin beds with the same headboards since before my birth. They stretch back across her life 70 years and through several homes. There's a bureau, a night table, both busily festooned with photographs, her father and mother, her children and grandchildren, and now great-grandchildren. The walls of the room hold one other highlight: four pastels of her four children, the pastels, too, now reaching well past 50 years of age.

A single artist did them, a teenager then, my sister Margy. Margaret after my mother and her mother, and even her mother before her.

After regular school for several years, Margy went to the Margaret Yard Tyler School of Art. It was in Upper Montclair, New Jersey, near a railroad trestle. The Lackawanna passed nearby, a commuter train that stopped within hailing distance at Watchung Plaza. The art school was on a second floor, a big wide room with a scattering of wooden easels and the scent of paint and the dust of pastels, dust that inhabited the room and seemed to flavor and shade the very air.

But my memory of my sister's art reaches back beyond the M.Y.T. School, or the four portraits on my mother's bedroom wall. Before then, when I was very young, my sister and I shared an epistolary relationship. My brother Mason had moved upstairs to sleep on the third floor where my oldest brother Peter already was. Margy and I were left to share a bathroom, and we began passing letters back and forth through it. Or rather the stuffed animals we possessed became the authors of the notes. We addressed them and soon Margy was sketching stamps on the envelopes — then perhaps 3 cents — and adding the wavy lines like musical bars that mimicked cancellation marks.

That was the beginning.

For a time then, on Saturdays, or after school when it wasn't too cold or wet, my sister led me down to the garage. We would make up stories there. Margy would write "once upon a time" on the walls, or some sentence or two to begin them, some sentence to end them, and between them on those beleaguered walls she sketched with chalk or her pastels. She would draw the stories.

The plaster on the walls was cracking and falling away in brittle pieces, age and wear and tear, revealing brick that fell in chips or dust just as quickly. Left behind, unerased, the stories Margy drew would break up. Pieces of her art joined the pieces of plaster, the slow erosion of the wall. Some survived, held their place, lingering, only slowly fading and even overlapping, remnants of the old with the fresh and new drawings creating that pentimento before, at last, disappearing.

What did Margy draw? What stories? What were they? I don't know. I can't scavenge them out of my memory. And if I don't recall the exact shift and shape, I carry the picture still of my sister drawing, me watching, her hand moving, her fingers holding the chalks of many colors as they made their minor mist.

I don't know when Margy stopped drawing in the garage, or whether I was the reason, pulled away by peers and drawn into sports. The garage became an arena for boys and any game that used a ball or a puck. My brothers and I practiced pitching against the walls for baseball. We cut tops and bottoms off a sequence of cardboard boxes, fixed them with tape or nails near the ceiling, and used them as baskets for basketball. And we rolled a well-worn, beat-up bow-and-arrow target, maybe a yard high, and fired hockey pucks at it after it became clear the pucks were well on their way to completely destroying the walls.

My sister and I were not close, certainly not after that, exacerbated by being in a family of boys, three brothers and Margy, the sole sister, and then as my life took me away, not just geographically. A career far from hers.

Margy's gone now, too soon, after a ferocious struggle with breast cancer, and the leukemia and all that can come after it. But the gift she gave, knowingly or unknowingly, that I didn't really remember or realize for decades — these garage drawings of hers, these early primitive storytellings, like those in the caves of Lescaux — however locked away in the shrouds of memory, have seeped now up into consciousness after 60 years. Even unknowingly, they fueled me and charted a future and, returned, they travel with me now, etched anew on the caves of my mind.

As I look back to them, they were looking forward all the way to me now. They stand as the first tracings of an interest and a love that has journeyed across my life with a significance equal to the relationships that like them have faded, and even those that flourish still.

PATERSON

The force that drives the water through the rocks
Drives my red blood, that drives the mouthing streams
Turns mine to wax
And I am dumb to mouth unto my veins
How at the mountain spring the same mouth sucks...

— Dylan Thomas

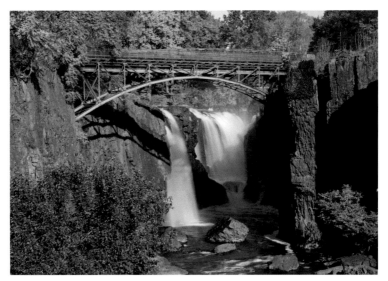

THE GREAT FALLS IN PATERSON, NEW JERSEY

WHEN I WAS IN 7TH GRADE, there was a girl who was tall and mysterious. Her height, her sharp intelligence, and scathing manner were intimidating to my then pint size. Every day she wore a simple necklace, the letter "A," the first letter of her name. Two years later her family moved away, and Anne left our class, and I only saw her once more.

Four years later, during our senior year, she came back to visit. That

returning day with us left her somehow vulnerable. Near its end she came to me and asked me to get her away. Why exactly me, and from what or where is vague now, even wherever "away" was, however brief. It's not even as clear as my memory at age 12 of seeing Anne on the #60 bus going home from school wearing a sweater and the gold "A" that fell between new breasts. I never made any association with the "A" to *The Scarlet Letter*, or that it had any correlation to Hester Prynne's act. The similarity was only that it made her a marked woman, one I noticed and haven't forgotten.

What has stayed with me from that brief last time I saw her isn't so much visual as emotional. The feel of her hand on my arm, the link of her eyes, what seemed to be in them: a hope for help, a trust that I would offer it. It was only then I realized what I had witnessed years before must have come as much from insecurity and bravado as what I had assumed. I wish now I could remember more. I wish I had seen her again. In the sometimes inevitable unspooling shapelessness of lives, I never did.

The girl who arrived to our class to replace Anne briefly became my girlfriend. New to the school, Brenda went through the boys in the class, I just one. She lived in Paterson, New Jersey, some distance away, and I spent way too long for my parents and their telephone bills in what were then called message units talking to her, trying to sequester myself on the back stairs to not be heard. We talked for what could've been hours, but about what?

Brenda had exquisite olive skin, dark eyes and hair, and she had tried smoking and seemed to know about adult things. It wasn't her figure, which wasn't so much. It was that knowingness, including sex, or sex as little as I understood it then. In another time and another place this would've meant fooling around, sleeping together, doing it. In my — or maybe our — innocence it was about what was then called "making out." We kissed, and from Brenda I learned about French kissing. It was exciting; it took me, however briefly, outside my limited knowledge and experience and, in my unadorned, foolish youth, put what seemed like

my entire existence in vulnerable sway. In not much more than a month Brenda moved on, to my parents' and their pocketbook's relief, and my oh-so-dramatic and not-so-long lasting adolescent grief.

Brenda was quite short and I still hadn't grown then. Several years later, having spurt up another 8 to 10 inches, I ran into Brenda and she seemed to have shrunk. Not really, but not just in height. She'd come into a couple of tough years that I knew nothing about except her grades had fallen apart, or so I had heard. She was no longer the new girl, the fresh asparagus, and had been passed over, a little like she had passed over me.

I heard years later that Brenda married a soft and chunky guy who was slashingly categorized because of his athletic ineptitude and who — fittingly for such short-sightedness — went on to become a doctor, a surgeon and a specialist, and the head of the department at a famous university hospital.

Beyond Brenda, what the relationship did do was introduce me to Paterson. First, because of her, the well-to-do section, the movie theatres, and a year or two later when I became editor of the school newspaper, to the working part of the town where I went every month to see the paper being typeset.

We all hold memories of certain sounds. They can tie to events or feelings large or small, and they can offer a mystery as to why they strike so deep. For a friend of mine it is the call of distant dogs barking. For another it is the chirp of poker chips. For me it is the small solid metallic click and clack of the type lining up and coming together. Plus, feeling them in my hand, the lead weights of them like tiny sinkers for a fishing line. Little lead chunks. Long gone now.

I didn't know much more about Paterson or its history, its silk production, or "the Paterson of industrial strife, of smokestacks and foundries and assembly lines, the Paterson of foreign languages, still native tongues of Italians and Jews and Poles and Irish and the Blacks, the

Paterson of desperately poor people in the 1930s, part of that enormous nation within a nation characterized by Franklin Delano Roosevelt, as 'ill-fed, ill-housed, and ill-clothed'" (Robert Coles).

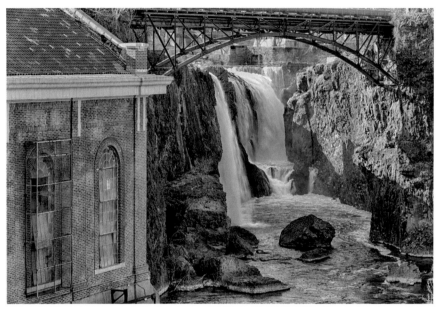

THE GREAT FALLS OF THE PASSAIC RIVER AND HYDRO POWER STATION

There was one other place in Paterson that I drove by. One rainy day — and I don't know why that day in the grainy gray cold, nearly sleet of the rain — I detoured to Paterson Falls. I got wet even before the Falls insisted in its din to shellac its own additional coat of mist on me. Still it drew me, the roaring cataract of it. It had this lackadaisical seeming energy and undeniable powerful force at once. At 85 feet high — only Niagara Falls is higher on the East Coast — you could climb partway down. The slippery, mysterious force of it sent me — once I left and went to see the paper put to bed — to William Carlos Williams.

The discovery of Williams' work was aided and abetted by my 10th-grade English teacher who took to talking about him and reading his poems, finishing with a flourish and slamming the book shut when done, a clap like a hammer on anvil, and shouting like Henry Bergson: "Contact! A writer, the good writer, the real writer must have contact.

Look at this man, this doctor, this baby doctor, his hands deep in the rich earth of humanity."

The teacher, John Almquist, exuded his own powerful force. He was rough-hewn, had a bull neck, the stout and leathery build of a running guard — he had played college football — and had a mole larger than Lincoln on his cheek. Yet he lived in literature and music. On weekends he played piano in a jazz band for love and fun and some additional income, and claimed to have been, for a while, part of an amusing and apparently heavy drinking and craven crew that churned out the series of Hardy Boys books for the Stratemeyer Syndicate and Grosset & Dunlap that I had devoured when 10 or 11.

This John Almquist had a love of Melville as well. If minus a limb, he could have been a benign Ahab. He could rise from his desk and stomp. He dominated a room and loosed imagination.

I don't recall whether his passionate enthusiasm for William Carlos Williams included mention of the artists Williams came to know as poet and writer if not as doctor or pediatrician. What he celebrated was Williams' life, his rubbing against the ordinary and grabbing a hold of existence from the very first moment of birth. He did read out loud more than once a Williams poem, calling out, "Listen to this!"

> *Memory is a kind*
> *of accomplishment,*
> *a sort of renewal*
> *Even*
> *an initiation, since the spaces it opens are new places*
> *inhabited by hordes*
> *heretofore unrealized,*
> *of new kind —*
> *since their movements*
> *are towards new objectives*
> *(even though formerly they were abandoned).*

No defeat is made up entirely of defeat — since
the world it opens is always a place
formerly

 unsuspected,

 beckons to new places

and no whiteness (lost) is so white as the memory
of whiteness

It was the Falls that wove their way with an insistence upon my imagination beyond Brenda or John Almquist — the power of the falling water. And when I read Williams' most famous work, *Paterson*, I felt I could hear and feel the fall of the water in its mix of prose and poetry. The ellipsis of Williams' verse with its shuffling waves of history and detail and storytelling seemed confluent. It wended into me in ways with and beyond the words and a kind of mimesis both elative and sad that I wanted, too, to capture.

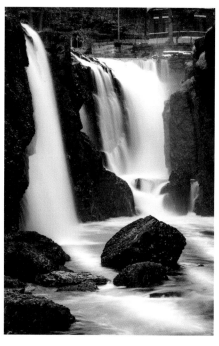

THE GREAT FALLS OF THE PASSAIC RIVER

So I found myself again there after college, revisiting it, standing in the spray, my face wet, conceiving a novel that I called then *The Cross-Eyed Stance*. It began with two teenage girls jumping into the Falls, not unlike the true, successful jump in the 19th Century by a man named Sam Patch that Williams described in the first volume of *Paterson*. Patch celebrated his survival by turning such jumps from one Falls or another into carnylike events, a booming barnstormlike career, until he attempted it once too often. That final time it took until the following year and spring thaw

before Patch's body was recovered.

In my novel — never finished and likely misbegotten — the two girls jumping weren't so lucky. One survived and one didn't, and their reasons for jumping and jumping together weren't clear to their stunned and aggrieved families and perhaps not to the girls themselves. The novel, set in 1968, moved on into the bitter and wrenching McCarthy-Kennedy primary campaign battle and the conflagration of that year, leaving the girls literally if not metaphorically behind.

But these are New Jersey memories, the Paterson Falls part of the Watchung Mountains that rise 15 miles outside of Manhattan and wrap about it like a 30-mile long parenthesis. This is where Dr. William Carlos Williams lived his life and practiced medicine and poetry and became known. He was a pediatrician among the working class and their matter-of-fact portraits and rich and earthy details infuse his poetry, part of what helped make it so startling and innovative and then celebrated before he died in his 80s.

Somewhere in that span, visiting New York, William Carlos Williams encountered Alfred Stieglitz, and was taken by the American artists Stieglitz represented, the ones unknown to me then, and the ones I would soon discover and be taken by as well and begin to collect.

With his galleries, first An American Place and then 291, Stieglitz declared independence for American art. Williams gravitated toward Stieglitz's belief before the two fell into dispute; such sparring was often part and parcel of a relationship with Stieglitz. Regardless, Williams saw these painters as new and genuinely native. He believed they were bringing into their work something kin to what Ezra Pound — perhaps his most cherished friend and the poet he held in highest esteem — and he himself sought to bring into their poetry. Williams came to know and admire the artists as well. He forged a close, long-term, if tendentious friendship with Charles Sheeler. In Philadelphia as early as 1905, he met Charles Demuth, an artist whose unparalled watercolors of flowers

combine such delicacy and strength. His greatest works break down realism into the purest formal geometric splatters, but he could also do slapdash watercolors of sailors with their penises whipped out.

Williams wrote a frequently quoted essay about Demuth. In fact, Demuth's most famous poster, a remarkable work, *I Saw the Figure 5 in Gold*, is taken from a Williams poem:

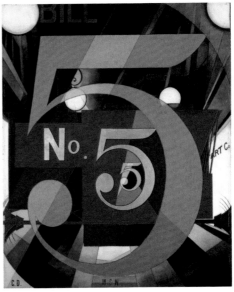

CHARLES DEMUTH, *THE FIGURE 5 IN GOLD*, 1928

> *Among the rain*
> *and lights*
> *I saw the figure 5*
> *in Gold*
> *on a red*
> *firetruck*
> *moving...*

And in 1953, after John Marin died, Williams wrote the introduction to the catalogue for the Marin Memorial Exhibition.

Williams was the great poet of the Amerian idiom — its break with English formal tradition, plain but musical — and these artists embraced in their subject and in their very brushstrokes what William Carlos Williams believed, "a naked attention to the thing itself." And as perhaps I saw in Paterson Falls and did not yet understand, they realized Williams' words that "the natural object is always the adequate symbol."

For more than 40 years I have lived primarily in California while on my walls hang the East Coast, New England and New Jersey, and the work of these painters, Steiglitz and Williams, and others championed. They ride sidesaddle with both my memories and my imagination, and link somehow to whatever creativity I have. They refresh and renew me,

and I'm not alone. Despite their age — now often 50 and up to and beyond 100 years — they haven't dated.

They fulfill what Joseph Conrad prescribed when he wrote, "My task is, before all, to make you see." And at once, as paintings so miraculously can, they join feeling with seeing.

What they gave to me, and still do.

MENTORS

PAUL CÉZANNE, *STILL LIFE WITH POTS AND FRUIT*, 1890-1894

AFTER ATTEMPTING TO START A CAREER AS A WRITER, I returned in failure from Los Angeles. The failure wasn't only economic. In a sense, it was worse. I had written a movie, it had been made, and it was awful. I came back to New Jersey where my parents were then and retreated to the third floor of a house on the border of two towns, Montclair and Verona.

The house had been one of the first two on the street and my parents had bought it decades before, during World War II. The third floor wasn't much more than an attic that had been broken up to include two bedrooms with crescent-shaped windows and a "secret" room at the back

of a closet as well as the part that remained an attic. The secret room was accessed by swiveling two latches and sliding out a flat piece of plywood the same color as the closet and snugged flush and otherwise invisible on one wall. I'm not sure my parents knew about it when they bought the house. I didn't know about it until, as a teenager, I moved up to the third floor. The ceilings in all the rooms were pitched as well, some dramatically, and it meant ducking once I slept there.

In my twenties, coming back, I set up a desk that I had inherited from my grandfather to plumb the failure, and see whether there was really a writer in me. Whether there was chance or not. Whether to give up. Whether there was talent or, perhaps more important, gumption. Every day was a struggle, and for the first time — but not the last — I blared music as I faced the sleazy yellow paper I had bought on the cheap by the ream, or the keys of the hand-me-down Olympia typewriter. There was Tchaikovsky, Vivaldi, Julian Bream, the Righteous Brothers and the Four Tops, Jim Webb, and Carole King. None played with a particular plan, or that made much sense.

My grandfather's desk had been the one he kept in his workshop in the cellar and it came apart — a mahogany-shaded top and sides that included drawers that all bolted back together. It was knockabout — my knees bumped every time trying to fit between the drawers and under it — but good. Eventually it moved again to Massachusetts to sit in a room overlooking the water of Cape Cod Bay, only to be ruined in a fire that scorched through the ceiling up from the kitchen, destroying the memorabilia from my childhood that had gathered in the room around and on the desk. Photographs, school papers, yearbooks, varsity letters, a stamp collection, an assortment of Civil War, Ford's Theatre, and battlefield material, and books. Many books.

I saved two things — though I don't why or why these particular two — a melted and twisted metal window crank that showed, if nothing else, the heat and power of the fire. One end no thicker than barbed wire or a fat toothpick. The second a copy of *Smoky* by Will James (without

any realization of irony) that was blackened on the cover, front and back. The edges of the pages crumble and leave ash on the fingers or fluttering to the floor whenever it is opened and it still holds the stench of smoke now more than a generation later.

JR MEEKER, *ADIRONDACKS*, 1873

In moving stuff to situate the desk on the third floor in New Jersey, I encountered a painting. It had been over my grandparents' couch in their living room in a very ornate gold frame. I had never paid attention to it. It was dark, purples and russets and dying golds, the Adirondacks at dusk, and it had come loose from its frame, which was still there, detached. All that remained around the canvas was a slender wooden inner band. Somehow the loss was a gain. Fanciness and fussiness fell away. There was the painting. Better, clearer, simpler. Much later, walking through Hirschl & Adler, a prestigious New York gallery, I did a double take in disbelief as I found myself backing up to stare at the same signature that was on my grandparents' painting. One Joseph R. Meeker. The gallery was having an exhibition that included, way not for free, his work.

But long before that I placed the painting on a bureau, tilted up, and took to looking at it while I scrubbed the screenplay that had become the movie back to a blank slate and rewrote it as a novel. A different structure, a different mood, and a different ending. There was a need in me to do it. It was cleansing and a restitution until I was able to rediscover the rough

and raw material that had first lured me. It wasn't fast work. I'm not sure it was good work. It was never published. It was slow and learning work. Finding shapes and sentences. Digging into character. Searching out a style, a tone, and coming then upon a pleasure.

It took months and while I worked I would see some nights the woman who would become my wife. Jenny worked in New York and lived with her parents down the hill in a well-appointed section, and we would often make dinner as winter came on, especially on Saturdays, and watch television or read in what was her father's study.

Many of the books on her father's bookshelves had to do one way or another with art. About that time he served as the Chairman of the Board of the Montclair Art Museum, an old, small place with a significant collection of the 19th century artist George Inness, who had lived in northern New Jersey a century before. Jenny's father subscribed to Sotheby's — then Sotheby Parke-Bernet — catalogues, and I took to looking through them.

It was the American auctions that drew me.

I had taken an art course in college — how easy and what fun it was to sit in the dark seeing slides of paintings early in the morning. The lecture hall was an amphitheatre and I gradually sat closer, and closer still, and let the paintings wash over me as the professor talked. It was a survey course of modern art that barely touched on any American artists until concluding with abstract expressionism.

In the auction catalogues, I was coming upon artists I had never seen and hadn't been taught, Americans, 19th and 20th century modernists who took after Cézanne, not literally, each breaking down realism in his or her own way. Bluemner, Demuth, Hartley, Marin, O'Keeffe, Sheeler. One catalogue especially shook my sensibilities awake: the Edith Halpert Collection sold in the spring of 1973. However drawn or painted, the works in it were shot through with America, a feeling and sense of the

country I was born and raised in and was part of.

There was Edward Hopper, as well, and an artist he shared much with for a while in the 1920s before they diverged in direction — a little like Picasso and Braque a decade earlier — named Charles Burchfield.

They stirred me.

During that time, to fill my days, to escape writing or after writing, I found that the Montclair Art Museum was screening the Kenneth Clark series, *The Origins of Modern Painting.* It had aired on PBS after his *Civilization,* which had been a great success. Whatever the weather, walking or driving, I would journey to the museum and wind down to the cellar to see the films. They were 16 millimeter, a half-dozen, each focused on a single painter — Manet, Monet, van Gogh, Seurat, Munch, Rousseau, and Cézanne. Their impact on me was enormous. It was difficult for me then to understand quite why.

In that year my life wasn't far from being hermetically sealed and largely lived inside, where for years, one season after another, I had lived outside, afternoons and weekends given over to athletics, especially football and ice hockey. The weather came with them with its dreariness or its beauty, its tumult and its changings. Without fully realizing it, or what my intentions were, I was now spending most of my time indoors at the desk on the third floor with only crescent windows. I had turned inside myself. I had no idea that what could've been a lonely time was in many ways a lucky one, and how my work, the stories I would come to tell — whatever the theme or territory — would be so inspired by light and location. Seeking to find a spirit in a place that informed and influenced a character and his or her actions. And with it the influence of what Kenneth Clark was to quote in the second volume of his memoirs: "Nature I loved, and, next to Nature, Art."

Clark was referring to the critic Bernard Berenson, and how astonishingly observant of detail he was:

...the lines of growth in a plant or tree and its relationship to earth. These things came as a fresh revelation to him every time he saw them. "Where were my eyes yesterday," he used to say. There was one old tree that he visited as a kind of pilgrimage almost once a month. He said its roots were a better illustration of his theory of tactile values than anything in art.

In the series of films, Clark journeyed to where the artists lived and worked. He stood not just in front of their paintings, but on the ground where they were painted. The films were in lush color and filled with the outdoors. It was his idea to show how the artists, "from whom modern art derives its freedom, were not 'born free,' but drew their inspiration from visual experience and actual places." He went to Giverny for Monet and Åskgårdstrand for Munch and Aix-en-Provence where Cézanne lived at last and painted.

When I would take the bus into New York to meet Jenny where she worked then, I bought books about art on remainder, including one about Cézanne for a dollar. Over the years I read and re-read it, and carried it along from one home to another, and I may have it still.

I was also reading then the novels that make up American literature in the remarkable time after World War I, roughly the same period as the artists I was discovering in the auction catalogues. There was Hemingway's early groundbreaking, fresh prose alive with Berenson's "roots." There was Faulkner assaulting the stone tablets of language and story with dialect and point of view. There was Fitzgerald's gifted laying out of rolling lawns, sumptuous rooms, and the breathtaking lists of Gatsby's party guests. Equally vivid were his haunting evocation of the sights and sounds of trains and train stations and the motorcar garage beneath the billboard with the eyes of Dr. T. J. Eckleburg that loomed over the novel. Gatsby was a book that seemed soft and sensuous and under its brilliance was hard as diamond.

The revolution seemed true in American poetry as well from E.E.

Cummings across Hart Crane and Robinson Jeffers to Robert Frost. And then, only a few years later, came John Dos Passos' great attempt in staccato prose to harvest time and place and an entire country in *U.S.A.*

I would come out of the museum in the wake of the films and even on dull, dank days the wet streets and pavement looked somehow freshly varnished. They were refreshed, or I was.

Other days and nights seemed paintings in themselves. On a single fall day there was the dance of leaves. The trees emptied, the leaves rained, and the streets flooded with their swoops and flutters, a kind of blizzard. The maples and poplars set loose a myriad of yellows and snatched bits of sun and converted them into tiny sources of light. They glowed.

Weeks later, in a freezing drizzle, the streets of Montclair found a rich, oily, and shiny black. The tread marks of the most recent tires lingered on the roads, visible. They seemed to sit up, rise slightly, what had to be an optical illusion. It was a dark world, a van Gogh night without the stars. The few streetlights that hung over the middle of the streets might have been unattached. There were but dim outlines of trees and a wide gutter of the last leaves. Some curled and puttered along the street, accompanying cars, faded collops of orange and brown.

After this time I had thought only stagnant — nourished by my time with my father-in-law's library and by Kenneth Clark films — Jenny and I traveled to Europe and lit out by train across France to where the artists had painted. We went to the banks of the Seine, and then to the hospital at St. Rémy where van Gogh had been sequestered, and finally by car to the place I most urgently wanted to visit, Cézanne's Atelier.

In Aix, we ascended turning tile steps and found ourselves in a high, wide, gray room struck by the sweet, strong scent of fruit. There were apples, oranges, and pears on tables and sills, waiting and ripening as if they were to become part of one more Cézanne still life. Some had begun to rot. They were darkening and pruning, like images of gray matter.

The room, especially near the long ribbed window along one wall, held their flavor.

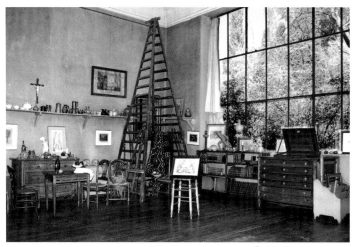

CÉZANNE'S ATELIER

It was a large space, with high ceilings that curved at the corners, gathering shadow, and there was plenty of air. It wasn't stale. There was light and dust and that sense of chalk and the room was cool while Aix wasn't. A corner had an easel, a statue of a broken Cupid, and an umbrella. Another a high narrow shelf with glasses and pottery, casually placed, and a painter's toolbox.

The corner of one wall near the door had a slot from the floor to the ceiling. Hooks the length of forearms and eyes the size of thumbnails latched it shut. Late in his life, Cézanne cut it into the wall to slide in canvases too big to make it up the stairs and through the doors. His *Bathers*.

As I stood in the room I felt a peculiar dimension. In its largeness and oddness it moved into Cézanne's perspective, his revolutionary sense of space and symmetry. The walls seemed to deepen yet flatten. The objects seemed to sit a kilter. They became greater than themselves and had room

to. Cézanne was in the air and the scent and the light. I was in a holy spot.

There was one more possession of Cézanne about. On the banister of the stairs we had climbed, hung a wide-brimmed hat, the one Cézanne used when he packed easel and canvas onto his back and early in the morning walked toward Mont Sainte-Victoire to paint. Nearly a hundred

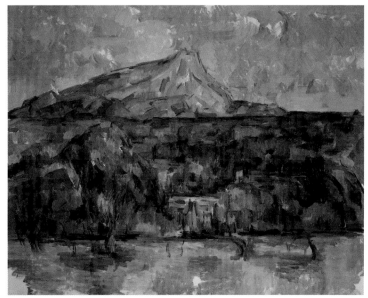

PAUL CÉZANNE, *MONT SAINTE-VICTOIRE, SEEN FROM LES LAUVES*,
1902-1906

years later, Jenny and I asked after his path and followed his lead. With fresh baguette and pâté, water and wine — if without paint and brush and his certain genius — we did the same.

With us as well were the first steps along my own path.

THE TRUNK SALE

WHEN I RETURNED BACK TO L.A. a second time to live and try to forge a career, I was newly married, unemployed, broke, and with no place to live. My wife Jenny and I found a building, finally, out Hollywood Boulevard beyond La Brea, almost to Laurel Canyon, that rented rooms by the week. Thirty-five dollars.

We had been married on a rain-soaked day just weeks before and spent the night at the Carlyle Hotel in New York. One night as a placeholder for a honeymoon and all we could afford. We then packed up a Fiat and began to drive west.

It was early summer, a time in Los Angeles where the fog can wander in from the Pacific and hang out. Not bother to lift or retreat for days. June gloom. This particular year the opposite occurred: a heat wave arrived. For days the temperature spiked above 100 degrees and even at night struggled and failed to dip below 80. Our room had no air conditioning. The air refused to move and the dry, still, stifling heat attacked both skin and lungs.

I was looking for a job with no leads and without success. I wasn't sure which way to turn and I would come back to the room in emotional if not physical exhaustion. The smells of dust and cleaning fluids and even past occupants seemed to rise out of the rug and its short shag seemed as dry and sharp as teeth.

In those sweltering days I sank into a funk of reading books, several Ross Macdonald mysteries and *The End of the Affair* by Graham Greene. Whether due to the heat or my vulnerability, they struck deeply, and years later when asked by the now long and seriously departed *Los Angeles*

Herald Examiner to write about a novel that held a crucial place for me, I chose the slim, troubling, risky, and beautiful Greene novel that William Faulkner called "one of the most true and moving novels of my time in anybody's language."

In my previous time in L.A., I had met a woman whose husband had had a sudden meteoric rise in movies, writing and then directing, and within a few years just as suddenly a fall and disappearance. Equally, this Greta had pulled herself up from nowhere. She was surprisingly savvy, short and voluptuous with a tiny voice, and a small but lovely bungalow up near the top of Nichols Canyon, which began its ascent across the street from the $35 room.

Divorced by now, Greta saved us. She showed up in the heat and invited us to stay at her house until we found an apartment or a house to rent.

She was seeing a tall, whitebread young man, a good tennis player who had been raised in La Jolla, gone to a Christian Science college, seemed wired straight and tight, and wanted to be an art dealer. His name was Kent Truog and his interest and a relationship with us was launched when he learned that I, in my foolishness, had plunked down my life savings — no whopping amount, but all I had — on a small painting, almost a miniature, by an artist named John Marin.

The discovery excited him. Marin was a noted American painter, but virtually unknown on the West Coast. (It's still true: the L.A. County Museum of Art has two fine works, but only Dennis Hopper and Brooke Hayward and Dory and André Previn seemed to have had Marins then; and in both cases I believe they vaporized in their divorces). Kent had recently been back to New York and seen several Marin watercolors and bought several paintings. He wanted to know all about my collection, not realizing and perhaps me not admitting that the tiny Marin *was* my collection. He was hoping as well, of course, that I might buy something he was selling.

He hadn't a gallery, even a home to show the few things he had. They traveled with him in the trunk of his car wherever he went, along with his tennis rackets and cans of balls. It was a funny moment, he opening his trunk to show me his wares, me feigning knowledge and interest, not to mention the inability to purchase anything. Two hopeful, foolish, naïve young men.

His paintings were small. They couldn't be anything else. It was a small car and a small trunk. One, as I recall, was by the painter Samuel Colman, another by a California painter, Stanton MacDonald-Wright, and a third was a work by a man I had never heard of named George L.K. Morris.

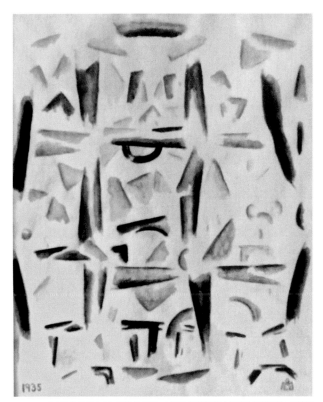

GEORGE L.K. MORRIS, *NEW YORK WINDOW #2*, 1935

The painting was a watercolor that looked like many splattered shards of glass. The pieces had a cubistic nature, triangular and rectangular and even parallelogram shapes. Their colors had many muted shades. The title was *New York Window #2*, and it was signed with Morris' initials and dated 1935. The name of the painting set into play an organizing principle. The mullions of a window and rough semi-abstract rungs and railing of a balcony outside. Slices of sky and high-riselike paint chips beyond. Perhaps.

I liked it. I wanted to help Kent. I took my time deciding, worrying the way all collectors of art do with the possible exception of the most savvy and most wealthy. Was it good? Was it worthy of the artist or of itself? But if art is driven by passion and taste as well as commerce — how much did all that matter?

The painting carried me back to Cézanne and his late watercolors. His brush by then had become spare and eloquent. There could be mere dabs of color. Exquisite strokes that looked less disciplined, quick and improvisational. He held high, as well, white space. He had found a way to make untouched paper as significant, integral, and powerful as where his brush had landed.

It is no news that Cézanne was remarkable and that he was instrumental in transforming Western art. He broke down the traditional realities of painting — how and what we see. To quote Robert Henri, "he correlated things never before correlated." Cézanne's career, however, is inspirational beyond that. Initially, he lacked a singular talent. His early work had a power but it was rough, even ugly, the subject matter and the very handling of paint and space and the human figures he drew. They were awkward and undistinguished. Cézanne kept painting; he didn't quit. Only through sheer and struggled diligence did he unearth his groundbreaking originality. His paintings came to capture an astonishing magic both intellectual and emotional. Something I felt had found its own small way into the George L.K. Morris.

In the same year I had bought the Marin, Knoedler Gallery in New York, no lightweight outfit, had a small Cézanne exhibition and sale. They were sketches and watercolors, some barely there. They were beautiful, if not major. Conventionally great Cézannes weren't just hanging around available any longer.

There was a funny thing then. It was the early '70s and American culture had been sabotaged by the cataclysmic events of the '60s. The clarity of button-down and crew cut had been swept away and wardrobe and hair had been set loose. Who could tell who was successful or rich or not? I walked into Knoedler in knockabout clothes; beat-up khakis, long hair and a moustache. Penniless. With amusement, forbearance, or perhaps uncertainty that I might actually be worth millions, they led me back into the bowels of the gallery to a private showroom. For the next chunk of an hour I was shown the works that weren't hanging, with prices in the hundreds of thousands and up. Beyond any ego, not to mention poverty, it was wonderful to see them.

So from the trunk of a car, a small BMW — quite insanely probably, even as inexpensive as it was (especially then) — I became the owner of *New York Window #2*.

After buying it — which undoubtedly should've happened before — I did some homework on George L. K. Morris. My watercolor was a bit of an anomaly. His work tended toward large abstract oils with geometric patterns and, for a time, Native American symbols. I found he was a theorist. He had written extensively in the '30s about contemporary European art and artists like Braque and Miro, and there was a sense of both in Morris' own work — Braque's cubism and the playful symbolic lines in Miro that evoked musical notes. Even more, Morris came to know, wrote about, and grew close to the artists who escaped to America as World War II approached, like Piet Mondrian.

Morris became a critic for the *Partisan Review*, a champion and founding member of American Abstract Artists (AAA) and, in 1935, he

married Suzy Frelinghuysen, whose New Jersey family had considerable wherewithal and a deep history of serving the country as far back as the Revolutionary War. She was no slouch either. She painted, as well, and sang opera with success into the 1950s.

I knew little of this when I sat down and wrote George L.K. Morris asking him about *New York Window #2.* (How had he come to do it, where was *#1*, was it similar, or was there a *#3* and a *#4*?) I didn't have an address so I sent the letter, without much expectation, care of Hirschl & Adler, the gallery where Kent Truog had bought the painting that now was mine.

By then the forbearing Jenny and I had found a tiny house to rent in the Hollywood Hills. It had a front yard the size of a couple of coffins laid end to end and a telephone pole instead of a tree with as many wires as branches. It was a funky neighborhood with good, quirky people and enough animals to populate a zoo. There was a noble Malamute, Elton, who patrolled the streets and lorded over a wide selection of other scrappy breeds. Down the hill lived an otter. He climbed up the hill and came to visit us, lonely, in search of his mate after his owners split them up when they split up. Across the street was a llama. He could startle cars as he liked to loom his long neck and head out over the road. His owner, William F. L. Singer, also kept a jungle cat, a chimp, and piranha in a thick, glass, pressurized tank in his cellar. He made films about pineapples and somehow managed to inveigle Ingrid Bergman and Elizabeth Taylor to come to lunch.

Yet we liked the little house once the front door was shut. I painted its three rooms, listening to the Watergate hearings. In the cubicle of a bathroom I did the walls and ceiling using an oil whose fumes made me dizzy, or was it what was happening in the country? The living room had a high slanted ceiling, a cork floor, and old floor-to-ceiling windows, each a yard square, overlooking a ravine. In the distance, across the Cahuenga Pass, perched the Hollywood Sign. We were at an askew angle — looking down the line of the letters — so they were hard to read. They would

be restored and reconstructed a couple of times but they were made of dented metal and dilapidating then. First light caromed off the letters as if striking mirrors and, for a brief season, ricocheted in our windows. Last light altered the letters, washed them with pink, peach, and rose before dark took both color and the letters away.

We had little furniture and were waiting on what there was to come West in a moving van, along with wedding presents. They didn't come quickly; they waited on other orders destined for California to fill the truck. We had two folding chairs and now two paintings, the Marin and the Morris, and not long after, a letter arrived in the mailbox from George L.K. Morris.

He wrote how he had come to paint *New York Window #2*. He had just married Suzy Frelinghuysen and while honeymooning in New York City he had journeyed out to New Jersey to meet John Marin for lunch. They had spent the afternoon together looking at a selection of watercolors Marin had recently completed. As they did, Marin talked to Morris about how fundamentally important it was to have an "understanding of accidentals." That's what art was.

The phrase stayed with Morris. It kept reverberating in his head. When he got back to New York, excited, he set up a pad of paper and set to work at the window of the Carlyle Hotel where he and his bride Suzy Frelinghuysen were staying.

We lost track of Kent Truog, as can happen, though I would now and again think of him and wonder about him, wired tight and white bread and with such taste, and worry about what might have become of him. But we had his painting and George L.K. Morris' lovely letter with its remarkable confluence of coincidences made more precious and valued as not so long after it came, sadly, George L.K. Morris' car skidded on a wet summer night and crashed into a trailer truck at a notorious intersection of highways in Massachusetts, and he was killed.

For years I had the letter close by, for a while in a safe deposit box, but then in one moving or another it went missing, and unfortunately, to this day, that's where it remains.

But the phrase "understanding of accidentals" isn't lost. It's with me still, and as I get older, life lived, thought and written about, I've learned it not only refers to art.

HAL, THE ARTIST

ROUND THE CORNER FROM WHERE WE FIRST LIVED in the Hollywood Hills was a point of land that reached out over the Cahuenga Pass. The Hollywood Freeway sang or snarled below, depending on the time of day or night. There were old concrete pillars — I don't know why or for what — and scraggly undergrowth. Otherwise the flat piece was strangely unbuilt upon.

I was struggling to write and failing with perfect success. In my futility to escape it and myself, I took to drifting out to the edge. There was a place to sit, a flat rock before the land fell away and dropped to Mulholland Drive hidden below, and then to the visible unstopping river of the Hollywood Freeway. When I was stuck — which was often — or discouraged — which was often — I'd give up the blank page or, equally troubling, the page with all the gnarled attempts and cross outs. I'd try making coffee, or reading, or staring out across the ravine at the Hollywood Sign. The Sign offered its myth to daily sight, a symbol of a dream. From the yard-square windows we had, you felt you could practically reach out and touch it and grasp the possible reality. Even trying to be sober or cynical didn't stop the heightened sense of its proximity.

So I'd walk up the winding street, maybe under the gaze of the llama across the road, or accompanied for a turn or two by Elton, the proud dog, and go past the last houses, one redone nicely, and one tucked back, barely visible and falling into some disarray, to the point. I'd sit on the rock and wish for success. At least to make a little money, earn a living to support my wife and someday perhaps a family. I thought of my father and his struggles. How I knew he carried a sense of both obligation and failure. On the rock I only yearned to earn just once what I estimated his salary to be. To the Hollywood Sign and the Freeway I sent up a kind of

prayer or promise: let me just make forty thousand dollars one year and I would be happy.

I had sent stories and a novel off to an agent in New York who had agreed to represent them and me. He was a laid-back, world-weary, aristocratic-looking man who wore a tweed jacket and glasses the one time I met him. His name was Al Hart and he sent me, under the circumstances, kind, hand-pecked, typewritten notes on buff stationery to accompany one rejection letter after another.

I remember walking out to the rock holding one more and seeming final letter. Al Hart had enclosed a savagely dismissive note from a publisher. I knew, if not recognized, the hunger I felt wasn't only about success or money. It was about recognition. Respect. A search for some. A hurt about having none. A fear that it would always be so. The ignominy of anonymity.

On these journeys to the rock, I sometimes would glimpse a scruffy man with bad teeth, a wayward beard and wild head of hair half-hidden under a hat. I came to know his name, Hal, from another neighbor, Bill Black, the man in the well-kept house next door to this bearded man. We didn't call each other by name even after I came to know his. We just hailed each other as we passed. Once in a while Hal would stop me, usually to my mild aggravation, and tell me about a plant in bloom, or some rock formation. Some were odes, some complaints, some yaks practically in code. I didn't listen closely.

He — Hal — was atmosphere; a small part of what made the several turns in the road and sharp-pitched dead ends a neighborhood along with Elton, the llama, the lovesick otter, the Schindler house down the street with a funicular, and the vision once of a young Kim Basinger naked on a balcony of one of the strange cantilevered houses around a curve several doors away. A couple dozen of them were plopped around the twisty turns nearby, shaped like wartime pill boxes or oversized dog kennels.

There was other lore and legend along the twisting Hollywood Hills street. Point at a house and it seemed to have a history or a tale: the one where a fast-rising news anchor was supposed to live, the one where the writers Will and Ariel Durant had churned out their best-selling books charting the history of the world, the one Sonny and Cher had rented before they were famous, the one — or was it that one? — where a blonde starlit had committed suicide, and the one that wasn't any longer that had been a castle built by a silent screen star. Only the skeletal remnants of its retaining wall on a steep hillside remained.

For all my lamentation, the walks and the rock were therapeutic. The days were stubborn and worrisome but we were young, our lives were simple, and the quirky area had vitality, a curious charm, and, on certain days, remarkable beauty. In the spring, the pyracantha bushes looked like mistletoe and were dense and burnished with berries, deep orange-red berries. They were inedible but they gave flame to the hillside. In the summer, the ravine was green, the leaves first spearmint and celadon shades and then darkening to a dusty loden. In the fall, the ravine changed its clothes as the leaves turned. The view from the windows became golden. In the winter, after rain, Mt. Baldy would rise in the distance, etched along the horizon, pale and snow-covered.

We came to know the Blacks, Bill and his wife Sue Ellen. Bill had been a bit of a beatnik and hippie in San Francisco a decade or two before, had a marriage that fell through and now had a good-paying job, a different wife, and when he went off to work in the morning was well-groomed, if with a bushy but brushed moustache. We shared dinners; theirs meticulously and finely set and crafted, ours less so, and certainly more economically so. The Blacks kindly allowed us to camp in their house when ours, though promised, was still under reconstruction when our daughter Jacy was born. Jenny and I slept with a newborn in sight of an enlarged photo of the Blacks taken nude in Topanga Canyon. Bill helped us, as well, find a piece of glass for a table. Not ordinary, specially cut to size, smooth and rounded, and as thick as a thumbnail. His daughters from his first marriage came to visit, the older in bloom and married to a troubled Vietnam veteran, the younger walking down to our house to

hang out, hoping to catch the TV series *Starsky and Hutch* on television. We had a TV while Bill and Sue Ellen didn't, though ours was third-hand and had a screen as small as a hand span. One morning, Hal appeared at the Blacks and said he was having trouble with his wife, Barby. She wasn't acting right. Bill offered to help and went to look and it was true. Barby wasn't right: she was dead. Hal didn't seem to understand that she had expired. He watched, befuddled, as Bill did what you have to. Even after Barby was gone, her body taken away and then cremated and buried, Hal couldn't quite comprehend it. He would talk about Barby as if she had just gone out for a while or was in the next room. She would be back soon. They were a love story. Without her he was lost, and he took to seldom dressing, rambling in a robe, and his health failed. He went downhill fast. Without her he didn't last long.

After Hal passed on as well, Bill Black called me to come take a look at what was in Hal's house. It seemed there were a lot of books. The house was a mess. There were stains on the walls and floors, and the rugs were a sorry sight. The heater looked unvented and unsafe and the stove — a tiny four-burner — was 40 years old, but the most astonishing sight was the ceiling in the bedroom. It was no longer flat, but concave; it was drooping over the bed from the weight of honey. In the crawl space above must have been a huge hive and the honey had leaked through. It was a dripping stalactite.

Books were everywhere, shelves of novels, and most of all art books. None were new; many were decades old, some touched with mildew, and well-thumbed if once- or still-fine editions. One especially caught my eye. It was a two-volume boxed set of Vincent van Gogh's letters to his brother Theo. Many of the letters were illustrated, his original manuscripts reproduced and highlighted by his increasingly powerful drawings with their ferocious energy and forceful curvilinear lines. So riveting and emotional — his combined craziness and his controlled genius on display in sepia tones in the splendid edition. The set, somehow especially under the circumstances, was impossible to turn away from.

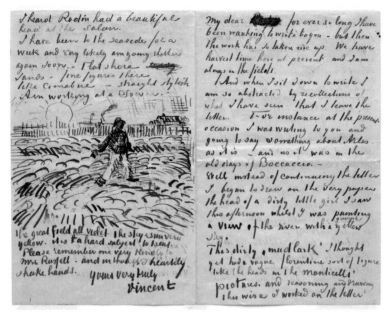

VINCENT VAN GOGH, *LETTER TO JOHN PETER RUSSELL*, 1888

But there weren't only books. There were scads of paintings, awkward stacks, and photographs, some framed and some not. Even those that were framed often lacked glass or had slipped within their frames and were tipped askew.

I recognized the paintings were original — original Hal's — and they dated back to the 1930s. I had never heard of Hal, not that that was wholly telltale. I was certainly not then, and only most sketchily so now, a holder of wide expertise. These paintings were small and vivid, quick washes and oils, the earlier more representative. They seemed like WPA works, sturdy buildings and strong men laboring, and kin to Regionalism, the school that claimed, sometimes under protest, such American artists as Grant Wood, John Stewart Curry, and Thomas Hart Benton. Regionalists tended to be tied to the Midwest while Hal's subjects were Californian. In the later paintings from the '50s, the shapes splayed and skewed, and seemed to lose their center. They turned to slashes as if the architectural lines had collapsed, or he began a search for a new, freer form that nevertheless felt haphazard. There were still more recent ones,

little more than dashed-off sketches, completely fragmented and broken. Beginnings, or endings.

Hal was an artist and he had never stopped working. He had never given up. I realized I was looking at a body of work, however unrecognized. I was looking at a life lived, however unacknowledged.

The ignominy of anonymity.

Among the photographs, I discovered some of Los Angeles from 40 years before that remarkably declared how much the city had changed. And in searching about I came upon a scrunched-up wad of pictures that had been taken even earlier. These were shots of Hal and Barby, young and fresh and determined, coming across the country during the Depression carrying their whole life in a car with them. It was hard not to think of Jenny's and my own similar journey across America long after theirs, but not so long before I found myself sitting in that sad and decrepit house.

I went through the books then and called a dealer from Heritage Books to come and look. Bill suggested I take one or two that I liked before they arrived. I wanted to take the van Gogh books. I didn't. The desire felt greedy, and it was only afterward that I understood the want I had wasn't just for van Gogh's drawings and his letters. It was because of Hal as well, a memento of a life I barely knew and only came too late to appreciate and want to honor.

The book dealer took the set.

Later, earning a living at last — if not the dream of forty thousand as I sat out on that point of land where I had first glimpsed Hal — as I kept remembering it, I went to Heritage Books to retrieve it, buy it now. It was gone. The set had been sold. Over the years in one bookstore or another, even now online, I've often thought and hoped against hope I might come upon them again.

But not yet.

A CALIFORNIA STORY

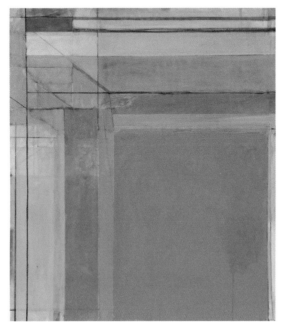

RICHARD DIEBENKORN, *OCEAN PARK #79*, 1975

He would start and then stop, draw back and then start again. Dick was suspicious of what he called the headlong, where you start and go on no matter what happened.

— Wayne Thiebaud about Diebenkorn

EARLY ON AFTER BEING BACK IN L.A., I heard that the artist Richard Diebenkorn had also moved to Southern California. He was teaching at UCLA, and had put together a studio near Ocean Park in Venice. My first time I had lived in a number of different places across the face of Los Angeles, off Adams Boulevard near USC, in a borrowed room in Hollywood, a tiny apartment in Los Feliz, and briefly north of Malibu. But I didn't know Venice well and Ocean Park not at all.

I was still young and, as far afield as Diebenkorn was from what I best knew, I was taken by the work of his I had seen. I thought I knew what he looked like: photos showed a well-set-up man with a brushy moustache, thick glasses and shirts with button-down flap pockets that could have come west from L.L. Bean. Without an address, I took off on an expedition to find this artist. It was foolishness for sure, and I foraged along Abbot Kinney Boulevard, saw and knocked on the metal doors of new lofts nearby, jigsawed around the canals over the narrow bridges in Venice, and of course I never found Diebenkorn.

I had picked a Santa Ana day for my trek, part of an unending week of Red Wind and the heat and threat of fire. One had already eaten up 2,500 acres in Topanga Canyon. Days before, it had lit up a chunk of sky and spun ash in the air, the bleached white shade of the inside of a shell that tracked you down, indoors or out. Window light looked like chemistry experiments, beaker colors, and left in its wake, finally, a dusk of stunning purple.

The temperature was still 99 degrees, even so close to the coast. I had bailed out of a tiny cubicle I had rented as an office that hadn't air conditioning. It was above 100 degrees there, too hot to work, and the tiny space had tissue-thin walls and I could hear two women talking in the office next door. I could see them through a louvered window, also not working, sitting on the floor sharing complaints, talking about the heat, aging, and the impossibility of relationships. One was casually brazen, remembering how she once had had groundbreaking sex, once, and ruefully laughing about spots that were just too tight to fuck in, like the front seat of a Volkswagen. She had had to say, "Well, sorry, Buckaroo." Despite herself and her tossed-off words, pain seemed to press through her words and make new coins of them.

I ended up my foibled, failed, fruitless-seeming journey parked atop a hill in Ocean Park near the Santa Monica Airport in the still unrelenting heat and clutching the remnants of the girls' conversation. It was late afternoon now and there wasn't a single subtraction or softening of light.

It was stark and made me blink and squint, as if I had sand in my eyes, and seemed to sharpen and yet shatter and splinter whatever I could see, like the paintings of Ocean Park by the man I had sought and hadn't been able to find.

As Diebenkorn wrote: "A painting... is an attitude. It says this is the way it is — and its beauty, fitness, magnetism, or emotion embraces the viewer and, if it does, seduces him — in some way persuades him that this is a way of viewing what it is to be viewed."

I looked down to Lincoln Boulevard and up to another hill and beyond it down to the Pacific Ocean. The rising and falling shapes jammed together. The configuration accordioned the land and defied realism. The shapes seemed to both fracture and flatten, an impossibility. The visual truth wasn't literal and had a metaphoric echo to how alien Southern California had felt to me the first time I had arrived.

Sitting in my car, looking west and then south toward the bigger airport, LAX, I thought back to then, several years before I was married when I had little money and no car. It was a strange existence in such a city. Wherever I went, I walked. The locus of my life was very small. I had hitchhiked often in college on the East Coast. I tried it once on the Santa Monica Freeway. Once. It was clearly dangerous and not done and, by the way, illegal.

On the plane coming down to L.A. from San Francisco, I had met a girl named Joyce and when we landed she gave me her number. Still carless, I called her. Joyce picked me up in hers and we drove out the same Santa Monica Freeway to the Pacific Coast Highway to Malibu. My first time.

On the beach, Joyce shucked off her shirt and revealed a one-piece bathing suit that showily narrowed and snugged into a metal ring beneath her breasts. She was opulently built, and clearly nervous, as if she both wanted me to notice, even make a pass, and very much was worried that I might. At first Joyce was full of questions about me, but they didn't last

long. As I listened she turned quickly back to talking about herself. We were still very much strangers yet as we sat on the beach a few feet above the high tide line, Joyce broke down in tears.

She told me about her boyfriend, his lousy treatment of her and, without looking up and noticing the two men who were walking practically over our feet, she told me that she was pregnant. I had no idea why she was telling me. Perhaps it was easier to share it with someone she didn't know rather than face the lousy boyfriend, or her parents, or her real friends.

I had no idea what to do or say or how to help, and only could wonder what was this world I had come upon where such intimacy was so easily and quickly shared as well as what the two men, Joey Bishop and Buddy Hackett, who had passed us so closely, might have heard, and the surreality of who they happened to be.

So different than the customs and sights and silences of where I had come from.

This became a definition of Los Angeles to me. As someone said: in Los Angeles cause and effect aren't linked like elsewhere. They are separated, broken even. Cause gets on the freeway in one place and effect gets off at another exit miles away.

I never saw Joyce again. There were a few phone calls, each more distant and awkward until they ceased entirely and her fate fell out of my life.

I kept a journal in those first years and they are full of encounters that seemed like they would lead somewhere and then didn't. They were like strikes of a match — a call from a barely known neighbor asking my help in fear of a prowler and my facing the wrong end of the shotgun she carried when opening the door in a way short bathrobe; a 25th birthday party for an ash blonde, more-than-pretty young woman held in candlelight because her gift to herself for the event was an eye lift, the stitching set like second eyelashes; and standing with an acquaintance

side by side on his roof with hoses in our hands fighting to save his house from a fire — full of incident and intimation but no fruition, continuity, or conclusion. Like Joyce, they fell away, ended without punctuation. We went our separate ways and on into separate lives, like ping-pong balls ricocheting down our own freeways. I lost track of these I mentioned — and there were others — and never saw them again.

Back then, still without a car, I took to driving around the city with a man I met, also new to L.A., in his Pontiac Firebird. He had an early cassette player and a tape of composer Bernard Herrmann's scores for films, mostly Alfred Hitchcock movies. We put it in as we ventured through the twists and turns of the canyons in the Hollywood Hills, as far west as Mulholland Drive and the San Diego Freeway, and toured east past the Cahuenga Pass and into Los Feliz. His car became a camera and with the music there seemed mystery and melancholy to what we saw, stories ready to sprout.

We would turn a corner or round a curve and come upon a house that belonged to the '40s and the housing development Hollywoodland, "a Spanish house, like all the rest of them in California, with white walls, red tile roof, and a patio out to one side" that earned the title as the House of Death in James M. Cain's *Double Indemnity*.

The very next house might be completely different, designed by Richard Neutra, Rudolph Schindler, A. Quincy Jones, or one of more than a half dozen about Los Angeles by Frank Lloyd Wright. It might be beautiful, all glass or a classic Craftsmen. It might be an oddity or a ghastly sight, as if it had wrangled its way in from a '50s "B" science fiction movie, cantilevered off a hillside, its entire underbelly — pipes and ducts and wiring — hanging out for all to see from the street below.

There was no sense to it. The architecture house to house seemed not to fit, like the landscape I would later see from Ocean Park, and split here and there like the lives I had glimpsed, and the diagnosis I had heard about cause and effect.

In every work of genius we recognize our own rejected thoughts:
they come back with a certain alienated majesty.

— *Emerson*

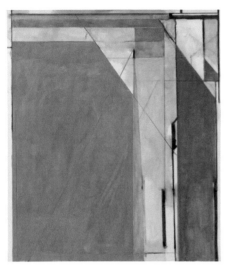

OCEAN PARK #70, 1974

When critics write about the artist I went in search of and didn't find, Richard Diebenkorn, and the near-100 Ocean Park canvases that burst forth from his time in L.A., they say he "successfully mapped out a neutral zone between conceptualism and painterliness, striking a balance between the romantic formalist sensuality of Matisse and the precise mathematical serialism of Mondrian." They say his "abstractions are composed of second thoughts, pentimenti, erasures and emendations," and that "many of his images involve the same elements: a scaffold of lines and bands, overlapping planes and atmospheric veils of color through which layers of activity can be perceived. The effect is an architecture of form in which the beauty has as much to do with the intricacy of the joinery as with the overall design." They say, "The strength, and the curiosity, of his work also involves the contradiction inherent in the idea that indecision, conflict and tinkering could become the essence of such sensuous and seductive painting."

Whatever the incisiveness or eloquence of such words, it's not what I see and feel most in Diebenkorn's great paintings. Rather it is the apprehension of not just the geography I witnessed as I sat parked and drove about a city decades ago, and still. It is the capture of an essence of a place, a people, and a way of life.

In the 20th century, it is Edward Hopper, a painter so different from

Diebenkorn yet one he nonetheless admired, who characterizes and embodies so much of what I witnessed and felt on the East Coast. A silence and stillness in everyday subjects that arrest both infinity and apprehension, and that he makes immutable.

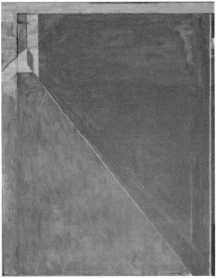

OCEAN PARK #140, 1985

And it is Richard Diebenkorn whose work — however seemingly abstract — feels charged with an echo of similar silence, unease, and sharp shadows in a scenography that waits in slanted glare and broken angles for the unexpected that embodies movingly so much of what I was to find on the West Coast.

THE WEATHERMAN

WHAT MIGHT HAVE BEEN 10 MINUTES OF MY LIFE — a stop at a gallery in New York that I had never been to before and would never go to again — turned into a couple of hours as day turned into night that stays with me still.

GORDON'S WORLD

Arriving, I walked into a place with a few paintings but largely a world of colors and shapes. Of objects. A wooden horse, a yellow bureau, a crooked frigate, a green bench, a figurehead, a red chest, patterned quilts, and weather vanes, both wood and metal, one with a carved wooden witch, its broom points of the compass and another with an iron rung man on a bicycle atop the directional arrows of north, south, east, and west.

No one was in the gallery, no customers at least. There was only a man who left me alone for a while. He kept his distance. He was perhaps 50 and wore glasses and had a goatee, or what once was called a Vandyke beard. He was a compact man and his eyes behind the glasses were fit deep into the dough of his face. His name was John Gordon, it was his gallery, and he — if I didn't know it — was an expert in Folk Art, the foremost one in New York and perhaps in the country.

At some point, without really coming much my way, John Gordon called out: "Does it speak to you?"

"I hate to admit it," I said, "I know nothing about Folk Art." And I hate to admit it now, but I don't even recall the particular object I was looking at and in some way in that moment was fascinated by.

"Sometimes the best time, even if it's misbegotten," John Gordon said, coming closer without really hurrying, "is the first thing you buy. It's love or passion unbridled. Does it call up a time or a place, or I like to think weather, but it's not yours really, it's the revelation of Its life that captures you." His voice had command and held an enjoyment, and perhaps a tickle, of kidding. "People who come here are looking for art. I don't call what I have art. I like actually to call these living things because they weren't ornaments or fictions. They had a function. They functioned. Function." He played with the word as he repeated it, and then he said: "I like words. I like the sound of them, the feel of them. They can feel like I'm touching what they say and are. Take kinds of wood — cherry and walnut and mahogany — or the names of colors — russet or ochre or amber or pomegranate. Or take ordinary words. Like — everyday. Isn't that our lives?"

In spite of his saying how much the simple and the ordinary were to his liking, John Gordon proceeded to seed his conversation with words that were musical and beautifully intricate. Knuckled, entwined, enlivened, seasoned, and spontaneity. He liked the word spontaneity. I had no idea then that he was known to be (as the wondrous critic Whitney Balliett at some point wrote) "an impassioned Ancient Mariner who could sit in his shop and discourse on the beauties around him non-stop."

As he continued to talk, I learned about patinas and the way spindles could and should fit functionally into a chair. And why. I learned about an antique red that wasn't fire engine and not quite blood, how beyond its aging and mellowing, its shade came from a pulverized mixture of brick and buttermilk.

We talked of shillelaghs because I knew a little of shillelaghs. How in the white ash and the black thorn the big knuckled (yes, knuckled) handles happened. Planted facedown in the ground, the seeds twisted upon themselves in the soil, making the bulbous knots of the handles as they reached to find the sun. Their desire to grow and the force of nature were that strong.

He talked about what he knew and loved, his Folk Art that I knew so little about, turning the pages of his life back and forth until he reached the time of his first collecting. It had been in Pennsylvania and led to some funny stories about plates and signs and a more serious questioning about the WASP way of life then. The lack of Jews yet the lack of bigotry. The lack of knowledge maybe even to express it.

After a while I found myself standing beside him in the window of his gallery. He took off his glasses and lay them on the wide sill and his face seemed to wash clear of years in the late and suddenly radiant light. It had been a wet winter day that couldn't determine whether it wanted to rain or snow. A low-hanging gray. The sun had cracked through now. It wasn't visible; the city's buildings blocked it, but its cast of light struck through the canyons of the streets and turned the sky opalescent.

John Gordon turned to me. "Every morning the first thing I do is come to this window," he said. "I get up in the morning and I can't wait to get here, and every morning what I see is slightly different. Every time it's never the same, the season, the weather; more than that the way the buildings set together. I feel almost as if what I see is new and yet it carries with it all the times I've stood here."

"And every time too," he said then, "I think of the same thing. I think of my mother and I can't tell you why. Can't. I don't know why."

I don't remember what I said, if anything, and he asked me then if I had seen a movie *The Way We Were* and he began to talk about it. I soon realized he wasn't talking about the film itself but about its romance,

not just that of Barbra Streisand and Robert Redford, but the romance of that time — the '40s and the '50s — World War II and the urgency of serving and winning — and then the saddening years after with the House Un-American Activities Committee and Joseph McCarthy. And not just of that time, but what was his time, his memory of it. That way we were.

He had invested himself so much more into a Hollywood film than even what was there, as we all can and do. He talked about its famous last scene in front of the Plaza Hotel where the two lovers now a decade later see each other briefly and longingly again. And he reached in and brought up from the depths of himself his youth and idealism, such sweetness and loss and a relished yearning as we stood at the window and the sky lensed through the shades of dusk and seemed somehow to capture his emotions. Tipping into a luminous pewter and a pearly blue and finally reaching the deep shade of a mussel shell. Colors that John Gordon might well name.

There was only darkness before I realized we were still standing there and I could barely see him. We needed to turn some lights on. John Gordon laughed then and said, "But why am I telling you all this. I don't know you."

And he put his glasses back on, and left his memories and dreams at the window in the changing weather, at least until he came in the next morning to see it anew, and left me with them yet.

GERTRUDE

G.M. YOUNG, *AFTERNOON CLOUDS*, 1929

ONCE A WEEK WHEN I WAS YOUNG my mother had tea with my grand-mother, and sometimes I was dragged along. My grandmother's maiden name was Grace Mason and she was a well-read, very reserved New England woman with a mole on her cheek like Abraham Lincoln. For the last decades of her life she lived alone in her house until she died at 93 on the 21st anniversary of my grandfather's death. It was a big house, once splendid, where she had raised 10 children, eight surviving until adulthood.

My mother and grandmother sat opposite each other and talked in two chairs in the alcove of the living room that was flush with bay windows. While they did, I would explore the shambling, neglected yard that encircled the house and then go upstairs off what was called the Music

Room to a balcony overlooking it. The Music Room was two-and-a-half stories high with a fireplace big enough to walk into and a far wall of lead-paned windows, some with lightly-colored glass. It was a magnificent space that sat abandoned, except on Christmas, with trails of stains from leaks in the roof finding their way down the walls and tapestries and the stonework of the fireplace.

Up on the balcony was a pint-size pool table. Half the pockets had lost their webbing, or what was left had become unmoored. The funky table was wackily warped. If you missed a shot, the tiny balls would find a way to abandon their intended destination and roll back to the center of the table. It was fun to play, when not frustrating, for a while.

Finally, I would surrender and join my mother and grandmother, sitting in the living room itself, and read or do homework and then, bored, gaze about the living room. There didn't seem a lot to look at. There was a collection of family photographs on a library table that had drawers on both sides and a painting over the couch.

The painting was a landscape, clearly not New Jersey or Massachusetts. The land was all but flat, desertlike, and in shades of yellow. Cornmeal, butter, and the color of a lion's mane. The bulk of the painting — more than the top two-thirds of the canvas — was clouds. They held the energy in their sense of movement and the way oil had been applied in different degrees of thickness, some a lively, roiling impasto.

I looked at it often — many times over several years in my boredom — still the painting didn't register. I forgot it, or thought I had. It faded and fell into the unconscious.

After my grandmother died, the house was put up for sale. Its grand size, need of a face-lift and the timing — a severe recession — made it virtually unsaleable. The price was lowered and lowered again before finally someone snapped it up. While it was in escrow, the family had at the possessions not without some clamor and dispute. At some point, as

the house waited on the outcome, I went for a last time to see it. Silver was gathered up and laid out together. Rugs were rolled up, books were packed in cartons, and furniture was tagged. It had always been an eerie house — so quiet and for so long largely unused — and now more so.

I had seldom been up to the third floor, but climbed the steps on this day. There were two stale, long-forgotten bedrooms. The decades of abandonment had left them dusty and desolate. In the smaller one there was a bookcase that still held books. It wasn't full and some had fallen onto their sides. It was a late winter afternoon and the room was losing light. The overhead fixture was burned out. I turned on the single other small lamp with a shade that once may have been white and had now turned papyrus.

I scanned the books looking for familiar titles; even one or two I might want to read or keep. Few had dust jackets. Most meant nothing to me. There were several boys' books about a character named Tom Swift and one from a series I knew, the Hardy Boys, and had read years before. This one was called *Hunting for Hidden Gold,* No. 5 in the series, but the edition looked nothing like I remembered. The binding and thickness and print inside were different. So was the one illustration. It even looked like it had been rewritten, or more likely the ones I had read a generation or more later, and newer, had been.

My searching bent me practically to the floor, and it was then I could see an object jutting out from the back of the bookcase. It must have fallen behind it some time, perhaps years or decades before. I jiggled it free. It was crumpled like a thick, unwieldy, unyielding fan. I straightened it as best I could, and saw that it was a painting, an unframed canvas. It was signed and dated, "G.M. Young '26," and it brought back the painting, also signed G.M. Young and palely dated '32, that I had looked at so often a decade earlier in the living room and then forgotten.

By then I knew my father's Aunt Gertrude, my great-aunt, had contracted tuberculosis and had moved to the Southwest for her health,

first to somewhere near Taos, and then to Tucson. In the crumpled painting, I was looking at Indians — Native Americans — who were coming to pray or beg outside the Mission San Xavier del Bac.

This work — quite real and struggled and potent if not pleasing or centered — timed with my awakening interest in art, and started me on a quest to find works by and more about Gertrude Young. The search was erratic and peripatetic and I regretted I hadn't done more. All I didn't ask or pursue and can no longer, not only about Gertrude, gnaw at me now.

My journeys did take me to various family homes and two invaluable places — 18 years later to the Mission San Xavier del Bac outside of Tucson, and before that to Seattle, Washington, where, though Gertrude had been dead for over 40 years, her sister, my Aunt Doff (as she was called) still lived, approaching 100, a milestone she would well surpass.

Aunt Doff had been with an ambulance unit in World War I, loved to climb mountains, taught school in New York City, retired in 1938, and moved with her friend and companion Katharine Van Bibber to Baltimore. Then passing 80, Katharine retiring, the two women had packed up a Chrysler with huge tail fins and moved to Seattle. The reason: in 1912, traveling with my grandfather in Seattle, Aunt Doff woke one morning early and saw Mt. Rainier out the window. Its beauty captured her. The mountain seemed a miraculous vision. She went back to sleep and when she reawakened Rainier was gone. The memory held for 50 years and brought her back to live in a yellow house out on the east side toward Madison Park.

By the time Aunt Doff — Dorothy by birth in 1878 — reached Seattle, she had a pouchy, grumbly face, several chins —practically dewlaps — and wore glasses. She was ugly, and maybe always had been. With age and in her essence, Aunt Doff was also a beauty. She was a vivid character, completely alive and living in the now. She was opinionated, quick to praise, chastise, and forgive; she knew how to move on with élan. Aunt Doff said about arthritis that she had gotten it in her 60s, but now in her

80s and 90s she had simply outgrown it. In the final year of her life, she wrote me a longhand letter that held not a speck of concern about her age or such a thing as possible death. A lifelong Democrat — one of the very few in the family then — in it was her vow to vote against Ronald Reagan a second time.

My questions to her about Gertrude were short-answered. I learned she had been a governess in the White House to Teddy Roosevelt's children, had been in an early exhibition at the Museum of Northern Arizona, perhaps one even in the Brooklyn Museum. Little else. Neither had any more helpful information when I inquired. Not all I wanted. Aunt Doff was no nonsense, but she had several of her sister's paintings, a fine one over the fireplace, another minute one in the corner of the dining room. It was the size of a small hardcover book and in a ramshackle dime store frame. Because it was tucked away and hard to see, I drew closer to study it.

"That's not a good one," said Aunt Doff.

"I don't know," I said.

"You like it?" she asked.

"Yes," I said, more from politeness than knowledge yet.

"I don't think anybody's even looked at that one before."

"It's a prickly pear," I said, referring to its subject.

She came up next to me. "You may be right," she said. "Yes, it is, but it's not much. I've never particularly liked it."

She unhooked the little picture and took it off the wall and handed it to me. I carried it into the window light and the sun found it. The painting awakened; it animated and came to life. Colors arose, the greens of the cactus and the sharp bright bits of chromium yellow that were its flowers.

"It certainly is filthy," Aunt Doff said. "Let me clean it, and you can have it."

"No," I protested.

But she had already taken the painting back and crossed the few steps to the kitchen. She wet and soaped a paper towel and started, to my horror, rubbing the painting clean. The next thing I knew it was in my hands, mine, to begin so far another 40-year journey, this time with me from one house or office to another, and is gratefully in sight on a wall now.

G.M. YOUNG, *DESERT BLOOM*, 1927

At age 105, Aunt Doff died, vibrant until her very last days. Afterwards, her companion Katharine Van Bibber sold the Seattle house and moved back to Baltimore. I learned Aunt Doff had left the Gertrude Young that had hung over the fireplace, the good one, to me, along with a sepia-shaded photograph of her sister painting outside of Tucson. They joined the little one I already had, two paintings and a photograph of a dead relative, a painter. I wish I knew more. I wish I could scoop up all her work, every painting, to see what she saw and felt and painted, and learn about her, and in some way about my family, and even myself. Those holes in the family periodic table that it is now too late to discover and fill. Hardly

a day goes by, and certainly not a week, that I don't look at them and wonder who Gertrude was, what she thought and how she worked, and consider the course of her short career from the realistic representation of San Xavier del Bac to the big canvas once in my grandmother's living room with its nearly abstract clouds that she painted only a half-dozen years later in the last months of her life.

Art is complicit with such musings. About the artist but also about ourselves. Paintings endow a sense of space, human or geographic, representative or abstract. They have the power to widen us, free the eye and the mind and unveil what we haven't conceived or thought of. They can expand the imagination and have the power to reach down into that crucial place deep in the loom where our thoughts and feelings touch and merge.

G.M. YOUNG, PAINTING

So the little Gertrude Young remains with me hard by, whether "not so much" or not, a prickly pear in bloom, as company and a connection to the history of my family and to art.

STORYTELLING

These are the stained glass windows of the American cathedral.

— Anonymous, about Norman Rockwell

I sometimes think we paint to fulfill ourselves and our lives, to supply the things we want and don't have.

— Norman Rockwell

NORMAN ROCKWELL, *SHUFFLETON'S BARBERSHOP*, 1950

WHEN I FIRST GOT A FOOTHOLD IN HOLLYWOOD, I met a man who also had recently fallen off the turnip truck. BV was equally young, wore a fresh beard, and had gotten a job at the bottom rung in Business Affairs at a studio. He was buried in an office without windows

in a brand-new, already ramshackle building at what had been and would be again Warner Bros. I was lodged, employed week-to-week, in the smallest possible cubbyhole in the basement of the same building.

BV was a long way from home: he hailed from Minnesota, his father had deserted the family when he was 8, and he had carried through law school and into adulthood a deep sense of dream, not of stardom, but an awe of those who had found a place within such a world.

When I met him, BV was in a state of marvel and incredulity. His first assignment was to finish off—dot the i's and cross the t's—of a renegotiated contract that left him in amazement. Beguilingly mind-boggled wouldn't be inaccurate. The contract was for Angie Dickinson, starring then in a television series. It wasn't only her salary, though that alone was cause for marvel. It was finally the other provisions included in her contract that supplied the awe — the limitation of hours, the limousine to pick her up and return her home, and the paragraphs about the requirements for her wigs and hairpieces. And then there were her dogs.

We shared that time, now some 35 and even 40 years ago, and the characters in television and movies, young or old, who seemed busy and with industrial strength out to prove just how insane — sometimes wonderfully, sometimes aberrationally — Hollywood was close up. There were personalities aplenty and moments that lifted out of reality.

One afternoon, for example, I stepped out of our building and before I could walk to my car I saw a man on horseback coming toward me. A towering figure out of time and mind warp, and a legendary one. It was John Wayne. His final movie, *The Shootist*, was filming on the back lot and the western street created only 100 yards away around a corner. The incongruity was gargantuan — a gimcrack new building and an iconic hero out of another time, a legend who embodied a past century. I watched him come, stunned. I'm sure he knew it, knew he was riding on pavement, taking his own sweet time before turning around to get back to the dirt street laid down on the set. His horse seeming as titanic as he,

and it needed to be. John Wayne reached me and smiled and glanced down to me from under his tall, worn, wide-brimmed cowboy hat and called out without stopping, "Hey, kid, how ya doing?"

No more, no less, a John Wayne line in a John Wayne voice. He looked huge, he was huge, enjoying himself as he moved on and left me with a mythic moment both real and not.

Any number of years later I found myself paying new attention to paintings by an artist I had always discounted. I wasn't alone. He had been the most popular painter in America while he was alive, but he was dismissed then and still by art critics and historians. Often ridiculed. He was labeled at best an "illustrator," a term he even insistently embraced himself.

He was, of course, Norman Rockwell.

I didn't realize it then, and it didn't occur to me until I saw a photograph of Rockwell with John Wayne, late in both their lives, that the fleeting instant I had been participant in could well have been the subject of a Rockwell painting. A boy, if you will, seeing an icon, perhaps with only my back visible, a perspective and point of view that seemed to be the case in many of his works. We the viewer filling in the meaning while Rockwell filled in often a surfeit of detail. Even too much.

He was a genius draftsman who couldn't stop himself. A compulsive worker seven days a week and holidays without exception. He was a driven man, an insecure perfectionist. He staged paintings with neighbors, photographed them, made sketches and drafts, and then sometimes started the process all over again before filling and finishing his paintings with layers of minute detail. He made paintings, to quote Roberta Smith, "that were instantaneously legible and technically breathtaking."

What John Updike called, "exceeding the necessary with an extra caricatural vitality."

Time and time again Rockwell couldn't leave well enough alone. The drowning of detail could suffocate his canvases and leave them claustrophobic. He insisted on giving "every hair of every mutt its share of picturesque completeness" (Robert Hughes). The staging — which he spent so much time arranging in his studio, snapping stills, sketching — often proved labored, rigid, and hamstrung. Especially as he grew older, Rockwell frequently set his characters up against a car or a wall or in a corner. The spaces, while rife with detail, lacked depth. The paintings imprisoned perspective; they shut it down. They locked the eye in, intentionally or not, and robbed the freedom to roam. They precluded mystery.

> *I love to tell stories in pictures. For me, the story*
> *is the first thing and the last thing.*
>
> — *Norman Rockwell*

For all the disparagement — including my own — Norman Rockwell's paintings were full of scenes, ordinary scenes, Everyman scenes, Hollywood scenes. This last may well be one reason that BV, who became a renowned collector of only contemporary art, still longed to own a Rockwell, and how two of Hollywood's most successful producer/directors, George Lucas and Steven Spielberg, each pulled formidable collections from Rockwell's immense body of work.

So much of the time Rockwell worked as an artist for hire, and the scenes he came up with in his relentless appetite to churn out paintings were often described as the way ordinary American life is or at least was during the *Saturday Evening Post*'s and his own lifetime; or rather the way we wished or wanted it to have been. They were immensely popular, yet the very same creations were simultaneously derided as nostalgic or sentimental or superficial. And he was repeatedly, authentically or not, one of his own severest critics.

These American scene paintings with such titles as *Christmas Homecoming, Before the Shot, Check Up, Puppy Love, After the Prom,*

Marriage License, Saying Grace, The Runaway, etc., when I leafed past them in books, made me feel at first exactly that — of course, there they are, he's done it again, captured that familiar event, that human moment and that family holiday.

But looking again, I stumbled upon a discrepancy. The truth was I had never encountered any of these moments. They hadn't happened, not to me, not a single one. It wasn't only the implicit or explicit idealism or romanticism. In final finished form so many of the paintings, at least in reproduction, didn't feel right. They were so rigorously real that they weren't real.

Hand in hand, there was a second discrepancy. When I happened upon a traveling exhibition in Tacoma, Washington, and then traveled to the Norman Rockwell Museum in Stockbridge, Massachusetts, I encountered a contradictory revelation. In person and in front of his work, there was an undeniable purity in as simple as a pencil line in any number of his drawings, and there was an unrealized power and punch in the surfaces of his work, in the very paint and colors and emotion in no few of his canvases. Even to the brushwork in Rockwell's famous Civil Rights painting, *The Problem We All Live With*, and what the writer David Kamp called "the juice streaks and viscera of (the thrown against the wall) tomato."

The so-called and self-named illustrator, seen so prolifically in advertisements and on the covers of magazines in reproductions, necessitated, knowingly or not, that we stand in front of and see his original work.

And there was something else: even if his paintings illuminated scenes that had never happened, even if we might have fancied they had, he painted stories. He was a narrative painter; a storyteller; a gifted storyteller, a storyteller who struggled ceaselessly, successfully and unsuccessfully, to etch perfectly the story he wanted to tell.

Take *Shuffleton's Barbershop*, a Rockwell masterpiece painted in 1950. Even in photographs its fineness can be ascertained. Yet such pales compared to the sight and scope and conceptual strength of the painting itself. The spatial depth, the saturation and glow of its brushes of paint. The burnt sienna and raw umber and cadmium yellow and zinc white. The sequestered, luminous glimpse of the ordinary men practicing with their musical instruments. And as Rockwell himself said, "the way the light fell across the magazine rack." In this case the right amount of rich and shadowy props and detail. Real and beyond real conveyed flawlessly.

Take a second of his most famous paintings, the cover for the *Saturday Evening Post* issue on September 25, 1954, *Breaking Home Ties*, that, along with *Shuffleton's Barbershop*, Christopher Finch wrote, "can stand out in any company." It's a beautiful, moving, emotional work, and one that became infamous beyond its justifiable stature.

NORMAN ROCKWELL, *BREAKING HOME TIES*, 1954

Rockwell sold the original painting for less than $1,000 to his friend, fellow artist Don Trachte, who proceeded to copy it and paint a talented forgery. The forgery passed as the original, hung in the Rockwell Museum for a decade, before the original was uncovered, found after Trachte's death behind a false wall in his studio.

Before the fake, there were no small number of early versions by Rockwell himself trying to capture the moment when a son, sitting with his father, waiting for a bus or train, leaves home. This was not new nor unusual for Rockwell. Copying and altering in search of an ultimate distillation was not just his penchant. It was Rockwell's imperative; it critically consumed him.

He came up with the idea at times of using a balopticon, an opaque projector that allowed him to cast photographic images onto his easel and the paper or canvas he had attached to it. He could do quick sketches and variations and establish color schemes before embarking on the final painting.

In the case of *Breaking Home Ties*, Rockwell posed different possible neighbors first in Arlington, Vermont, and then in Stockbridge after moving there. For a while, there were even three people intended to be in it, the third the mother, before she was omitted. He decided finally on his friend Joseph McCormick for the father, shot photographs and did charcoal sketches. He then traveled to Cimarron, New Mexico, and at Philmont Scout Ranch singled out Robert Waldrop to be the final model for the son. Then there were more photographs, sketches, and drafts.

And more.

"I could not decide on the proper setting," Rockwell later wrote. "None seemed to convey the idea that the boy was leaving home to go to college. By the time I had discarded the third charcoal, I had begun to lose confidence in my original conception. I decided to add the mother. A rough sketch showed me that her presence added nothing. After trying

the [train]station platform I returned to the original setting..."

In the final version, father and son sit on the running board of an old truck, with the consistently present Collie and suitcase at the forward-looking son's left leg. Only a glimpse of land can be seen beyond and through the truck. We are blocked from seeing further or more. Such is powerful.

NORMAN ROCKWELL, *BREAKING HOME TIES*, STUDY, 1954

"Creativity is allowing yourself to make mistakes. Art is knowing which ones to keep," wrote Scott Adams. And amidst the myriad early versions, there is one that I was lucky enough to acquire set in the train station, not on the truck running board, where we can see beyond the father and son, see into the empty station, see across the wooden plank floor, see a window, and see light pouring in. It is not so much more than a finely painted sketch, but the eye is allowed to escape the two men, wander and wonder, and still swim back elastically across the lonely place to fix again on them. Each time the location and return only add to the weathered

father's quelled sorrow and the forward-looking son's expectation in this moment of parting. The apprehension of a primal human narrative. A story, an equally fine and powerful one, making its own case.

But only one, a dropped and abandoned one, for this endlessly restless and uncertain storyteller unable to decide on or determine perfection of his storytelling.

Yet his driven attempts are compelling. The trail of his searches — whether they were illuminating or simply detritus — is a part of his fascination. If a stroke hadn't stopped him, and then death, Norman Rockwell would still be journeying to his studio seven days a week and holidays to strive over and over to grant to me moments with John Wayne, with fathers and sons, and America with scenes he believed rose out of our mostly deeply seated myths and dreams.

Searching for stories, real or actual or not.

REALISM

Reality is not what it is. It consists of the many realities which it can be made into.

— Wallace Stevens

THAT MAN I HAD MET SO EARLY ON, BV, moved from his nook and cranny of the cellar of the so-quickly-erected and as-quickly-falling-down building where we met to become a long-term successful agent. For years we stayed in contact, and before I knew of his interest in art we shared ice hockey. BV was from hockey-centric Minnesota and I had played in high school and college. We went to any number of Los Angeles Kings games and before so long BV had shares in season tickets. In those days the Kings were pathetic. They struggled to rise above the laughable and excremental. Their uniforms then — until Wayne Gretzky arrived — were purple and yellow but widely hailed as purple and urine.

In between periods, and the pathetic play, we began to talk about art. BV read assiduously and traveled widely. He sought out museums around the world. The number he visited was vast. His own taste was realistic, he said, and only that. Clean and meticulous and contemporary. He had a Warhol and a Johns, a Lichtenstein and a Wesselman, and a Rauschenberg. He also collected photographs, especially after he was married.

Memorable black-and-white images framed certain walls in his houses. Henri Cartier-Bresson, Robert Doisneau, André Kertész, and a signed print of the closing image from Edward Steichen's beyond-famous exhibition, *The Family of Man*, W. Eugene Smith's *The Walk to Paradise Garden* — the remarkably beneficent image of two small children walking away into the light by a man not known for beneficence.

Smith was a tough and uncompromising photographer, a thorny and

amphetamine-popping workaholic, who was arguably the originator of the photographic essay. His great work was stark and blistering, bequeathing indelible black-and-white images. The series he was responsible for — *Nurse Midwife*, *The Country Doctor* and *Minamata* — are among the most moving or disturbing ever captured by a lens.

Most of all, for a while, surrounding them, BV hung a school I hadn't been aware of labeled Photorealism, works then and still are often dissed by critics and classicists.

They worked from photographs, a series of them, wide and close-up of the same object or place in different times of day and different light. Using them together they would paint the scene and reach beyond what the human eye could detail. An extra declension. In some of their work, as you approached the surface of the canvas, the concrete specificity would crumble and collapse. In others it would sustain right to the acrylic.

One Photorealist, Ron Kleeman, did a huge painting of a New York firehouse that existed on lower Broadway. A thousand bricks, not to mention great old red-rimmed mullion windows, a fire hydrant and the gleaming front end of a fire engine all supremely rendered. So seemingly real. However, when I drew within a foot, the painting became abstract. All Kleeman's brilliance of specifics turned into snitches of paint. No less fascinating or beautiful and the achievement no less for it. Each Photorealist seemed to have a fascination, even an obsession, with one scene or another — streets, storefronts, movie theatres, ketchup bottles, or women.

I didn't understand at first why these works caught my eye or were to my taste. They could be enormously accomplished, quite beautiful, yet weren't they, after all, relentlessly literal. Typically, they provoked controversy and critical dismissal. Who'd imagine a saltshaker in as dramatic light as a woman in a Vermeer? Who'd want to? The gifted Ralph Goings saw ketchup bottles, pepper grinders, and silver napkin holders as well as saltshakers like that, and did.

I came to see that these paintings in their super-hyper-concentrated realism were not real. They were beyond real and knit with a peculiar paradox. These contemporary and apparently hard-edge snapshots of our time held an insistent contradiction. They breathed nostalgia. They were not only new; they were throwback. Consciously or not, they were distant lineage — step-great-grandchildren — of the 19th century American Trompe-l'oeil artists William Harnett and John Frederick Peto and their still-life gatherings of dead fowl, candles and candlesticks, letter racks and pipes. A century apart, both ennobled ordinary objects. And in their use of neon signs, luminous diners, and movie marquees, Photorealists carried a curious echo, closer in time, to the cinema of film noir with its sharp shadows and wet night streets and pulsing signs and lights.

ROBERT COTTINGHAM, *ART*, 1992

I met a number of them and — whether at great speed or at a crawl — they each painted like crazy. Robert Cottingham, a wonderful man, lived in Newtown, Connecticut, in what looked like a farmhouse perched close to the road, like a stagecoach stop in some bygone era. He was celebrated early, his paintings of great iconic neon signs poised above stores and in streets,

and sometimes in their own abstract wash of space. What he called "the jewelry of our downtown neighborhoods." After a while he abandoned signs and initiated etching individual letters. He did a whole alphabet from A to Z, and then followed with a series of acrylics of vintage typewriters and small, perfectly rendered perfume bottles. They were all stunningly done against fields of entrancing pastel shades. In his ongoing discovery of different subject matter, he came to feel he had left Photorealism behind.

DAVIS CONE, *THE GLEN*, 1988

Davis Cone painted movie theaters. He journeyed around the country photographing them. He had a graying ponytail, and painted slowly, and insanely scrupulously. In his studio, thermostats and barometers decked out the walls and humidifers purred to keep his acrylics wet for his meticulous brush strokes. His paintings were extraordinarily rich in detail and increasingly striking. His interest finally was in the times of the day. He painted broad daylight and complete night, but he loved most late light. The strobing or softening of the sun; the butters and harvest golds and the pomegranates and the ultimate burgundies and purples before night. The colors in the last gloamings — the lavenders, the plums, and the mulberries — he captured on his canvasses and was never satisfied when he saw them reproduced. Never.

Charles Bell painted marbles, gumball and pinball machines, and he painted toy clowns. His paintings were literal captures and yet fantastic. Even surreal. His virtuosity was spectacular. He imbued even the marbles with a luscious mystery and luminescent power that were far beyond any marble. In their own way they were breathtaking.

Among the times that I most recall and cherish are the chances to visit a studio and see an artist at work. It's not just the famous, and not simply about painters. It extends to how I still can't help read about how writers write, not just the mental process, but the daily ritual, the physical part, what used to be right down to the kind of typewriter and why, and even the details of sharpening pencils and what number of pencils they were. Or pens — fountain, or ballpoint, if not quill.

I had the luck to see Cottingham and Cone and Charles Bell in their studios, in Bell's instance, not knowing how sick he was. He looked a bit haggard, even ravaged — but what are artists other than a driven, compulsive, and a mite or major off-kilter species? That day, and maybe all days, Charles Bell was a patient host and kind. What he painted was far from territory I knew or generally gravitated toward so he well could've been irritated, or at least bemused, by my eyebrow-raised queries that probably didn't cover my ignorance. Instead he was most gentle. He was working on a huge canvas, massive marbles, both ethereal and with utmost solidity, in a field still to be determined. He said it was a work that was driving him insane and that he would never finish. He said it lightly, laughingly, and I didn't take him seriously, yet perhaps he was. He knew. My visit was on short notice and to my regret I couldn't stay long. Only months later he died.

There was a virtual plague in the time that I met Charles Bell that struck artists and collectors. AIDS. Across the arts it was in the nature of a disaster. I met several in those years — the mid-1980s — who were vibrant or wounded, in or out of the closet, and who had sensitized and acute taste or a prescient eye. It reached into Hollywood and sometimes back across into art. I met one film executive who was taken by art and

collecting, like an obsession. He bought and sold fervently, turning profits, his taste premiere. He helped launch several careers, painters famous now whose works fetch seven and eight figures. He lived in West Hollywood at the corner of Crescent Heights and Fountain, and had transformed his closets into vertical shelves that rolled out to hold his canvases. He was still young, barely into his 40s, and then he was gone. He was not alone. AIDS brought down no small number.

Their loss was seismic, impossible to measure, and harrowingly sad. Daily, for several years, there seemed only a mounting toll. The disease swiped a savage chunk of a talented generation. It is only true that without their loss a number of museums would be demonstrably poorer, and one or two might well not exist. It's easy to forget now, only 30-some years later, the fear and calamity of that time, and that it was nothing short of a plague.

As I got older, and as I saw more art, I found my sensibility altering. My love for the artists, many called Modernists, who yanked American art into the 20th century and who played out along the edge of abstraction didn't diminish. My affection actually increased. However, with considerable surprise I found myself increasingly gripped by works both before and after that fell one way or another (like Photorealism) into what was classified in the catchall of Realism.

In 2005, in concert with the publication of a memoir and along with fellow writers on the television series *The West Wing*, I was invited to appear at the National Constitution Center in Philadelphia. Beforehand, however briefly, I escaped, lucky enough to be granted a private tour of the Pennsylvania Academy of the Fine Arts, a place I'd never been. The Academy was celebrating its 200th anniversary, the oldest such institution in the United States, only 40 years younger than the Royal Academy of Arts in London and 15 younger than the Louvre.

I was virtually alone in the museum; it was almost closing time. It was both lonely and stirring to walk the halls, and I thought of how, at the turn

of the 20th century, Philadelphia and the Academy were an extraordinary breeding ground for American painters. A full congregation owed a large debt to Eakins and Sloan and Henri who taught there.

There were quality examples in the collection, some hung, some unfortunately not, of artists I knew and loved. It hardly mattered, it turned out. Instead I was faced with the works of Thomas Eakins and Winslow Homer. They offered a fantastic antidote.

THOMAS EAKINS, *WALT WHITMAN*, 1887-1888

I read once in a book this sentence: "For the first time in my life my jaw literally dropped... I boggled." The author, John D. MacDonald, was playing with the cliché and then justifying it. You can start the jaw drop with Eakins' groundbreaking paintings of anatomy classes, but it is his portrait of Walt Whitman — after he also did a sequence of photographs — that makes the quote for me immensely real. In the painting, Whitman is aged, old and bearded, and he seems to wear none too lightly kindness and wisdom and loss. Still all that he carries in his face is beyond such simple definition. A life lived in it. I'm not sure even now I'm prepared to talk about it, or capable of describing its power and greatness further. So let me not fail with words. It must be seen, and is an essential American masterwork.

There was only one Homer hanging, the exceptionally big and daunting *Fox Hunt*, the largest painting Winslow Homer had ever done until then. His range across decades was unparalleled: the pen-and-ink illustrations

closely linked to Matthew Brady's groundbreaking photography from the Civil War, the astonishing paintings he did in its aftermath, the watercolors of the Caribbean, and the masterpieces of Maine, with figures and without, the late ones simply the sea itself. As Robert Henri wrote in *The Art Spirit:* "He gives the integrity of the oncoming wave. The big strong thing can only be the result of big strong seeing."

WINSLOW HOMER, *FOX HUNT*, 1893

"Strong, simple, big, honest," Rockwell Kent was quoted about them, but they weren't simple. They came from days and years of studying the ocean and what he called the "peculiarity of light" until they became ineffable. "These last pictures," Barbara Novak said, "represent his ultimate way of reifying ephemerals... Nothing more clearly points up Homer's fixation of a single moment than this withdrawal to a distance. From this distance, the moment yields up not its transience, but its quotient of eternity."

That night at the Constitution Center as I signed my book, a memoir about my New England family, my grandmother's ancestor Pilgrims who came over on the Mayflower, the location and even those who had gathered seemed to tether me to the history of our country, the statesmen and artists, who stretched both before and after Eakins and

Homer. Back to Gilbert Stuart, John Singleton Copley, John Trumbull, and the Founding Fathers they painted, and forward to three generations of Wyeths who lived and painted so nearby, including Jamie Wyeth's post 9/11 works.

I'm fueled by museums, and not just by what is on the walls. It is the spaces of them and those that come to them. A fatigue can ensue, yet often the opposite rules. Visits and exhibitions build one upon another, feeding and stimulating, often not answering, only offering new and wider and deeper questionings. And the next morning, before leaving Philadelphia, I detoured briefly from the ride to the airport to a small gallery.

The show there wasn't paintings. Photographs adorned the walls in two small rooms, and they were wildly different. In the first hung Lillian Bassman and Richard Avedon. Fashion photography from the '40s and '50s in striking black and white and the stylized shapes and silhouettes of the female face and form. In the second was William Eggleston. His finely colored and stylized pictures of Southern and rural decay rendered somehow into bizarre and yet breathtaking beauty.

It was hard, if quite wonderful, to grasp that the images in these two rooms had arrived via the same instrument.

It is impossible to express the beauty (of the image) in words. All painting is dead by comparison, for this is life itself, or something more elevated, if one could articulate it.

— Constantijn Huygens
(About camera obscura in 1622)

The word "photography" stems from the Greek, photo for light, graph for drawing. Hence, drawing from light. The accepted pioneers began breakthroughs and discoveries and development of photography early in the 19th century. Niépce and Daguerre in France, Talbot and Archer in England. What the camera could do, its candidness, inspired Impressionists to paint scenes of the everyday, capture the fleeting or the

momentary as well, whether human behavior, weather, or time, or even the hour of morning or evening, their very name coming from Monet's famous *Impression Sunrise*.

But the relationship with photography and painting goes further back, as far back as the 5th century B.C. Chinese philosopher Mo-Ti, who recorded the discovery of an inverted image, and not much later Aristotle, who comprehended the optical principle of camera obscura. He viewed the crescent shape of a partially eclipsed sun projected on the ground through holes in a sieve, and the gaps between leaves of a plain tree. In 1490, as well, Leonardo da Vinci wrote clear descriptions of such in his notebooks.

And then there is Vermeer.

JOHANNES VERMEER, *A LADY AT THE VIRGINAL WITH A GENTLEMAN (THE MUSIC LESSON)*, 1662

How did he paint so realistically 150 years before the invention of photography? In the past few decades, there's been fierce debate whether

he used camera obscura. Philip Steadman made the case in *Vermeer's Camera*, and more recently Texas inventor Tim Jenison, after a "bathtub epiphany," embarked on an endeavor to prove it with the further addition of a "mirror on a stick" jiggered to a 45-degree angle. "He must have had a way to not only trace the shapes, but capture the color of a projected image. If he could do that, his paintings might be a form of photography, achieved not with film and chemicals, but with the human hand," he said in the documentary, *Tim's Vermeer* about his intrepid and obsessional journey to duplicate Vermeer's *The Music Lesson*.

A kind of 350-year-old color photograph then?

Jenison's absorbing theory blew open controversy — called *"bollocks… (and) reducing genius to a trick… (and) a stillborn simulcrum"* by Jonathan Jones. What remain indelible are Lawrence Gowing's words: "Vermeer is alone in putting it to the service of style rather than the accumulation of facts." As his contemporary, Samuel Dirksz van Hoogstraten said, "I am certain that these visions from reflections in the dark give no small light."

And as I studied Photorealism — even as a newer wave that might be called Post-Photorealism threatened to emerge — it was impossible not to see that the confluence of modern art and photography is profound, whether in sympathy or opposition. The debate concerning the values of representation has been set afoot and will not settle. It shakes any possible single meaning from the word realism, and what is "real." Whether at a gallery or a museum, or on my friend BV's walls, I came to realize any definition was bound to be too narrow, too limiting.

The photograph and no shortage of schools of painting were bound together inextricably, not singly or simply, and had been since the advent of the shutter and the lens, and well before.

LIGHT

Light, that eternal mystery, will always baffle the eye and soul.

— Gordon Parks

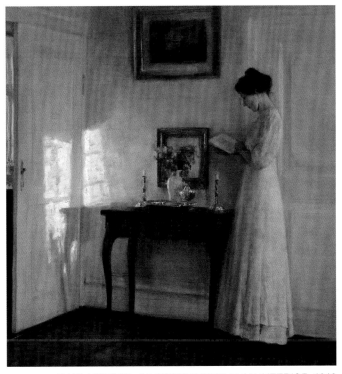

CARL HOLSOE, *A LADY READING IN AN INTERIOR*, 1910

EARLY ON IN MY LOVE OF MOVIES I was lured by story. It wasn't long before I became aware that the characters in those stories were lit, and that lighting had a power and effect. It crafted and sculpted faces and places. It was significant in creating mood. It engendered and enlivened emotion. Spawned and hallowed them.

In painting there was a similar discovery. Soon Vermeer captivated me. This was from sitting in an auditorium seeing slides and from illustrations in books. I hadn't then seen a single Vermeer up close. There is only a limited number of his paintings in existence, perhaps 50, and less than a dozen in the United States.

They are so oft illustrated and so famous you can know them too well and not at all. When I saw my first few, as I did at a show at the Metropolitan Museum of Art in New York, I ran right by them in disappointment. The larger weren't of such interest to me, and the ones that I knew would be had no size. So easy to be mere blips in the vastness of an enormous museum, and miniatures beside the behemoths of contemporary art.

JOHANNES VERMEER, *GIRL WITH THE RED HAT*, 1665-1666

Measure those with women, the way they are lit, or the ones with the fall of light on walls. The warm glowing wash of it. Only teen inches by teen inches, as in the case of *Girl with a Pearl Earring*. Or less. *Girl with the Red Hat* is an exquisitely diminutive 9 by 7 and some fraction of inches, and *Girl with a Flute* not even. Such renown and influence across

500 years on so few canvases and so few inches.

And then there was and is the light. What Philip Steadman called Vermeer's "special genius for capturing the qualities of light."

So small I wanted to get up close to the paintings, rub nose-to-nose, smell and lick the paint. Bathe in that light. One of my favorite quotes in literature is from Joyce Cary's *The Horse's Mouth* and the words of his character, the artist Gully Jimson, who proclaims his love of the act of painting and the paint itself, "Paint. Lovely paint. Why I could rub my nose in it or lick it up for breakfast." I had to be torn away.

Of course, the subjects were women as well.

Once away from Vermeer, I realized I had to look down inside myself, into what had made and formed me, and I realized it had to do with claustrophobia and with love of movies.

In the house we lived when I was a child, there was little light. There were boys and energy and beaten-up walls and there was little money to lighten them. Rooms were dark even before dark. Such had no meaning when I was young, but it had an effect.

I came to realize with the help of Vermeer, and certainly of art, that I had coaxed out of childhood a relationship with electricity and nighttime, saving electricity to save money (my father worked for a utility company), and memorizing the shadows and darkness in the house I grew up. The exact measurement of rooms when there was no light, where the walls were, and the exact placement of furniture. I practiced knowing them by shutting my eyes and feeling for them like Braille. It was a kid's kind of adventure, scary fun. In looking for light, a way to like the dark.

Learning as well the whispers of the house, the sounds of its dark silence. The creaks in the stairs. That's not specific enough: finding exactly which step groaned or squealed, and where, and which didn't. The issues

they made like measures of unhappiness or distress, and a satisfaction in precisely knowing them. Doors, too, the unoiled or ill-fitting hinges. And the whistle of wind in the winter in the slits where windows didn't fit. They were cranky and didn't completely close. One side yes, the other not quite, and chill sliced in, freezing air, and the particular note, the *scree* that came with it.

I came to realize in that dark house, dug deep in, lay the knotted confluence and birth of much that haunted and drove and yet nurtured me. In light and lack of light lay both claustrophobia and inspiration. Epiphany is too big a word, but solace is not for the impact that light had when I found it, or it found me. A flashlight under the covers, a single GE bulb under an aging shirred shade, the first piercing of a rising sun through pinhole cracks in a dark green bedroom shade.

They were the beginnings, the first spare wattage of what — as foolish as it may sound — has been a quest for the radiance light can give to a room, a scene, a face, the brushwork in a frame on the wall, and to my life. It reaches into my own dark places, offering succor, and falls nothing short of love.

When I was a boy, perhaps 8, my parents had a friend, J. Wesley Mapletoft, both warm and gruff, who loved beer. He downed them at a ferocious pace, with no effect, using two glasses or steins when he opened one, pouring the beer back and forth between them until there was only head. All before drinking it. One night he brought with him an early Polaroid camera. The first I had ever seen. He took a picture of me in a hand-me-down, battered bathrobe with wide wacky lapels that must have come from the '40s. It had been my brother's, and perhaps belonged to others before that. When he unpeeled the photo, it wasn't quite right. Not fully developed, the groundbreaking process failing to perfectly work. A wet streak fell across it, like a splatter runs down the side of a paint can.

For years I saved the picture as it curled up. I put it in a book to reflatten

it, which book and where I've long since forgotten, but it awakened an interest in cameras. For my 9th birthday I asked for and got a Brownie Hawkeye that began a procession of cameras — a Contax and several Nikons and a small Nikkormat that was stolen when our house was once broken into — that lasted through the revolution of film into its digital eclipse. The Brownie wasn't sensitive enough, or the ASA wasn't fast enough to use inside the dark house. Instead, I marched around the yard searching for things to shoot in the light. There were leaves and flowers and bugs and there were the trees themselves in the fall, and wet streets in the rain, the tricks of windblown falling snow, and the search for unique sunsets.

ASH FORK, ARIZONA

I carried a camera back and forth cross-country and still have, mounted on cardboard, a black-and-white image taken in 1971, in Ash Fork, Arizona, at dusk along the original Route 66, where trains once ruled and a Fred Harvey House reigned. Two railroad tracks, the light lingering on the rails. Two silver streaks, parallel parentheses still aglow, broken only by the silhouette of a single railroad car. The only light left on the land.

I next took to trying to capture the human face, first with a 50mm lens, then a 105, both before and after we married, Jenny often the subject or

victim. Trying to craft the light, fashion it and her face, shade windows, scrim lamps, create source light, half-light, noir light. What I came to call church light, perhaps in homage to the first time I had seen her beyond childhood, walking into a shaft that was rushing in through white stained glass in church the Sunday after JFK was assassinated, November 24, 1963.

You can use all kinds of adjectives; even stretch the bounds of such a part of speech — pearly, resplendent, shimmering, crepuscular, ugly, baleful, guilty — to describe light, and I probably have.

Perhaps the only positive outcome for Jenny was a birthday gift some 20 years later. I couldn't afford a Vermeer, not even its frame if one ever became available. But in the 19th century came a school of Scandinavians who let women bathe in light from windows visible or invisible. The most recognized was Vilhelm Hammershøi; lesser known was a second artist, Carl Holsoe, and by chance I encountered an exhibition where a Holsoe was for sale, and I bought it. The woman in it catches the light, her cheek scalloped by it, the book she is reading in its path as well. Even more, a silver tray and a set of the silver candlesticks are stabbed by it.

Most extraordinarily, the shape of the window reflects on a wall and door beyond her and within its striking, stirring white light, up close, nose to nose, there are the subtle, opalescent hues other than white. In tender strokes of a brush, the smatterings of most all the colors in the rainbow.

Without at all realizing it at first, I found myself buying books and building a collection, whether novels, art books, or even films with such titles as *Northern Light, Window Light, Visions of Light, Light Years, Light and Shadow,* and *The Lights of Earth.*

Without at all realizing it at first, I found myself writing scenes often using light as the beginning, the source of creativity. The strike of the match, the inspiration for the mood, the situation the character was in,

the emotion that was at play, or the action that was about to take place.

Without at all realizing it at first, I found myself, when I was directing, forging a primary bond with the director of photography and the camera operator. At first looking to them for the way to achieve that light that had been my first source and ingredient. Learning slowly then to trust my own eye so together we could bring it. Add light, subtract it, scrim it, shut some off. Using the dark to heighten the light on the set or in color correction.

Without at all realizing it at first, I was adding windows to the homes where I lived. Eyebrow windows, stained-glass windows, garden windows, and popping in skylights. In my head just now I added together the number of skylights done across the houses that I've lived in. Five in one, seven in another, 21 in all. So far.

Before and after the photos and the books and the writing and films and homes were and are the moments of experience, however small and fleeting, quickly transient, or wrenching and long lasting:

— The changing kick of brightness off natural ice — it seemed to shiver on and off as it came through the trees — as I first learned to skate as a boy.
— A golf course at dawn, where I once worked, the droplets of dew on the grass, like infinite sparks.
— The hard carom of L.A. light off a wall that half-lit my older daughter Jacy as she peeked around a doorway at perhaps 5 years old.
— The expanding crawl of dawn across my younger daughter Julia's face before she awoke as a baby on a Massachusetts morning.
— The wink of fireflies in a New Jersey night, the infinite brilliance of the Milky Way in a Montana one.
— The dart and dance of fish aglimmer underwater while scuba diving in Australia.
— The flicker of a candle reflected in a woman's iris, the certain scissoring peek through certain skirts when backlit, and the mysterious

shape-shifting of breasts through translucence.

— The glints of sun off fresh, new coffee plants at Khe Sanh in Vietnam where once Americans lay under siege.

— The tessellations and metallic shivers in shades like loose change along the laddering tiers of rice fields where Margaret Mead lived above Ubud in Bali.

— The deep dark shade of the lava that turned the earth into a black moon at El Playon in El Salvador, the sun only impossibly making it blacker against the unbearable white of the human bones of the tortured and murdered spread across the volcano bed in the time of Oscar Romero.

There are many.

The exotic and far-flung visions don't deny the ongoing tattooing of sights that still come in the ordinary and close to home. They can be achingly akin to the ones held from childhood, as tiny and commonplace as motes of dust haloed by the breaking sun, or some unseen glimpse of light that awaits to awaken yet one more source of creation and emotion.

These moments come from life; they come from movies, and they come from art. They come from dreams and nightmares and fantasies and the twist and twitch of wherever that place is that twines together heart and loins and spirit.

In them for me, for no more sometimes than instants, light and life join and bequeath a quantum of divinity. In them for me, there is safety and splendor. In them for me, there are sparks of transcendence. In them for me, there is religion.

I am light struck.

MUSEUMS AND WOMEN

Set together, the two words are seen to be mutually transparent, the e's, the m's blend... Both words hum. Both suggest radiance, antiquity, mystery, and duty.

— John Updike

TALL

IN THE OLD AND NOW LONG-SINCE-GONE Plymouth, Massachusetts, Public Library, the children's room was down narrow, dark, walled stairs in what could have been a cellar if the library had not been built on the side of a hill. Upstairs — and I longed to be old enough and skilled enough to forage its stacks — lay the adult fiction. It existed on two

levels, the second up-twisting, metal-rung steps that overlooked the main entrance and lobby of the library.

The fiction section's uniqueness was in its floor: it was glass, pebbled seeming, and reinforced by wire but still translucent. I wasn't reading the books on the shelves yet, but I liked to look at them and leaf through them, and I could hear anyone walking on the level above and in a sense see them. I discovered, looking up, the limited transparency and the colors and shapes of clothes and legs, the blur and shadows up a woman's skirts and especially their shoes and heels. They were closest and particularly in focus. Heels rat-a-tatted on the glass, sharp reports, cap pistol-like, and there was a sensuality to the sound and sight beyond the literal and beyond exact diagnosis.

The truth was you couldn't really see anything. Shapes, yes, and movement, and the heels. They were quite abstract, molten paintings on the move, changing silhouettes, odalisques. The savor of chimera and Modigliani. I (and perhaps John Updike might have) found an allure in them. They tugged at me — tied to books and women, and not so great a distance from spontaneous art.

It was the beginning of a mystery that has played through my life both clear and unsolved — the incalculable way the secrets and sharings of art entwine with both the spiritual and the carnal, and the way the strands fold into a single mystery. How for me far beyond the literal there's sex in art.

Or as a very successful, claiming-to-be-broke movie director said to me, "I would be rich and retired if it weren't for art and women, but aren't they the same thing?" To which an art dealer added when I related the observation: "Yes, but one only needs occasional dusting."

Neither statement not without certain danger of certain umbrage.

Years later, finishing a film in frigid Washington D.C., I went with an

actress and a crew member to see the Phillips Collection. Both women were wrapped in winter coats. The actress' coat had a fur collar and she also wore a fur hat. She was beautiful. The costume designer, a woman very alive and fashion aware, wore a long overcoat that she unbuttoned once we were inside. It swung open as she walked and offered glimpses of her skirt and legs.

The primary exhibition was in honor of Elsie Driggs, an American woman modernist who is not so recognized and did few great paintings. The several she did, though, stand out. They remain remarkable.

Driggs' early works were often delicate, evanescent washes in the wake perhaps of the peerless watercolors of Charles Demuth. Her later works — she painted off and on into the 1990s — ranged far and wide from the Precisionist paintings her reputation so hung upon. The Daniel Gallery represented her then: it was a stable for artists in the 1920s who became fascinated by modern architecture, industry, and transportation.

That was part of the Precisionist's mission and excitement — to capture with scrupulous accuracy industrial images, the mechanical or architectural strength and energy of a train or plane, a skyscraper or factory. They then imagined them through their individual prisms. What must have influenced these artists was the photographs of Stieglitz, Steichen, Strand and Charles Sheeler that preceded them. In Sheeler, the two art forms singularly dovetailed. His skilled paintings nearly equaled the severe brilliance of his photographs.

All seem now antecedents for the heightened advertising pop feel of such artists as Ed Ruscha in the '60s and '70s, and even more recently in the scrupulous camera eye of Photorealism that flowed to and past the millennium.

What the Precisionists didn't seek — and perhaps didn't want — was the emotional element Edward Hopper brought to his stark cityscapes and his solitary people. Some Hopper paintings, I feel, flatten after a few

viewings and come to feel simply barren rather than potent. In the best, though, there is no denying the enduring iconic power. The houses he isolates and the figures he solitaires in hotel rooms or cafes or gas stations never give up their haunting and enigmatic intensity. They remain profound masterpieces.

Within a few years in the 1920s, Elsie Driggs did a groundbreaking canvas of the *Queensborough Bridge* and a crystally distilled painting entitled *Aeroplane*, a painting of a Ford Trimotor she had flown in. The shape and particulars of the plane feel insistently precise, yet it is laid against a lustrous gray sky. The sky is bottomless, the light nimbuslike, and it's impossible to tell whether the visible lines in the painting are strands of rain or simply an artist illustrating lines of force or geometric streams of wind.

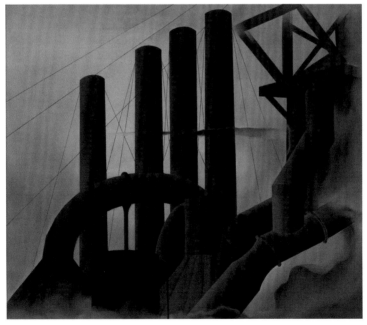

ELSIE DRIGGS, *PITTSBURGH*, 1927

Elsie Driggs' greatest work, *Pittsburgh* — though heralded as Precisionist — reaches beyond such definitions. As a child, Driggs and her family moved from Pennsylvania to New York by train. During the

night, her father awakened her to see Pittsburgh factories ablaze. The sight, "an inferno of unusual beauty" (to quote Thomas Folk), haunted her. A generation later she returned to paint them. The spectacular vision she had witnessed no longer existed. The method of producing steel had altered. She painted what she now saw: the dark-coated, even menacing charcoal chimneys of the factories and the blend of smoke and sky that wound around them with extraordinary supernal beauty.

For Driggs, the painting *Pittsburgh* wasn't just modern. She had been to Italy and studied there, and discovered the works of Piero della Francesca. She gravitated toward this burnished classicism and gave the paintings keen study, particularly the veils the women wore. For Elsie Driggs, the sky in her painting wasn't just fog or smog. It was her own glorious attempt at a rending of the veil.

LIZ IN THE DARK

I knew little of Driggs' work before — the exhibition was eye opening — but there came a moment when I stepped back from the work on the walls, and couldn't help take note of the company I was keeping. Alone, a museum is contemplative and salubrious. Sharing the experience presents a different kind of enrichment, helped that day by the presence of two women in their winter coats. Watching them and listening to their heels on the hard floor. They offered a decided alternative to look at and consider, tied to the walls and adding to them.

I had been seeing one of the two women, and their widely varied reactions — one absorbed and responsive, the other not — to what the Phillips Collection wore on its walls that day helped lead to an altering of the relationship if not at once, and an end to it.

A number of years later at a wedding, I met a woman who worked at a museum. Sylvia was tall with pale skin and soft features and she dressed in a fashion that made the exactitude of her body impossible to decipher and left to discovery. She was blonde, a natural, left-alone shade that in certain light circled brown. Her hair color seemed to mold in sun and lamplight to caramel, toffee and cocoa.

At the rehearsal dinner, without paying real attention, I offered her a glass of wine; or rather I saw that the waiter had neglected to provide her wine and asked that to be rectified. She took note. She had a keen sense of observation. She stood back from the rising spirits and cocktail babble, and later after the ceremony — as can happen at a wedding — from the drunken and not so drunken but not unmisbegotten hijinks.

I was alone at the wedding, estranged, my father had just died, and Bill Clinton was announcing (even in France where the wedding was held) that he had "not had sex with that woman, Ms. Lewinsky." Sylvia was also alone, and we stuck up a togetherness from what I thought was a mutual interest in not climbing the wall to the swimming pool in the middle of the night with or without clothes, and with or without spouses or significant others. For Sylvia, it tied back to the small act of grace at the rehearsal dinner and to a glass of wine that I could hardly remember.

At the wedding, as well, was one of the most striking women I have ever seen. She and her handsome husband had a new baby. Alyssa was tall and robust with a rich and firm figure and a face that spun the head. Her looks were such that one felt she must or should have spilled forth from legions of magazine pages selling expensive perfume or couture clothes. She had a reserve that beauty can necessitate and one that seemed braced with a bristle of intelligence. Her husband, after first the baby and the

nanny and then Alyssa retired, was one of those who went over the wall.

Sylvia and I were left behind in my old-fashioned, spacious room where decanters of alcohol waited on the mantel. No minibar or tiny bottles in this particular hotel and no charges attached to the decanters.

So sex then, left alone, post wedding, in the middle of the night? No — there was talk, conversation, and what in those way late hours only grew more intimate and connected until dawn paled the sky. Sylvia did have things to say about the Pool People, a sense of amusement and caution that left little doubt such antics were not on her dance card. In the moment I thought it might be shyness or scruples or judgment. Or even a shame in someway tied to her elusively dressed and hence enigmatic body. Nothing quite so simple. More about where and when, and what was the point? If none, really, then what was the worth?

A few days later we met for lunch in London, went to a tobacconist, Harrods, the small gem-like Sir John Soane Museum, and the masterful Courtauld Institute of Art. Sylvia said little, but when she did it was brisk and illuminating. Her sharp eye scanned not only what was on the walls but the shape and size and very design of every place we went. Her father had been an architect and she had an acute grasp of space.

The window of time she had offered me was brief; a couple of hours, and it ran its course quickly. Already late, she asked to see my room in the hotel where I was staying. I had been given a large room that was below street level. A dark grotto. I had thrown it over for a smaller corner room with French doors that I left open. There was a church and a great poplar tree in full summer dress outside. In the slight wind, the leaves stirred and shimmered light through the open doors. The room seemed to quiver.

Sylvia kissed me. She honed in suddenly, frictionless and without question. It was awkward and ungainly but full of feeling and rich with promise and surrender. She made a sound. A moment later she was gone.

Since we lived in widely separate parts of the country, it was not easy to see each other. Our times together were infrequent, and I came to know what, in my desire for her, was an urgency to know what she desired, and what she longed to flee.

At the museum where Sylvia worked, she shortly became its major curator. She was versed in art, her knowledge deeply held and felt. Without a stitch of imperiousness, she had highly developed sensibilities and preferences. She put up with my interests. More exactly, she enjoyed them, enjoyed me taking them so seriously, where her interests were wider and more rooted. She could analyze Rembrandt, put him into his time and place as well as across to ours.

She was funny about some collectors. One, coincidentally, we both knew sought out museums with great relish and would report back that he'd seen eight van Goghs, or was it nine? *Nine* van Goghs! She was amused at his keeping totes. That this was what mattered to him. Nine van Goghs.

We went together for a memorable while to museum exhibitions, Turner, Rothko, Winslow Homer, Arthur Dove, and a small, neglected, tucked-away-and-forgotten collection of art and mementos that had come one way or another from the Vietnam War. Sylvia never praised or dismissed a show in the moment. She absorbed it, let it wash over her and marinate. Once outside, however, her passion flashed out. She would shine with delight or, with considered opinion, take no prisoners. She could be withering.

In Sylvia there was a remarkable confluence of work and self. She was serious, disciplined, and in search of ideas — about artists and paintings and movements but often seeking a conception wider than just that. She plumbed me, and not only me, for ideas for exhibitions that she could curate and her commercial minded and yet conceptually driven head ranged far and wide. We kicked around possibilities well beyond paintings that reached back to dinosaurs and up to Jacqueline Kennedy's wardrobe

and the cultural reflection in the design and look of motorcycles.

The germ of an idea might be literal, but it had to widen to capture a greater meaning, idea, or notion. She held one after another up and turned them around — not always in a single conversation or day — like crystals to measure the light. If they weren't original or striking enough and didn't expand, they were dropped or faded away. The cast of Sylvia's mind spawned in me a kind of craving to know what she thought and felt. She had a fervent blend of yearning and reserve that embellished her existence.

Sylvia had her oddities. In hotels, I had to meet her at her room, or get mine no higher than the second or third floor. It took me a while to understand and a while longer before she would admit it. She wouldn't ride elevators. She loved word games, liked to fool with her hair, and the back of her neck was extraordinarily sensitive. She liked clothes with shiny fabrics — silk and satin — and cashmere with cowl necks in cold weather. She didn't like skirts.

It quickly became clear she was very wary of her figure and selective about what she would wear. She did have sturdy and less-than-shapely legs but was tall enough to carry them. She had me convinced in her hiding that there must be dramatic shortcomings. Yet she had no compunction — and didn't need to — about donning a bikini to sun herself. It provided first evidence of an astonishing head of pubic hair. Strands snuck out, delicate and frizzy, which didn't faze her. She had no interest in trimming it. That lay outside of her concerns. It was irrelevant.

She had a casual, awkward, winning grace, and could improvise with quick and easy alacrity. To go to an unexpected premiere in New York, she realized she had no right clothes. Off she went, disappearing, only to return in a surprising jiffy with a dress that superbly flattered and fortified her particular poise.

One winter night, Sylvia took me into her museum after hours. Over a

million empty square feet in the sparest light. She stopped by her office, slapping my suggesting hands away, dismissing my playful lecherousness without any loss of humor, or taking it for a moment seriously. She packed up some things in her oversized leather purse that served as her home away from home as well as briefcase. "Come on," she said. "I want to show you something. You'll like it."

She found a set of keys, flicked off the lights she had flicked on, greeted a security guard down the long hallway and we set off. It was a bit of a trek, up floors and around winding corridors in the back alleyways of the immense space. Far out of the public domain. We were on Sylvia's terrain. Soon I had no idea where we were.

At last, Sylvia unlocked a door. Inside was a space that seemed half-reception area and half-laboratory. Again she turned on lights and again she turned them off. All but one. Then she opened the door to the room beyond.

I couldn't see at first. One dim, blue-white fluorescent bulb. The smell was overwhelming. It was sweet and rank but not fecal. Slowly, shapes appeared in the polar light. Bones, pale bones, white bones in glass cases. Some with hair or gristle or — no, it wasn't hair — it was insects. Beetles? Sylvia knew the exact species and I don't remember. The aroma — the stench — was unforgettable. Man, with all of our technology, couldn't pick clean bones like they could. The beetles were the best and they were busy helping the museum out. Sylvia was right: it was revolting and it was riveting. Nature at work. A very essence.

We didn't stay long and my senses upon leaving had the oddest reaction. A few moments to recover — and then I wanted to make love. Simple, primal, equally essential. We didn't, of course, in the outer room or in the maze of hallways that she had led me through.

It is seldom in the sensation of museums that I don't think of that dark room, sense the long-ago shapes I glimpsed through the glass in

the Plymouth Library, and hear the heels in the corridors of the Phillips Collection — and it is then I look about and see the people stopping by and sharing this moment of their lives with me, and thanks to Sylvia as well in someway I don't completely understand, I feel a kinship, a part of a whole — and that we in one museum or another are all together as Shelley wrote:

Nothing in the world is single
All things by a law divine
I one spirit meet and mingle
Why not I with thine?

PIECES OF GLASS

What we imagine, like what we remember, represents a good part of what we are and a good part of what we will become.

— Tim O'Brien

There is much more to seeing than mere seeing. The visual image is a kind of tripwire for the emotions.

— Diane Ackerman

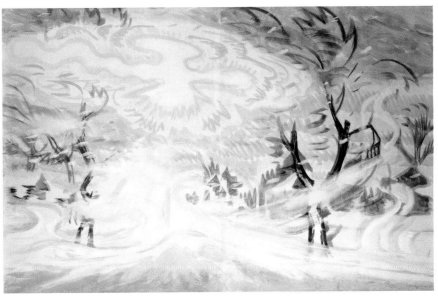

CHARLES BURCHFIELD, *SUN AND SNOWSTORM*, 1917

WHEN I FIRST HAD A DRIVER'S LICENSE, I witnessed an auto accident and happened upon the scene of another.

The first was on a bitterly cold snowy night in New Jersey. A car skidded on the icy street into a telephone pole and the pole broke. Not in two.

It cracked like a breaking branch on a tree, pulling the wires down. Or perhaps the collision forced the wires to yank the pole. The wires didn't come free. They fell as far as the roof of the car with a great shower of sparks. The driver, perhaps my age, was largely unhurt but shaken. His passenger, a girl, his girl, wasn't so lucky. Her knees had caromed off the lower part of the dashboard along the glove compartment and been opened up. They were bashed and bloody to the bone. She was hysterical and the boy was temporarily useless. We did what we could to help, most importantly, called an ambulance. It seemed to take a long time to come, the girl crying and in pain and unable to walk, and the police arrived first.

I don't remember the cause of this accident, whether the boy was speeding or drinking. I remember the glare of the snow, a sharpened crystalline edge to sight as in dreams. I remember the slow-motion skid of the car across Grove Street. I remember the sparks. I remember the crunch of our boots on the freshly fallen powder. I remember the explosive visibility of our breaths. I remember the girl's cries. I remember the sight of her blood in the snow. In the night, in the baleful light, it looked practically black.

But what happened before and what happened next?

The second accident was in opposite light. It was late afternoon, the sun lowering and bright and blinding. I came over a rise and saw the aftermath of the scene on the next rise. There were cars and police and an ambulance, but mostly it seemed like a sea of broken glass. The time of day lit them, set them reflecting and aflame, like so many pieces of a burning and broken mirror. It was a beautiful and unforgettable and dreadful sight.

A light again like in dreams, or nightmares.

The road was blocked and traffic was stopped. I got out and drew closer, reached a young woman lying on the ground at the edge of the glass who had been taken from one car and was receiving medical attention. Her

skin was very pale, as was her hair, and there was blood bubbling at her mouth. She looked my way and turned slightly toward me and I realized there was a shard of glass socketed in her neck. Her eyelids wobbled and her head kept turning and came to rest against the ground. The ambulance men got very busy and I backed away.

Was she still alive or was she gone? And what happened next?

These two accidents are buried in my experience yet never very far away. I see in my memory the car skidding on the icy street, the blood in the snow, the great pool of glass, the shard in the girl's neck, and her head slowly rotating to a rest over and over again. The images are vivid and remain so. They feel precise and true, what I originally saw, perfectly retained and correct.

I know better.

Strong emotions create strong memories, but as someone wrote:

> ...bits and pieces of an experience are parceled out to different regions of the brain... The job of assembling them falls to a part called the limbic system. Like a neural file clerk, it pulls disparate aspects of each memory from the separate file drawers scattered through the cortex, gathering them into a cohesive whole... so not surprising full file drawers send perfect accurate snippets and assemble them inaccurately.

Memory is fallible, it is fungible for all of us, and I am a writer.

Wanting to be a writer, I jotted down notes about both accidents, one on foolscap, one on the back of an envelope right then, and shoved it into the glove compartment of my car. Where it went, what happened to it, to both of them I don't know. They are gone, lost, and aren't to be found.

Now I can't help query if these incidents — these memories — these pieces — are completely accurate, or how accurate, or even what I once remembered as compared to what I now remember. On a good day, I like to think I turn over the things that have happened in my life and wonder if there is somewhere in them, now and again, truth, or illumination, or stories to be unearthed.

I'm not sure any of us are otherwise different, and certainly not artists. Ordinary and great alike go back into their experience and their themes. Da Vinci sketched the finest and most famous hands and fingers, Bellini sculpted men and boys, Vermeer found women lit in window light, van Gogh saw the living fields and starry nights of France, Edward Potthast went back with children to the beach, and in the artists that I came best to know the works of — John Marin went to the sea and Charles Burchfield went to the woods and to the weather again and again and painted them anew but drawing as well from the old.

> *We make out of the quarrel with others, rhetoric; but out of the quarrel with ourselves, poetry.*
>
> *— W.B. Yeats*

John Marin painted very much in the instant. He sought to apprehend the moment, whether the ceaseless and changing movement of the ocean in Maine or the rush and pulsing energy of New York City in the first half of the 20th century. There is music in them, a jazzlike quality of improvisation, exploration and re-exploration. "Electric" and "staccato" were both words he invoked in his own poetic explanations.

Yet he often set his paintings within frames, the ones he hand-carved himself and the ones he created with canvas or paper left untouched, or slashes of paint within both his oils and especially his watercolors. The critic Alexander Eliot described what Marin did:

> *The work of many landscape painters looks as if it's been laboriously traced on a pane of glass set between the artist and the scene. Marin*

broke the glass. The straight lines that swing through his paintings like guide wires keep the eye shifting from the flat surface of the picture to the tilting transparent planes inside it. The curving calligraphic lines follow the rhythm rather than the contours of what was actually before him, re-creating the contradictory pulls and thrust of his great subjects and experience itself...

In his rough-hewn, freewheeling and free-form writings, Marin himself wrote about this in his own terms of realism and abstraction, or more accurately the distinction between realism and any artistic re-creation or re-imagining of it and not just in the moment:

A copied sea is not real — The artist having seen the sea — gives us his own seas which are real... he rearranges he focuses to his own satisfied inner seeings and longings... to be looked at with a looking eye — with a looking eye of many lookings — to see as it slowly reveals itself the process of revealing... the artist — releasing the different folds of his seeings at periods of his many living...

That's the story.

JOHN MARIN, *DEER ISLE, STONINGTON, MAINE, NO. 10*, 1924

So many Marin paintings have a direct immediacy and the twin effect of simultaneous distancing. The dynamic between actual glimpsed reality and his *"inner vision thing"* accompanied by his reoccurring use of frames within frames gives his work an elastic tension, indeed like seeing through Alexander Eliot's broken glass. Even Alice's looking glass. The critic E.M. Benson called this Marin's "Near and Far Vision," and at their best his works capture in paint at once the absolute now and a tweak of distortion well akin to the shiftings of memory through time. To quote Marin:

> *A true work of art can stand many seeings — revealing anew at each seeing...*

With Charles Burchfield, starting in 1943, there is no question. In 1916 and 1917, he had painted prodigiously and experimentally. In the '20s and '30s his work turned more solid and studied and realistic. He met Edward Hopper and the two most taciturn men became close friends. The American scenes he painted came to be called Regionalist, a classification he grew to disagree with, even detest.

With the Second World War underway, Burchfield began a reappraisal and re-evaluation of his work. He began to reach back to the ideas and experiences of those early years as well as forward, often retrieving works he had begun or finished and revising them. The pentimenti of his changes and further changes are often visible in strata upon strata of pigment. They could be additive or subtractive, but often he expanded them. The revisions included scrubbing watercolor or gouache or charcoal or chalk or pencil away and re-applying one or all of them. Most significantly, it involved adding new sheets of paper to the original, sometimes a single piece, in other cases as many as half a dozen.

Burchfield's process was meticulous and extraordinary. In longhand in his journal he wrote down the step-by-step method he used, including diagrams — how he cut a beveled edge to the original work with a sharp utility knife, did the same to fit the additional piece or pieces of paper tight, and using Sanford's paste along the joining line to "insure a firm

adhesion" married the old and the new before mounting them on board. In his late works, Burchfield united old paper and new scores of times.

I have a Burchfield painting of seven joined pieces. It is for his work breathtakingly large, entitled *Winter Diamonds*, and is dated 1950-1960. In 1950, in his journal, Burchfield mentions a major snowstorm and how the sun, snow, and subsequent ice seemed to wage war in the aftermath of the blizzard. Then, in 1955, he and his wife Bertha sent out a Christmas card of the painting as he must have been working on it. A far warmer and softer version. A far less daring and less remarkable conception. It has little of the wildness or visionary dreamlike dazzle of the final painting's great central tree tossing off "diamonds" of sun-glinted ice to spectacular effect.

CHARLES BURCHFIELD, *DIAMONDS IN THE SNOW*, CHRISTMAS CARD, 1950-1954

The culmination may have come in the wake of what he called *The Great Ice-Storm* that stretched across New Year's in 1959 into 1960:

> *...a phenomenon of incredible and varied beauty; day after day revealing new startlingly beautiful effects — Never before have we seen such sights...*

In Los Angeles, I sometimes ponder the absence of such marked seasons and the spellbind of snow. It can be hard and cruel, but as a child the sights of it — its first silent falling flakes and its magical aftermath in the sun — what if you've never seen them?

Burchfield's attempts to have at the subject weren't done. Just now, in researching and writing this, I find there is yet another small, striking, similar painting, perhaps one more draft still, in a small museum in the Midwest.

DETAIL OF ORIGINAL SIGNATURE FROM EARLY VERSION OF *WINTER DIAMONDS*

And when I drew close to the one I have, to study the painting further, my eye only inches away, I saw spare scatterings of something remarkable. In addition to watercolor, chalk, gouache, and pencil, there are tiny grains of sand, salt, or mica fragments that Burchfield must have been inspired to sprinkle across the expanded and joined paper.

But that wasn't all. That close, I made another discovery: an old signature, partially obscured, on what must have been the original, small watercolor dated

CHARLES BURCHFIELD, *WINTER DIAMONDS*, 1950-1960

in the 1920s. In Burchfield's journals in that decade, there are many notes about winter weather and snowfalls, several of which could tie to this initial work. The last digit is impossible to decipher, and there is no way to know now what that first – an apparently complete and signed work – looked like.

The final painting is roughly 3 feet by 4 feet. That piece centered within the 7 is less than 20 inches by 30 inches, and the tree so fired by the brilliant sun extends well beyond that original sheet. Clearly, whatever his original watercolor was, however realistic and observed, it has vanished.

> *Once again I am making extensive alterations to the picture*
> *simplifying and increasing the sense of the magic of the universe.*
> *Our winter now is almost identical to the 1917 winter... (1960)*

Again and again in his journal entries in his later years, and in letters to collectors, Burchfield worked not from just the present. He reiterated how he had returned to his early years — back even beyond the 1920s to 1916 and 1917, and in his last year of life further still to 1915 — for inspiration and to the recollection of memories from his youth.

CHARLES BURCHFIELD, *SKETCH FOR SUN AND SNOWSTORM*, 1917

In having a chance to dig through the Burchfield archives in Buffalo, I found that such elastic snap and connection across the decades in his work kept surfacing and unveiling. The various shapes of sun and moon, for example, repeat and graduate through phases of day and month and across the years of Burchfield's life. Look at the shape he created in a sketch for the sun in 1917 and in the final painting itself, *Sun and Snowstorm* (at the head of the chapter), and as well his painting initiated 30 years afterwards and completed a decade later in 1959, *Sunshine During a Blizzard*.

CHARLES BURCHFIELD, *SUNSHINE DURING A BLIZZARD*, 1947-1959

It is essentially the same sun, it is essentially the same painting, and it is a completely new and different work.

Burchfield was dipping deep into the well at the center of himself in these later works to remember and re-experience, but at some point his reconnections and reconstructions, even re-conceptions — his marriage of old and new — left his initial works and his actual remembered experiences clearly behind.

Burchfield and Marin are not alone. Beyond just subjects and themes, so many artists paint on and over old paint, even if on fresh paper or canvas, even if not literally. So it is too with memory. It continues to live, and if not with our hands, if not with brushes or pencils or pens, is that not what we all do?

For myself, I find I am as well reaching back increasingly to my own equivalents of Charles Burchfield's 1916s and 1917s, with perhaps further back still to come. Memories and recollections that span across decades, some newly uncovered, some that come with renewed frequency. Memories and recollections that can offer beautiful and unforgettable and dreadful sights in the mind and imagination.

They don't come whole. They arrive in light like in dreams or nightmares in pieces, like the shards of glass on the road now so long ago, vivid and mysterious, and I turn them over, hungering for the vanished notes, in search of meaning, old and new, and I contemplate once again what really happened, and what I once remembered and what I remember now, knowing the vagaries of memory and that they are not the same.

But still I wonder, I wonder, and I know only that I will never exactly know. Such musings of time and place and memory and art bleed across one another now, and I only wish and want that I could somehow simply paint them and make them whole.

Or, with my own pentimenti, write them so.

ANDREW

NO ONE TALKS ABOUT HIM in the art world anymore. Bring up his name and there is always a reaction, at least by those of a certain age and a certain time. There is an immediate response and it's always the same: "He had an eye," they say.

Maybe because they don't know, or don't want to know, or don't want anybody to know they know. Just, "He had an eye." Always the same, and never more.

I met him when I was young and I thought his name might be something like Bobby. He looked like a Bobby, but in the art world there are no such names. There are only formal names. There are no Freddys or Johnnys or Jimmys. Or Bobbys.

His name was Andrew, Andrew Crispo.

Andrew was small and compact, almost gamin size. He had short, dark, still-curly hair that was cut close to his scalp. He wore sweaters and tight pants in colors that were surprising and you didn't notice unless he walked into bright light. What seemed in shadow to be blue was really purple, red that was really pink. He was a sprite, and it turned out a very, very dark sprite.

He told me once about his early days, the dawning of his love of art, long before he had a gallery. I never knew until later about the rest of his life then, his birth, his illegitimacy, his hooking, and his street life. He had bounced around in Pennsylvania, landed in New York and happened into a gallery run by a man named Bernard Danenberg, a character himself, and had seen a painting lying on the floor. He was very young; he had no

degree, either undergraduate or masters, in the arts. He only had interest. Clearly there was some reason the painting was lying on the floor, some intent, but no one was paying attention to it. It was a watercolor and it was unframed. Andrew or anybody else could've easily stepped on it.

Andrew felt it was good; he knew it was good. How he knew is the mystery of talent and taste. Andrew wanted it, but he couldn't afford it. This was over 50 years ago, and in terms of today the cost was minimal. More than that — a miniscule, now laughable amount. Still for him there wasn't a way; it was impossible. He dickered for the picture regardless, using passion and innocence as tools, driving an intense bargain, and bought it without having the money or a clue how to find it. He found a way to borrow the sum — never mind how — and he had his first piece. The Georgia O'Keeffe watercolor was his.

With his superb taste Andrew quickly made great connections. He nurtured a monumentally successful relationship with a renowned European collector, the Swiss billionaire Baron Hans Heinrich von Thyssen-Bornemisza, with very deep pockets. Bottomless really. He and they plucked up remarkable works — extraordinary pieces — that now 25, 30, 35 and 40 years later would be impossible to find in private hands or shake loose from museums. Andrew sought them then, found them, snared them, and they went through his hands or remained in his own growing and stunning collection.

Quickly, Andrew found a way to shine a fresh light on artists. He didn't discover the painters. With savvy insight he re-discovered them, or made it seem so. While still an assistant, for example, even ahead of opening his own gallery, he curated a notable exhibition entitled *Four American Primitives* that centered on Hicks, Kane, Moses, and Pippin. This was in 1972, well before I was aware of them — except perhaps vague images of Grandma Moses works — or much else.

By the end of the decade in books and catalogues, I had happened upon Horace Pippin. His work was naïve, awkward, and extremely

powerful. The colors in his work could be somber and sobering or richly saturated, and he painted on pieces of fabric and wood as well as canvas. He weighted his details emotionally, not literally. But it was Pippin's story that was most compelling. Born in Pennsylvania, he was a crate packer in Paterson, New Jersey, a while, shipping furniture across the United States. When there was a painting, he would run his fingers lightly over the canvas to feel the thickness of the paint. It was as close to a museum as he had even been.

HORACE PIPPIN, *THE END OF THE WAR: STARTING HOME,*
1930-1933

It was World War I that "brought out all the art in me," Pippin said. He enlisted in the 15th New York Regiment, serving as a corporal in what would subsequently become the 369th Colored Infantry Regiment of the 93rd Division. In October 1918, he was shot in the shoulder by a German sniper. He returned home with a useless right arm. Other artists wrestle with drink, women, homosexuality, and self-destruction. Horace Pippin's struggles preceded any of those. To paint at all he had to clasp his brush in his deadened right hand, then use his left arm to hold his right, and push hand and brush across the surface of canvas or wood. His first painting took him three years to finish.

Pippin went on to vividly paint scenes from the war, some dark and disturbing, as well as a handful of works dealing with the Civil War, including three portraying the abolitionist John Brown. During World War II, whether he knew of Edward Hicks' *The Peaceable Kingdoms* or not, Pippin painted a series he called *The Holy Mountain*, leaving the fourth unfinished when he died. Andrew exhibited one and came to own another. His collection, whether the gallery's or his own, kept expanding until it was prodigious.

Andrew seemed very busy when I first met him, a gadfly, and yet remarkably youthful and accessible. Not usual things in many, many galleries. He seemed to take an interest in my interest; or at least be amused and entertained by it. Was it because I was trying to make it in Hollywood? Did he see something in my youth that reminded him of his own, not that long before? Or was it more or less than that? I will — and likely luckily — never know.

Andrew was a hondler. I saw a painting in his gallery in the Fuller Building on 57th Street. It was a middle-period Charles Burchfield with a meadow and distant barns riffled with wet wind. The painting had size, a limited but beautiful wintry palette — beige and buff, tawny gold and inky blues and grays — and some magic. In its foreground, seedpods had burst open and blew in the wind. They trailed across the painting, snaps of yellow and burnt orange and the deepest, darkest dots of garnet in the kernel of white fluffs. It held within its *December Fields* the seeds of both early and late Burchfield.

The painting was hung when I saw it. When I went back to show my wife Jenny, it was gone. We found it finally on the floor in an alcove off the main gallery. Jenny sat on the sisal matting beside it to see and study it. She happened to be wearing a tan skirt and sweater that seemed to match and movingly collude with the sisal and the Burchfield.

I talked to Andrew and tried to buy the painting. We didn't have the money he was originally asking or finally, in trying to negotiate, insist

upon. Within months I was lucky enough to win an award that had a cash prize and I called Andrew. We were back in California when I got him on the phone and he doubled the figure that he had quoted only 60 days before. I have no idea whether he knew or cared, but it offered a lesson: in the art world, if not haphazard or completely capricious, prices can be startling fungible.

I lost track of Andrew not long after that, too busy with work, and not in the wealthy league where he was sporting, and had little sense of the demons inside him, clearly despicable, that led to drugs, sex games, bondage, S&M, Liberace and Roy Cohn, and a double tap — two gunshots to the back of the head — murder with him as a suspect. And what finally brought him down and sent him to jail not for the last time, income tax evasion.

He must have had some sense of his own horror. He asked someone I knew while looking at a possible painting to purchase, "Are you scared?" and then said, "You should be." It seems to me now he could well have been talking about himself and not the work of art.

Sometime before the fall, he was on a train heading to Long Island with another noted art dealer. He turned to this dealer and said, "You know what you should do?"

"What?" the dealer responded.

"You should shove me off this train," said Andrew without a note of exclamation. "Kill me. No one would know. I'd be better off. The world would be better off."

In court, when sentenced to prison again, he said, "A man's character is his fate and I am ready to accept my fate."

In 1987, Sotheby's put up for auction 69 paintings from Andrew's collection. There was no small number of remarkable American 20th century works among them. He had gathered a murderer's row that now

were to be sold under orders of the IRS and the court: O'Keeffe, Pippin, Guy Pène du Bois, Charles Sheeler, Thomas Hart Benton, Arthur Dove, Grant Wood, Milton Avery, Preston Dickinson, Louis Lozowick, and three major Edward Hopper oils.

The Hoppers all sold well, two ending for a number of years in Steve Martin's collection. The larger, *Hotel Window*, he eventually sold for 20 times the price it had cost in 1987. The greater one, *Captain Upton's House*, he still has. "He seems to perfectly capture the Yankee heart, the parts that Norman Rockwell left out; brooding loneliness, sexual tension, the silence left in the day after all the hard work is done," Martin has written. "Hopper is like no other artist. This is odd because his pictures are so traditionally narrative. But I can think of only one other who can isolate a figure in a room with the same intensity, and that is Vermeer. But Hopper is not rooted in Vermeer, or anyone else." The Hoppers, all three of them, are illustrative: Andrew had such sharp, discerning and discriminating taste. With it he breathtakingly saw originality and beauty, and he was entangled in commerce and corruption. In the history of art — not to mention I've come to suspect any number of enterprises — men who have such a touch of genius have turned out to be con artists, swindlers, sybarites, despots, traitors, and, yes, murderers. I'd like to know why and to offer a reason or an answer. I'd like to. I don't have one.

I heard he was out of jail. I heard he moved to Charleston, South Carolina, and then moved from Charleston, and then I heard nothing else. Nothing. Once I did see another painting of his up for auction, another remarkable work that sold well.

"He had an eye," they all say. Always the same, and never more.

A NEW ENGLAND STORY

*Whenever I find myself growing grim about the mouth;
when it is a damp drizzly November in my soul; whenever I
find myself involuntarily pausing before coffin warehouses,
and bringing up the rear of every funeral I meet... then, I
account it high time to get to sea...*

— Herman Melville, *Moby Dick*

I am haunted by waters.

— Norman MacLean, *A River Runs Through It*

WINSLOW HOMER, *NORTHEASTER*, 1895

IN THAT DECADE THAT WAS FULL OF HIPSTERS, poseurs and imposters, radicals and rascals, and maybe even what Mark Twain called "rapscallions," there appeared tiny advertisements in the back pages of *The New Yorker* of land for sale in Maine. The ads were miniscule, no more than the width and breadth of a fingernail, placed by a real estate

outfit undoubtedly long since gone called White Caps. It was such a time when with chutzpah, audacity, and perhaps stupidity, you could call the number listed in the ad and act as if you had solvency. Or perhaps it sustained the realtor to have inquiries at all.

In any event, I called White Caps. Not so long afterwards, joined by Jenny, my fiancée then, and her sister, we were on our way to Maine. We drove and then were picked up and shortly were on a small plane that flew us over the swatches of land for sale. In the best of cases, they were oceanfront with rugged, unhewn outreaches of granite stretching into the sea.

From the air, at first all we could see were scrub pines that find a way to grow near the water along the length of New England. We had glimpses of the Atlantic now and then and the granite shoreline. We found a place to plunk down — a small landing strip — and hiked on foot to the coast. We passed a river, not even that really; a creek, a brook, a spring. Its water on the move. Even as small as it was, there was a magnetic trill to its splashing path.

It was soon overcome by the imminence and then the sight and sound of the sea. It was only then that we had the true sense of the scale of the granite. The chunks were alarming in size and in their rough beauty. What was most extraordinary was their color. They were pink, a pale, millenniums-worn-and-torn shade that defied any soft or cuddly definition of pink. There were flecks of black and white to them, but they were pink, distinctly and determinedly pink, a remarkable pink.

The lots were 10 and 20 acres in size, raw and not built upon, and without water or electricity yet dragged in. The asking price seemed both a lot and a little. What now beyond 40 years later would be obscenely cheap. I have no idea what has happened to the parcels and their slabs of pink granite. I can only imagine they are no longer in their pristine state. That they are developed and well built upon now. We didn't buy a piece, not that we could've afforded it, even as comparatively inexpensive

as they were, and I've tossed about now and again what if we had? What would've been different, how might it have changed my and our lives?

We left the pink granite and I still think about it. Not finally so much with regret, but stirred by the memory of it: the feel of it underfoot, the wash of the waves, larger and smaller upon the heft and slabs of it, and the pink, that they were pink. Pink.

As the artist John Marin wrote about the state that drew him most summers the last half-century of his life:

> *Old Mistress — Maine…*
> *she's lovely…*
> *with an unforgettable loveliness — an unforgettable beauty*
> *Turns masculine — borders big and mighty — against — the*
> *big and mighty Atlantic*
> *Tremendous shoulders to brace against his brother…*
>
> *Maine makes or breaks…*
> *The sea — it's the sea*
> *The rock-ledge — it's the rock-ledge…*
> *Trees — bushes — all — all — all themselves of*
> *themselves —*
> *of their belonging —*
> *This insistence of being themselves…*

The depth that visit to Maine cut even beyond that. It tied into my childhood — 150 miles to the south, still on the water along Cape Cod Bay. And the dream of owning one's own place, or equally and perhaps even more finding and building one's own. How far and wide we can go in search and still seek in some way something that is close to home.

That place to the south was profoundly set in my life. My family had moved to New Jersey, but my grandmother was from Massachusetts and in 1920 my grandfather built a house on a 100-foot-high stand of bluff

overlooking Cape Cod Bay. We called it the Big House and it sat on the highest elevation midway between two Points. I was first there at 3 months old, and every year after for long or short periods until well into my 20s when I went west.

When I go back still — starting miles away, approaching — up surge stirrings from childhood. They tie to family and as well to the change of seasons, the music of the wind upon the leaves, the scent of scrub pines, and then the sea.

The last street we often take to reach the house, The Strand, dead-ends at Cape Cod Bay. A dip in the road and then oak and maple trees hide it in the summer until the road rises and the Atlantic with it. In daylight, whatever the weather and whatever its state and shade — slate or teal or sapphire or cobalt — it somehow is then all I see.

In 1980, after nearly a decade away, I drove back to see my parents for lunch. I had vowed that number of years before to never come back, to leave it behind. Too many memories, good and bad, both intimidatingly powerful for me then. It held such a place inside me. Yet as I left, down the street, was a For Sale sign. Before I knew it I had made an offer on what was then a small, simple, one-story summer cottage with a single bathroom and red-and-black striped awnings about a tiny screened porch.

That's suddenly 30 years ago and more, and the house now has a history along with my family and me. A second floor was built, a basement cleared, a larger porch added; it was expanded, it was winterized, it burned, it was rebuilt, it was savaged by Hurricanes Bob and Sandy and storms as merciless without such names. And it was left alone too long as life, good and bad as well, kept me and us away.

There are few paintings on its walls with so many windows and their views of the sea. Or that is the art.

For any number of years I worked long weeks in California and well into Saturdays. I would then climb on a red-eye — they were half-price then — that would land in abandoned dawn at Logan Airport on Sunday mornings. Jenny, my wife by then, and often our daughter Jacy would kindly pick me up and we would drive south. I'd have a cup of coffee, perhaps some breakfast, and then, exhausted, would climb the steep stairs to the secon-floor bedroom. There was a bay window and rather than collapse into the bed I would lie down on a too-small couch, bracketed by windows and ocean to the east, north, and south. The sun would still be low and dancing on the water — though I'm not sure the weather mattered — and I'd fall asleep. A nap really, the sleep not so long, but among the most relaxed, pleasing, sweet, and nurturing of my life.

> *The three great elemental sounds in nature are the sound of rain,*
> *the sound of wind in a primeval wood, and the sound of outer*
> *ocean on a beach. I have heard them all, and of the three elemental*
> *voices, that of ocean is the most awesome, beautiful and varied.*

— Henry Beston, *The Outermost House*

WINSLOW HOMER, *A SUMMER NIGHT*, 1890

I've written of women, and not just one, and there were days on the beach as a child, adolescent, and young man, and there came with them the sun-salted awareness of girls and young women — fresh wet hair slicked back on scalps as sleek as otters, pale grits and grains of sand stuck to tan thighs, the expanding exposure of skin as bathing suits shortened and split into pieces, the snap and sheen of their material, and the whirlpools of phosphorescence around the legs that wore them in the shallows on bonfire and beach barbecue nights.

A nascent awareness, bright and vivid in memory and imagination, but not as much or crucial as the ocean itself. Maybe there can be a twining. A well-known John Cheever short story that joins the wonderment of women to the sea and ends with these last lines:

> *The sea that morning was iridescent and dark. My wife and my sister were swimming — Diana and Helen — and I saw their uncovered heads, black and gold in the dark water. I saw them come out and I saw that they were naked, unshy, beautiful and full of grace, and I watched the naked women walk out of the sea.*

WINSLOW HOMER, *THE LIFE LINE*, 1884

When I was a boy we waited on the nor'easters that arrived usually in August, and certainly by early September. The seas would rise, the tides crawl up the bluff, and electricity often fail for a day or two or three. Boats were swept from moorings if not perfectly set. The gale winds made for a struggled crawl upwind, then turning downwind you'd feel like you were flying.

Before the storms came we messed around in boats. We learned to care for them, caulk and paint them, and ably row. A couple of summers we spruced up an old dory with two pairs of oarlocks and raced against ourselves to the three-mile buoy. There was an exhilaration in tackling and finding the shared rhythm, the stroking, while watching the tight spinning swirls in the water made by the dipping oars, and a satisfaction in the final exhaustion that outlasted in spirit the chewed-up and blistered hands.

And we sailed almost every day on small boats, and once in a while on sloops, ketches or yawls as crew for my uncle as he made his way across Cape Cod Bay to Provincetown, or through the Cape Cod Canal and over to Martha's Vineyard or Nantucket with a stop at the Elizabethan Islands, and down the coast of Massachusetts, past Rhode Island to Riverside, Connecticut, where he lived then. And when the wind was crisp, hiking out on small boat or large, and spray was in my face, I was in the ocean's thrall.

The ocean could seem limitless in its likeness and yet never alike. As van Gogh wrote about the Mediterranean: "It has a color like that of mackerel, by which I mean it's always changing. You can't even tell if it's blue (sometimes)."

A paradox and a truth I can't break down or further decipher. Except when becalmed or overwhelming in storm — the ocean did seem always on the change. It felt inescapable, and like the course of blood, the sea never stopped its movement. And I was to find the flow of rivers was kindred. I am, it turns out, lured by and live by waters. I'm taken as well by those who attempt to capture them — whether by camera, brush,

melody, or words.

The sea and the ocean "like all great works of art," as John Wilmerding wrote about Winslow Homer's painting *Breezing Up (a Fair Wind),* "…what you see on the surface is not everything, and with each looking, there are new layers of meaning to be uncovered."

It is surely what has led to the works that hang on my walls, or ones that I would love if they did, and to my interest in those that painted them. Sometimes it comes from first sight — the freshness and energy of John Marin and the way he serves as a window — if perhaps a gloriously broken pane — to the sight of the sea (or across the Hudson River to New York City for that matter), and challenges the eye to ride along the edge of abstraction.

JOHN MARIN, *SCHOONER AND SEA*, 1924

Or after years of cursory knowledge to a riveting admiration for Winslow Homer — a master of setting a scene, a story, in just his gift of composition, his placing of people even before the rugged strength and gutsy physicality of his oils or the utter finesse of his watercolors. From

the Civil War to Prout's Neck to the Adirondacks and the Tropics in one medium or another — for me he stands tall with Turner. Is there, finally, any greater American artist?

From his origins as an illustrator, Homer evolved into a master of technique and experimentation. Just opening the valuable book *The Color of Light* that traces in depth his watercolors to a random page, I come upon *Adirondack Guide* and this description of it:

> *Transparent watercolor, with touches of opaque watercolor,*
> *rewetting, blotting,, and scraping, over traces of graphite, on thick,*
> *moderately textured ivory wove paper.*

This is an artist at work using all his tools, well-known and consummately discovered, epitomized in closer study by what Homer accomplished with a flick of a knife. He scraped away the paint and nicked the paper to carve out a minute highlight in the guide's eye. The precise placement of the notch corners *our* eye to focus on him.

There have been Marine painters aplenty, though perhaps that's too limiting a term with the place that I had flown to, Maine, a special draw for a fulsome array of artists — Thomas Cole, Frederic Church, Alfred Thompson Bricher, John Sloan, George Bellows, Marsden Hartley, Rockwell Kent, Neil Welliver, even Edward Hopper for several summers, and a quiver full of Wyeths.

The allure can carry to less than masterpieces. Just well done, good, solid work. I once saw — and only a photograph of — a very large painting, perhaps 4 feet by 5 feet, entitled *In the Trade Winds* by an artist I'd never heard of, William Frederic Ritschel. I don't know if I've seen his name again, or ever another piece by him. Oddly enough, it had been owned by a Coca-Cola bottling plant in California, and was up for sale at an auction. In it a schooner is under full sail and cutting a wake. The ocean was rough if not stormy and circling the bow, leading the way, dolphins leapt. You could make a list of the shades of blue and green in

the fierce sea. It wasn't estimated for a lot, but sold well, and I should've reached out for it. I still see the ink-blue dolphins jumping in my head.

Or, even now, I've been sent an image of a painting 100 years old of several ships, oars out, slipping into the fog. The tiny heads of the sailors, the closest distinguished by touches of color. Tufts of burnt orange. The most distant boats wrapped in mist, little more than evaporating wraiths. The painter is not known to me, barely known at all I suspect, but no matter. I'd like to see it. Like to.

"In painting water, make the hand move the way the water moves," John Marin wrote to Alfred Stieglitz.

The tools I have are words not brushes, but paintings hang close by. The paintings are full of waters, the land around them, and seasons of the earth. They call to mind the times I've experienced — exciting, dangerous, risky and ripe. Whatever talent and ability I may have always finds a degree of failure, a falling short, but there is some small measure of endurance in the attempts, like the rise and fall of tides that will long outlive me, but to my last, the sight and smell of ocean and river will remain. I live in sight of them and, closer still, they keep me company on my walls.

Waters strike to the deepest quick in me.

PETALS ON A BOUGH

In a Station of the Metro

The apparition of these faces in the crowd;
Petals on a wet, black bough.

— Ezra Pound

ANDREW STEVOVICH, *LOCAL/SWITCH*, 1997-1998

FOR SEVERAL YEARS I WAS IN AND OUT of New York with some frequency because of meetings with publishers or dealings in television. At some point, Warren Adelson, a gallery owner I had first met years before in Los Angeles, invited me to stop by for a cup of coffee. His gallery then was up Madison Avenue in the Mark Hotel and amply sized. It was quietly impressive, extending onto two floors, a staircase connecting them as well as the elevator. There was a fireplace in one room, a kitchen, a bathroom, and Warren's office that had a stillness about it as if it had been soundproofed. Back behind the walls on which paintings hung,

there seemed to be a small coterie of invisible troops researching and/or cataloguing the works of one artist or another, usually 19th century Americans. Few scholars or experts, for example, knew more about John Singer Sargent and Maurice Prendergast than Warren Adelson did.

Warren had a low-key, patient, mild and almost retiring manner. He clearly had perfected one of the bewitchments of the art world, the ability to cloak what was real and what wasn't. Without broadcasting it, quietly but definitively, his Adelson Gallery seemed patently successful and manifestly endowed.

Success in the art world can't be easy and remains a mystery to me. How galleries survive through thick and thin, where the money comes from and where it goes. Financial backing is seldom if ever mentioned or explained. And shell games and chicanery do knockabout. Once or twice a decade, scandal ensues. One malfeasance or another splashes across the news, whether the dillydallying of a dealer or an accusation of price fixing and collusion among the auction houses. Bankruptcies follow and sometimes jail terms, and then books appear, searching out after their own success and attempting to trace down what actually may have happened.

Warren Adelson and I hadn't shared central experiences, whether as life-changing as childhood or war, or as bonding as schools or neighborhoods. We hadn't spent much time together. We didn't know each other deeply. We lived a continent apart, saw each other now and then, mostly about art, and caught up with each other in a casual way. I knew a little of his history and he knew a little of mine.

But I called him once when I was struggling and looking, if necessary, for a place to retreat and deal with it. I knew he had some experience. I reached him on his cell phone as he was entering a restaurant on his way to dinner with friends. He stepped away immediately and took my call, and I'll always be grateful to him.

What we talked about over coffee that particular day I don't remember, but, tickled, Warren showed me the work of a young, living artist he now represented. His name was Andrew Stevovich, and over the next two decades I kept exchanging his paintings, trading up, until for 15 years I had as large a work as any he had done.

Andrew Stevovich was contemporary although his paintings seemed equally steeped in classicism. There was a feeling in the fine finishing of his work of the Flemish and Italian Renaissance painters, yet his flat, enigmatic subject matter was modern and his own. He had forged a fusion of old-master formality with the ironies of the present tense that was original. His paintings were full of people: we find ourselves with them at a carnival, a nightclub, a racetrack, a card game, a movie theatre, a coffeehouse, or we come upon a woman alone with a butterfly, a tulip, a cat, a clutch of grapes, or a martini. We arrive at some unknown chapter in their stories as witnesses, if not voyeurs, to their expressionless and strangely sealed worlds.

NIGHT SCENE WITH NEON, 2003

FLORA, 1984

Stevovich's people are mysterious and even if as tightly packed together as sardines seem as distant and remote from one another as the spare few in an Edward Hopper painting. They all pose a question, a question that's often a riddle. What are these men and women? Who are they? What are they up to, and what exactly is going on? They and we wait for what

is about to happen — or has just happened, or might have happened, or should have happened — in the ordinary places of our days and the darker dens of our nights. They wait, along with us, suspended in these charged instants.

And there is in their separateness a loneliness somehow, a loneliness even in a crowd.

About the same time I was introduced to Andrew Stevovich's work, I met a woman, Bailey, because of a canceled plane flight. She worked for the airlines. She wasn't normally behind a ticket counter, but had to step in to deal with the disruption. The flight was full and we had boarded and waited and then had to unload. There was confusion and chaos among the passengers at the gate and no satisfaction. No help was to be had. We were finally directed to another ticket counter. The rush to get there was intense, 200 and some passengers on the run, only to be stuck in another line. There was jostling as it elongated, and a building frustration, and only one employee to handle the onslaught when we arrived. She wasn't adept. Anger brewed. A meltdown, hers or ours, was oncoming. It was then Bailey appeared to the rescue and took command.

She wore a dark blue jacket and a pencil skirt — a woman's suit — a blue button-down shirt and heeled pumps I didn't yet see. She had sharp, attractive features, small, slender hands with long fingers, and short, curly hair as wiry as an Airedale. She was polite to any request however urgent or hysterical or inane, and swift to handle them. Her efficiency was extreme, and even buried in line it was striking to watch.

Still it was insufficient. Behavior around me blew out of the box. As I was approaching my turn, a person behind me crossed the threshold into tantrum. I stepped aside and let him proceed ahead and watched Bailey deal with it. She refused to rattle despite every right to. Her control was superlative. I was both amused and impressed. She glanced at me watching her and, without her attention to business wavering, I thought I glimpsed a glint in her eye.

Whatever my hurry or worry, I was witnessing what could only be called a scene and an act of magnificent competence, no small thing, and it wasn't hard for me to step aside for another indignant claimant and wait my turn a little longer. Now Bailey knew I had to be watching her, as well as a strange species: patience in the face of so much impatience. She turned to me next and asked what I wanted. How she could help me. "No," I said, "I think under the circumstances the question might be how can I help you?"

She laughed, and looked at the mass of people she still had to face. "Maybe a stiff drink in about three hours."

"I can do that," I said.

"No, really."

"I'm going to Los Angeles," I said.

"We don't have any more flights available today obviously that aren't already overbooked. I might be able to put you on Delta."

"You can do that? Usually doesn't one airline refuse to — "

"We have our ways," Bailey said.

"I can see that," I said, and I reached out over the counter and touched her arm. "But I can wait. There are people who truly may need your help now."

"Thank you."

I stepped back and Bailey was deluged once more. I looked at the pack of people, the intense faces, gritted and blank, and thought for a moment I had been cast into a Stevovich painting without the beauty or fine patina. I kept an eye out and then started away, thinking I'd walk to the next terminal and get on Delta.

"Excuse me," Bailey said, calling me back. "If you ever need help in the future, here's my card."

A few days later back in Los Angeles, I took out the card and was surprised by the strength of the anticipation and tension I felt. Even excitement. I asked my assistant to place the call, and when Bailey took it I came on the line: "There's no reason you should remember me from the other day, but I wondered if you were still bailing people out, had managed at last to escape, or were being treated for bruises and contusions from outrageous human behavior, physical and mental."

Bailey said, "I'm sorry?"

"I apologize. JFK. Last Tuesday, the canceled flight. I was the one who... I don't know... I'm sure I wasn't alone... who admired your courage under fire."

Bailey said, "Thank you, but am I supposed to remember you?"

"I guess not," I said, embarrassed, and torn in that moment between wanting to puff up and sell myself, help her remember, hope then she would, or get off the phone in one quick hurry.

Bailey said, "Can you describe yourself?"

"I don't know," I said. "Six feet, glasses, beard, a goatee really — "

Bailey said, "Going gray, maybe 200 pounds, a little exhaustion about the eyes, what I took to be maybe a little humor in them?"

"Could be," I said.

Bailey said, "No, I'm sorry. I don't remember."

She neatly had me and I said, "Listen, I come to New York now and again. I'd like to call you and have a cup of coffee or a drink and help you remember."

Bailey said, "I don't know. I have a horrible work schedule and I'm pretty crazy busy."

"I understand completely," I said. "Anyway, I just wanted to say you were something to watch, behold really, so good luck and — "

Bailey said, "But I'd like that."

When it happened, a drink turned into dinner. Bailey was very crisply dressed. She wore a double-breasted jacket that stayed double-buttoned until dessert arrived. She undid one button and then the second to reveal a significant figure, and perhaps how cautious she was until then about meeting me, or anyone in such a coincidental, chancy and glancing way. Later, when we kissed, she said, "I'm glad we got that out of the way. I can see that's not going to be a problem."

I was to learn Bailey wore a series of protective coats, like the double-breasted jacket, and not just literally. Emotionally. There were intricate layers to her tremendous proficiency, places where she didn't want to go and territories that were for a time strictly kept off-limits. She had startling shut-down switches and tricky vulnerabilities.

Bailey didn't like to talk about her life and it had complexity. There had been a bad, punishing marriage that seemed to have leavened only after it was over. It was way too late by then; any caring had been scraped away. There was a void where feeling once had been. She had a just-turning teenage daughter, a tough, loving, working-class father who was a die-hard New York Giants football fan. He wanted her to move back to her childhood home. He tried to insist: he didn't think a woman should, or should have to, raise a daughter alone.

Then there was the boyfriend. He remained mysterious, even whether he was still around. Or how, in what way? Clearly he was, it turned out, if on his way out, and again not happily or lovingly. He was one more incompletely removed appendix. He had tried to mold her and battered at her self-confidence. He insisted she get a tune-up, have her breasts done.

Her control was paved with potholes and fissures. She talked about it in a roundabout way in terms of clothes. The way she dressed. There was a severity, especially for business, that she insisted upon. Yet she would

hide underneath — her words — something for herself, something delicate or sexy or carefully provocative. A certain bra, the briefest of panties. Or none.

I once read about a case in Europe where a woman was taken to court by her neighbors for the sounds she uttered while making love. Her defense was that "such acoustic signals under the circumstances were not unusual" and that to be prosecuted for her human behavior was out of bounds. The case was dismissed. Bailey could have faced similar charges.

Our meetings and couplings were erotic and oddly neuter. We never crossed over into each other's lives. It was exciting but erratic and I was complicit. I had been accused of being a rabid football fan, for a time of the Giants, but I never met her father. I didn't meet her child, nor did she meet mine. It was hard after a while not to consider what each of us was hiding or lacking.

The last time I saw Bailey I had to convince her to meet. I was on my way to an exhibition opening at the Adelson Gallery and to see an Andrew Stevovich that I hadn't seen and had an opportunity to buy. We met at a sidewalk restaurant off Madison Avenue. She was waiting for me inside, half in shade and half in deep late-afternoon sunlight. She wore a fitted black outfit, tight even, unlike her, and she had never looked better. She was visibly nervous, also unlike her, and seemed rushed, as if she had only very reluctantly squeezed me in. We had a quick drink and then walked outside to say goodbye.

It was spring, nearly summer, the maples still in fresh dress. There was the slightest wind and it shifted the leaves and trembled the light. I kissed her. If she was reluctant it didn't last. She pressed herself in her black dress into me, her breasts as hard as apples, and I convinced her over her gone-mild objections to come see the painting with me.

The exhibition was crowded and dressy, as if Bailey had anticipated

coming and knew perfectly what to wear. There was a bar, waiters in white with champagne, and others with hors d'oeuvres. We found Warren, and after hellos and introductions he ushered us downstairs to the lower floor and a back room. It was not a small room and not a small painting, perhaps 5 feet by 7 feet. So big, it wasn't hung; it was perched along a low-slung bookcase that ran the entire length of one wall. It had grandeur.

The painting, *Local/Switch*, held crowds of people. Several times I took to trying to count the number. It was an intricate, closely packed cram of enduring urban passengers on a subway. They were caught in a frozen Stevovich moment — their faces not quite blank, not quite expressionless, both real and surreal. They were odd and disturbing but the painting was beautiful. It wasn't in the people literally; it was in their stillborn dance, their composure and their clothes and hats against the more animated faces in the advertisements posted above their heads, in the very composition itself. The painting lifted out of the most mundane and everyday an intricate, dense radiance. It had a rich palette and there was a sheen to the canvas, an incandescent finish.

The people, though, were haunting. Even in their deadpan tweak, Stevovich lifted these strange human creatures and gifted them with a remarkable glow. They seemed to be waiting, but for what? The drama was withheld and hidden. The questions evoked turned into the riddles with only elusive glimpses of an answer. Again, one could only speculate: Who are these people? What is their story? They remained stuck in mystery.

And in their unique peculiar loneliness.

I don't know what Bailey thought. In her controlled way, she yet seemed a bit overcome, moved, or horrified. Perhaps the painting, perhaps its size, or even the implications of dipping into this strange, rarified world of art. She told me she had to go. She told me she was on her way to see somebody else. She told me he was now in her life. She told me she had

had to make a choice because he insisted and I hadn't.

She said again she must, must go. We made it as far as the street and the doorman at the Mark Hotel and the wait for a cab at rush hour. She looked at me, and kept looking at me, saying nothing now, and clearly in some way torn, standing in her black dress and ignoring the first cab offered, standing and waiting, until a second cab came and this one she took.

I never saw Bailey again. I tried calling once and her number had been disconnected. I bought the Stevovich painting and lived with it for close to 15 years before moving to a smaller house. I have no room for it now, but I miss it, and am surprised how much, even beyond its stunning and entrancing and polished surface beauty.

I realize now how Bailey and I were in some sense as unknown to each other as the characters in Andrew Stevovich's painting, the people on his subway, his "Petals on a Bough." The two of us were disparate. That may have been part of the initial allure that offered a possibility of drama and tumult we never managed to penetrate or break through. I don't know why. We never left our own compartments, and we remained closed off to one another whether because of circumstance or timing or our inherent selves. Like the subway riders, our story remains a mystery.

We never escaped that same peculiar loneliness they seemed to share. In our case, it wasn't even the one that can exist in a crowd. Just two people. Perhaps that's the most lonely there is.

I miss the painting, and I hope Bailey is well.

NOIR

Our interest's on the dangerous edge of things
The honest thief, the tender murderer
The superstitious atheist...

— Robert Browning

ROBERT MCGINNIS, *THE SCRAMBLED YEGGS*, 1972

IN COLLEGE, PROBABLY TO DO ANYTHING BUT STUDY, I took to reading mysteries and thrillers. Devouring them. Perhaps it started even before, spinning a paperback stall in high school at Rogers Supermarket in Massachusetts and coming upon a book by a writer named John D. MacDonald. I picked it out, opened it, and gazed at the first sentence which read:

A smear of fresh blood has a metallic smell. It smells like freshly sheared copper.
It is a clean and impersonal smell, quite astonishing the first time you smell it. It changes quickly, to a fetid, fudgier smell, as the cells die and thicken.
When it is the blood of a stranger...
When it is the blood of a friend...

The image was fierce and pungent, striking and sensory driven and one very successful hook. This was Noir, and over the next 20 years I would read most of John D. MacDonald's over 60 books, many more than once, the first paperback originals, the final several hardcover editions published by Alfred A. Knopf.

I wanted to be a writer and MacDonald's prolific work was instantly accessible yet often pointedly tactile with a trenchant and sensual sense of place, usually Florida — its fickle tropical weather and the incoming hordes that land-rushed the state in the '50s and '60s. He was wise to the ferocious development he witnessed, the scams and greed and absurdly quick profits that accompanied and fouled it, and the subsequent threat to the land and water he loved. In quickly wrought novels, if less than masterpieces, he also captured a time, the Eisenhower years, that weren't so easy or golden and could be a trap, and then to the upheaval of the '60s that followed. There were passages in MacDonald's work that were eloquent, fine writing, and in them he often unearthed unsettling emotions, dark and light, and drizzled in piercing commentary about America.

Most of all, he seemed to know more than anyone should or had a right to about our human capacity for evil.

His books brim with a slow-building, oncoming, overwhelming sense of dread and entropy. Select people find each other and redemption in themselves and in sexually coming together. Their rendering is no antidote to what John D. MacDonald seemed to know in great gobs and

with infinite variation: most of man is cheap and tawdry, his survival precarious, he has a need for violence, and the elements can do away with him on a whim.

No matter how heroic one may be, how hard he or she fights, one may be sucked into the night and disappear. We mourn and carry on, but happy endings, even earned, seem Band-Aids and small change. No matter how much life MacDonald jammed in — and there is plenty — it fell before man's disposability. We don't live long, we are our own waste, our own fast food, our own aluminum cans.

ROBERT MCGINNIS, *DEADLY WELCOME*, 1959

That very first sentence of that very first book wasn't all that beckoned me to his work. There was the cover, and after that the covers of the paperback originals — pulp art — vivid, often lurid and flamboyantly melodramatic and flavored by those decades and the artists who scraped out a living doing them. The covers were re-productions of original oil paintings by such stylistic workmen as Earle K. Bergey, Virgil Finlay, Mike Ludlow, and Robert Mc-Ginnis. At times their artwork even preceded the story or novel, serving as inspiration for the story or novel that then wore them.

Noir arose in the '20s and '30s with magazines like *Black Mask,* and then in the '40s, with the coming of paperbacks, the covers were rife with ripe colors and ripe women. Ripped vermilion blouses and crimson-splashed lips. In the '50s came pastels, pinks and limes, but still there were women. Good girls and bad girls, babes and molls, curvy and sexy,

damsels on display or in distress. Not to mention voyeurism, bondage, rape and pillage.

It was Rodin who said a woman undressing was like the sun piercing through clouds. In these paintings women are seldom naked, but there is much undressing, many piercings of sun.

They reigned over trashy novels and mysteries, although well-regarded authors weren't immune. "Highbrow" works equally could strut such stuff. And mock these "lowbrow" books with such covers at some peril. The history of the finest literature is crisscrossed with murder and mayhem, from Euripides to Shakespeare, Dostoyevsky to Graham Greene.

In the summers in Massachusetts, even younger still, we traveled in a pack, beach cottage to beach cottage, rented or owned, and in one came upon a corner bookcase with a curtain loosely drawn across it. When we pulled it back, we discovered shelves of books, including paperbacks, mostly mysteries. Several were by Erle Stanley Gardner and easy to read, *The Case* of this and *The Case* of that, and we took to playing Perry Mason for a while on rainy days, and assigning roles — Perry and Della Street and Paul Drake and the defendant, almost always a girl.

There were also older paperbacks as well in ragtag shape, their bindings chipping and breaking, with pages ready to fall out singly or in bunches. The greatest number, practically a collection, were the Lord Peter Wimsey mysteries by Dorothy L. Sayers. They heralded quotes from the *New York Times* ("A model detective story... Fascinating") and *London Times* ("Highest among her masterpieces... could not be improved upon"), but their covers were abundant with women.

Curvy, sexy, maybe good, maybe bad. *Usually* bad.

Decades later, after we had grown and the parents had passed away, the house was broken up. Possessions that the family didn't want were packed and put up for sale. It transported me back to my grandmother's

house after she had died, and spoke to the truth of what happens to all we have and hold in our lives. The grief that lies about in garage and estate sales amidst the remains. In the cigarette box, the lamp, the serving spoon, and the trivet exists the evanescence of a history. Perhaps such sales aren't only about bargains. There's the picking up a strand of a life, nudging it toward infinity.

I had long since forgotten the books, but I came upon a klatch tossed together in a stack on the floor, awaiting a cardboard box, and offered not individually but in a bunch for a dollar or two. They had survived, if worse from wear, moist and mildew-dotted from the closeness of the sea, the pages turned tallow. I held a few and leafed through them carefully, remembering, fearful they would fall apart in my hands.

One Dorothy L. Sayers captured my eye and awakened my memory. *Strong Poison* its title, price 15 or 25 cents, cover commanded by a woman, perhaps Harriet Vane, the notorious character in the Wimsey novels. Cigarette in hand, she was dressed in gold. Her cat eyes cast sideways, protective or defensive, good or evil, impossible to tell, and she had rich, deep cleavage. There was no denying the curve and flesh of her breasts. There was no denying, even wrapped in a shade like burnished butter, the taut point of one nipple.

"Taut point" — however true, the phrase is purposeful, right out of pulp lingo, and clearly an awareness in the intent and fulsome painting of the cover.

Google failed me at first. I searched it and other sites, hoping to retrieve the image, a picture of the cover that started in all likelihood as an oil painting by a largely anonymous artist. It has lingered, come out from some concupiscent cranny of my memory, and left me wondering of its accuracy, how much is some hegira of my young and now older imagination. A ruched golden dress, a cryptic askance Mona Lisa look, a vivid scintilla of anatomy.

Then there it was on some obsessive's blog:

STRONG POISON COVER, 1951

Garish and gaudy, brushed with lubricity, these covers were meant to grab the eye and the loins, and offer the lure of dark adventure and escape. A fantasy, a hankering, even a yearning out of a corner of ourselves that most of us had never had and never would.

In moving several years ago, I stumbled upon a series of small brown notebooks, journals I had kept when I first came to California. They are full of happenstance incidents, things I witnessed or was a small part of — several car accidents, one with the girl who kept saying "I'm fine. I'm fine. I'm fine," and wasn't; one with a blue Honda turned around so it was impossible to tell exactly what had happened; one with a car turned upside down; and the one with a woman with opulent breasts and tight pants exchanging insurance information with another woman with opulent breasts and tight jeans. There was also the neighbor with a tank of piranha in the cellar, the escaped otter prowling a Hollywood Hills street, a lush girl on the unemployment line who became famous, the...

They seemed very L. A., these fender benders, some literally so and some not, and each had an itch and grit that inflamed my fancy and felt like they fell out of a possible rough draft of such noir books. They only awaited a next scene, a plot line to connect to, a structure to tie up with, and a conclusion that never came.

And they were in concert with the California novels I read and admired

for their writing or for that inevitable coming together that doesn't finally happen as much as we might want it to, sometimes desperately. Gavin Lambert's *The Slide Area*, Joan Didion's *Slouching Towards Bethlehem*, Daniel Fuch's *West of the Rockies*, Alison Lurie's *The Nowhere City*, and Charles Bukowski's *Post Office*.

I felt I knew no single story of this place yet I knew many stories. Like its sprawl, the stories lit up only in tidbits, and maybe the only thing to do was write a series of them, short-hard-swift, and let them lie with one another, take on a confluence.

In the brown notebooks, I came upon many such "fender benders," and just to pick one, no more, no less than others, I found this entry:

> She gets out of a Chevrolet and kisses a black man and carries a thin briefcase, a bag, and a pocketbook. She has red hair, short and crisp and close to her scalp, and wears open-toed black heels, and a blue suede coat with red stitching. She has lean, long, slender legs, and pale, nearly translucent skin. Her breasts offer a firm shape even through rugged suede. They're a potent mystery; the male eye and associated senses conjecture. She can't stand still at the bus stop (where I wait as well), and quickly asks a question of a girl there in boots and jeans cuffed just below the knee at boot top — this year's Paris and 18th century pirate style. This girl has dark, close-cropped hair and earrings. She has a severe, not-quite-successful model look that's recessive before the second girl's.
>
> The girl in suede looks at me and smiles. Why does she look at me? Why does she smile at me? Such things aren't done at the enforced anonymity of a bus stop. I smile back, and then she looks again as I fend off a drunk.
>
> The drunk has vast whites to his eyes and pale hair and a moustache. He wears crepe loafers and leans. He asks me why I'm smiling, which I ignore. He looks over my books and comments on Chekhov. "He's a pretty good writer... I guess he's made a good living

off of writing." "No kiddin', " I say. He goes on; his tongue could be tightly in cheek, despite being soused, close enough to put me into the gravitational waft of his breath. "Look," I say finally, "This is my space, and that's your space. Stay off of my space." He goes into an elaborate reaction response, but doesn't stop talking, or leaning in. Now it's about the blind man who has arrived, waiting for the bus also. How the blind man isn't blind, he's a faker. Perhaps he's right, the blind man's head is always faced in the most interesting direction, like toward the girl in suede. His nails though are bitten or worn at least to the quick, as Ray Charles' reputedly were, and he has a belly that seems to escape his body's direction. He holds a radio tight to his ear that I cannot hear.

The girl in suede looks at me when the drunk leaves, lurching down to the next bar and disappearing in. I hold her glance, and she holds mine, and I smile again, can't help it, not a come-on as much as embarrassment, something to do. She glances away, but often back, and can't keep still. She walks around the bench at the bus stop toward me. She fishes through her things and comes out with white gloves, drops one. We all look at where it falls, blind man included it seems to me. I pick it up.

The gloves go up the wrist and are too big for her hands but she puts them on.

When the bus comes and we get on and it starts to move, she lurches into me, suede and stitching, breast and hip and haunch. She says, "It was cold out there, better in here."

"Yes, you looked like you were cold."

She smiles at me, her suede coat still only fractions of inches away, and she looks away, and this time doesn't look back.

I can't get a hold of it. There were many possible things going on. All as they lie there are implicit, only minutia, a nocturnal street ballet. Comings and goings and passings in the night. Cliché ignition points for stories, where our minds run — into reality,

melodrama, fantasy, however the story is told.

They are the moments when we think our lives might change —
and then they don't.

Now 40 years later, what to make of these jottings in a notebook? Too innocent and uncraven for Hammett, not enough "slumming angel" for Chandler, perhaps lacking on the face of it a family or Greek myth enough element for Ross Macdonald? But it has possibilities, Travis McGee, Harry Bosch, or Jack Reacher possibilities. The blind not blind, the drunk not drunk, the suede hiding what in her thin briefcase, bag, pocketbook, or besides her breasts beneath the red stitching? And the gloves, what's with the gloves? And why a bus, waiting for a bus? This is L.A.

And more, probably much more.

Mysteries render such possibilities as realities. They dish out settings and situations far from our normal everyday lives, and take us to the unforeseen, precipitous edge of things where the implausible or impossible occur. Shit happens, but with exceptions there are solutions. Take a murder. A whodunit. A horror happens, gentlemanly or graphic, English or American. A riddle presented. A detective, literal or not, pursues. Evidence accumulates, twists and turns occur, and then comes "an aha moment," a term used in Hollywood as a necessity in scripts, and close to the word uttered by Nick Charles in *The Thin Man* when he recognizes who the murderer must be. "I said: 'Ah,'" Hammett wrote. Just the single word without embroidery or embellishment.

Mysteries are stories that spin the universe and then give order back to it. However varied, they finally follow a formula. There is a pattern to what at first seems random, darkly happenstance or a bottomless conundrum. A design. The events wrap and tie up, unlike the bewildering puzzle of most of our ordinary lives. A shape and a sense and a wholeness.

Years ago, by chance, I wandered into a gallery in Pasadena, California. I walked up a flight of stairs and into the world of "pulp" paintings. The

babes and molls, the gats and gunsels, the ripe colors and spicy pastels. The gallery had collected and was selling 30 of them, many with copies of the original magazines or paperbacks saved in Lucite boxes beside them.

One after another, the paintings were seized with rapacious intensity. They blasted off the walls, strong and melodramatic and overstated. Both riveting and almost laughable. The kind of laughable that was an attempted defense against surrendering to their lure.

Not without appreciation, they pummeled away at me until I left. It was a windy night, a dry, gusting wind. Driving home, I saw it shaking the trees I passed. They bent in its sway, leaves turning belly up, like before rain. I could feel the wind even shimmying the car, enforcing two hands on the wheel, and I called the gallery and bought one of the paintings.

I move paintings about now and again, and I'm sure I'm not alone. In the 20 years since then, I've moved this Noir picture room to room, house to house, taken it down and put it up again, never known where to put it, or even quite why I had bought it, this oil practically bursting out of its frame in color and imagery. What was it, what did it represent beyond the itch for the forbidden, a quick twitch of the loins, intense and potent, but not deep certainly? As someone wrote: "This is how we think when our fancy is inflamed but our minds are weak."

The particular painting, by the artist Rafael DeSoto, a well-known prolific pulp artist, has a shower curtain, the shadow and shape of a woman showering hidden behind it, and a man in a mirror and a fedora. He is perhaps breaking in. He has a gun. She is reaching for one, perhaps in defense, set on a red stool. Her fingernails are red. The fish that swim on the yellow shower curtain are sketched in red.

There is a black wall, honing toward green, and cream tile. The oil is thick and white where water sprays from the showerhead, where spats of it drip from the woman's extending arm and fingers.

The painting is not Rembrandt, hardly da Vinci, scarcely Vermeer, and not Raphael. It is Rafael DeSoto: alluring, enigmatic, sexy. And not a lot of future looming ahead for the man or woman, one or the other, or both. Or none at all.

RAFAEL DESOTO, *DIME DETECTIVE COVER*, 1944

I've found a place for it at last, and an acceptance because I realize a couple of things: it's not going to hang on any museum wall, but it's well-done. More simply and importantly: it's fun, and I like it.

Rafael DeSoto was one of the best of these cover artists whose pulp paintings pulse with vividity, punch with fierce imagery, yet the escape and evasion they insist upon is still laced with secrets that can only be guessed at, and they remain connected, like buoys to the anchor lines of those deeper emotions, hungers, and hurts that haunt and pursue us, whether bruised love, loneliness, or sorrow.

Day is dying, night coming on, the weather changing, and the wind is blowing now as I write this. I can hear it even through the shut, double-pane windows, the hiss and whisper of it, and see the bending swim of the leaves on the trees. Yes, bellies up. They sing to me, reach in and stir me, and I know in these Noir works — in this Rafael DeSoto painting — beyond the luscious and the carnal there lives a link, however jaggedly tweaked and elliptical, to the bottomless fathoms of what Pico Iyer calls in Graham Greene's work "the shaking of the heart."

THE WHEELCHAIR TOUR

WITH EMPHYSEMA, WALKING BECAME INCREASINGLY DIFFICULT for my mother. She was on oxygen, her hearing (even if she didn't admit it) was failing, and she took to falling. Sometimes it was just bruises that would bleed and were slow to heal. Sometimes she would wake in the hospital, which she hated, though she liked the hospice care that followed once she was home again.

First a walker and then a wheelchair became a part of her life. By now living in California, I only occasionally saw her, and my trips east were often planned around just that. Once when I was on my way to Massachusetts, she asked me if I knew about the Charles Burchfield exhibition. She was deep into her 80s then and sharp, very sharp in small doses, all of which would continue into her 90s. I had no idea what she was talking about. I had heard about no such thing, and had my doubts.

My mother was correct: in Duxbury, Massachusetts, no metropolis, there was an Art Complex Museum. It was a splayed-out, one-story complex in a woods. Well, if not in a woods in a glen, a copse, a grove of trees. It wound around them, or they around it. It was remarkable that it was there, and quite remarkable in itself, and it was true. At that moment, there was an exhibition of Reginald Marsh and Charles Burchfield in coordination with the New Britain Museum of American Art.

I said, "Let's go."

But it wasn't until we arrived near dusk on a dark day that I realized that my mother could not withstand the walking she would have to do. The Art Complex had a wheelchair that I commandeered and she accepted. Together, we wheeled through the exhibition.

Art had come to interest my mother increasingly as she grew older, and well into what could have been her retirement years, she became a docent at a museum. She served for 20 years, only stopping when she moved away, never losing in art or life her feisty interest. Remarkable, and seldom without explicit opinion.

For the first and last time, I served as a docent for her. I toured my mother around the complex and through the paintings, stopping to tell a little history, express an opinion, or wheel her close so she could see better the particulars — the details of clouds or birds or even the way of brushstrokes. She was patient, perhaps really interested — it was hard to tell in some sense because I was behind her — but I realized somewhere in the wheeling that this was a time with my mother I had certainly never had with my father, and never had before with my mother, and surely would never have again.

There were few others there, though the son of the man who had established the Art Complex was when we arrived. His father, a Weyerhaeuser heir apparently, had owned five Burchfields, the latest dated 1937, and he had bequeathed them to the Complex he helped fund as well as found. His son had bad teeth, must have been pushing 70, and seemed to know little about Marsh or Burchfield. Or likely care. By the time my mother and I were done, he was gone.

There was no one left, and the outside world had fallen into complete dark. It had started to rain. The last employee in the Art Complex other than what appeared to be a guard offered us an umbrella. I accepted for the journey along the wheelchair ramp down to where we had parked our car. I got my mother in, ran back to return the umbrella with thanks, and could see even as I returned to the car the lights going off in the Art Complex, sense locks being locked, and see the shapes that remained of the trees, like wraiths, that surrounded it.

But back before we left, I had relearned an important lesson. Holding the helm of the wheelchair helped it happen. My mother asked to circle

CHARLES BURCHFIELD, *SEPTEMBER ROAD*, 1957-1959

back to a certain Burchfield work, *September Road*. It was sizable; say 33 inches by 45 inches, and perhaps the best painting in the exhibition. It was dated 1957, and like much of Burchfield's work in that decade, it was swept with wind and change of season — in this case oncoming fall — and birds on the wing.

I had seen reproductions of the painting in books, knew it was energetic, and a good work, yet had let it slide by when we first passed it. I had not taken the time to see it fresh. My mother's request allowed me to strip it free of the image I carried from pictures. This can happen, and it certainly has to me. It is tough to look at the *Mona Lisa* without bringing all its fame and familiarity to it. I have to shake off all the images and perceptions I might harbor. They can become baggage. I have to remember to see the painting that is actually now in front of me. Clean, as for the first time.

Years before my wheelchair driving, I had gone with my daughter Jacy to a Mark Rothko retrospective at the Whitney Museum in New York.

MARK ROTHKO, *ORANGE AND YELLOW*, 1956

The exhibit occupied an entire floor. I had seen a Rothko or two, and of course over and over images of his work littered through books about art, and even books about just Rothko himself.

They did not prepare me for the impact of his paintings in person and gathered together. Scale first. There is no comprehending their size from reproductions in books. Rothko's late paintings, now so iconic, are immense. They must be measured in yards and meters rather than inches. They occupy walls, and in several cases, happily or unhappily, have had rooms built to hold them. Even faced with their magnitude, it is their force that is most daunting. It is startling, even shocking, how much emotion seems to pour forth from what could be described as just strips and often vast swatches of practically monochromatic color.

Mark Rothko was an intellectual, highly educated, who studied philosophy, especially the work of Friedrich Nietzsche, and was intensely drawn to classical and Greek mythology. He was a driven and passionate man, contentious, overwrought, arrogant and insecure. He was, to quote

John Lahr, "A fractious, hard-drinking, unhealthy, and unhappy soul... a gourmand of his griefs." He was also consumed by art, obsessively aware of other's works and equally his own.

After immigrating to America, Rothko had Arshile Gorky as a teacher and then Max Weber. In 1932 he met Milton Avery. Avery's even nature lured Rothko, and Avery's paintings "full of poetry and light" with their rough, colorful forms that play on the canvas not unlike cutouts altered Rothko's own work. The childlike quality in much of Avery's work drew Rothko, and with it came a belief and an insistence that art must stay linked to the limitlessness of childhood imagination.

Rothko kept linking up with artists. After Avery came Adolph Gottlieb and later Clyfford Still. The friendships didn't always last, or last well. Still was in many respects an opposite. He was cantankerous and unapologetically anti-intellectual, but his work magnetized Rothko and influenced him. Still's mature paintings had vertical streams of color, often bold and saturated — say, a rich black — that reached across a majority of his canvas like flames before breaking off in jagged edges to reveal striking strips of contrasting color — say, egg yolk yellow and luminous white.

Unlike Rothko, born in Russia, Still came from North Dakota and he once described his paintings as "living forms climbing out of the earth." Rothko was reaching for something different, what he called "unknown adventures in an unknown space." For a while Rothko took to describing his pictures as "dramas." The word has pertinence but is also insufficient. Rothko was up to something else and something more.

He found the key when he saw Matisse's *The Red Studio* at the Museum of Modern Art. It so struck him that he went back again to visit it every day. When you look at it he said, "You become that color, you become totally saturated with it." He began then to paint the enormous canvases he became famous for — the ones that, if there's comparison to any other masterworks, it's not so much to his contemporaries as to the very late great paintings of J. M. W. Turner.

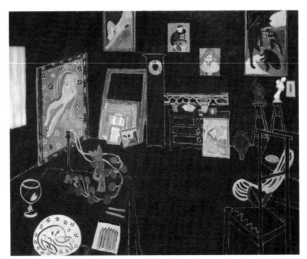

HENRI MATISSE, *THE RED STUDIO*, 1911

For all of this, there was an equal contributor to Rothko's paintings. From an early age music affected him, and he pulled it deeply into his life. In his work he sought the same kind of expressive power he felt in music. The emotions it can instill. The sense, too, that an orchestra in its playing reaches out to its audience. A relationship is created. Likewise he wrote that critics could not explain his paintings: "Their explanation must come out of a consummated experience between picture and onlooker." It was a reason as well for the size of his works. "To paint a small picture is to place yourself outside your experience... you paint the larger picture, you are in it."

In these late paintings, he started with layers of binding and priming that provided his glowing and then storm cloud and finally dark falling fields of color with transparency and luminescence. He had accomplished his task. These pulsing works, whether flush or poignant, were enveloping and haunting. They were mysterious, as if they held secrets, and felt even spiritual. They coerced you beyond observation to enter the moods he had created with paint and color and size, his music, to prove as he said, "My art is not abstract. It lives and breathes... I'm not interested in the relationships of color to form or anything else. I'm interested only in expressing basic human emotions — tragedy, ecstasy, doom, and so on."

J.M.W. TURNER, *SNOW STORM - STEAM-BOAT OFF A HARBOUR'S MOUTH*, 1842

My daughter Jacy turned to me at the Whitney and said it differently and more simply, "They are like the weather in our lives. There are good days and bad days."

Back in Duxbury, I was glad my mother had asked to return to *September Road*. We were, it turned out, hardly ever to talk about the exhibition again, but I asked her then why she had been drawn back to the painting. She said, "I don't like some of his paintings. They're dark; they're moody, a bit creepy. But this one, I don't know, I wish it were spring, I love spring, but the fall — I can feel the way you feel in the fall — sad, but alive, like I could walk a long way again."

Charles Burchfield and Mark Rothko — could two painters be more different? Yet the dates of their lives more than overlapped. Both warred with depression, profoundly loved and were affected by music. Whatever their respective demons, they swirled such feeling into their work.

Since I first wrote this, time has passed. My mother has died — enthusiastic, passionate, impatient, irascible, and emotional until within 36 hours of her death. The hole left isn't small, "'tis not so deep as a

well nor wide as a church door but 'tis enough." That wheelchair day remains — perhaps even more prized because she is gone now — and with it what both men, and maybe the best of artists, bequeathed to my daughter and my mother, and to all of us.

A rapture.

THE RAINY NIGHT

LACMA LIGHTS

On a rain-drenched night in L.A. a few years ago, there happened to be an opening of a major exhibition, a Diane Arbus retrospective, at the Los Angeles County Museum of Art.

Raymond Chandler wrote about such nights. Film noir teems with them, using their atmosphere as surely as knife-sharp shadows. And the night was "a great big package of rain, oversized like everything else in California" to quote the narrating William Holden in Billy Wilder's *Sunset Boulevard*.

The truth is there are not a lot of such nights. Perhaps it's no mystery then that when they come they are haunting and ensnare both beauty and danger. The air smells fresh and full of eucalyptus, television news worries about floods and mudslides, and people careen about in their cars like others do elsewhere in snow.

These nights seem to harbor magic, good or bad, and like in dreams or nightmares bring implausible and upside-down events and people together. On this night at the exhibition were Arbus' photographs, of course, and then an odd propinquity. No, two.

For the first time in years I encountered Greta, the woman who had come down Nichols Canyon in the heat wave and allowed Jenny and me, newly married, to stay a while with her until we found a place of our own. She seemed to have hardly aged and still had her fine pale youthful skin and her childlike voice. After requisite sniffing about one another, she said, "Oh, I know. Wait right here a minute." She disappeared, was back before long and not alone. With her was an actress I had worked with along with the actress' husband, Diane Arbus' widower, Alan Arbus.

The actress and I had done a television series together, my first, and it hadn't lasted long. She was not beautiful or conventional. The actress had something more difficult and unique, an odd, off-center, quirky talent, and she hadn't always been easy to get along with. She had a technique then that had horrified and irritated me. If she didn't like what she was asked to do, or a line of dialogue, she would do it or say it, but perfected the ability to simultaneously have her finger snaked up her nose.

The series had been a long time ago, decades before, and the aggravation I had felt had long since molded into amusement, even a reluctant admiration. It was good to see her. Along with the weather and the famous photographs, the incongruity of running into her and the identity of her husband tweaked the evening.

It was still raining, slowing but not stopping, when I left the exhibition, but the evening wasn't over. It was a slippery walk across the marble patio and down the steps from the museum. The rain had soaked the streets and streams ran along beside the curbs. The gutters gargled and wind plucked at hats and yanked at umbrellas.

In the lee of the building beside the street was a man unsuccessfully

attempting to stay out of the rain. I was past him before I recognized him; he was the father of an acquaintance. I said hello and asked if he was all right. He was waiting, he said, for a cab to happen by, an event in L.A. of head-spinning unlikelihood and an act of sheer dementia. I offered him a ride.

His name was Alexander Eliot, and though I hadn't bothered to ask or notice, he had had a remarkable life. In looks he could've been the last hippie. He had a hat on, but his unkempt and wild long hair was wet and awry and tangled outside of it. His beard made him look like he had stepped out of the Civil War; perhaps he was a member of Lincoln's cabinet reincarnate, like Edwin Stanton, the Secretary of War who had been bedside at the Petersen House when Lincoln died and in legend proclaimed, "Now he belongs to the ages."

Alexander Eliot got in the front seat beside me. He had a coat on, it wasn't a raincoat, and he must've been soaked. He didn't seem to mind or notice. As we drove I asked him why he had been there. He started to talk about Diane Arbus. He had known her well.

Eliot had taught at Hampshire College and had written a number of books, several tied to myths and mythology, including one with Joseph Campbell. But he told me as we drove what I had forgotten, or maybe never knew: he had been *Time* Magazine's art editor from 1945 to 1960. It led me to ask him what other artists he had known. Pollock, de Kooning, Dali and Josef Albers — it seemed he had met them all. Hung out with some, like Arbus.

He mentioned his time in Europe when he journeyed to meet Henri Matisse, who by then wasn't well and was confined to bed. Still, Matisse was busy making his paper collages. Eliot asked him his advice about being an artist. What should he do? "Draw," answered Matisse. "Draw, draw, draw."

As no more than a shot in the dark, I asked Alex Eliot about Charles

Burchfield. He reached over and touched my shoulder and said, "He was the nicest man."

I was startled at this living connection. This artist I collected, Charles Burchfield, had lived and worked on the East Coast; he was all but unknown on the West Coast, and he had been dead for more than four decades. Here in the rain was a man who had known him. The fall of the rain seemed to intensify. The windshield wipers seemed to heighten. I longed to hear more.

With that in mind some weeks later, I went to see Alexander Eliot in Venice where he lived near the beach. His wife Jane answered the door and let me in. Alex wore suede bucks and wide-striped socks, a green-striped shirt, a tweed jacket, and a paisley tie. He had dressed for the occasion in his own unique way, in a crazy quilt, clashing wardrobe to accompany his beard, big glasses and wild mane of hair.

He had at the ready his book, *300 Years of American Painting*, that he had put together while at *Time*. In his years there, the magazine had collected a cache of color photographs from his articles and reviews and, unusual then, he had gathered them into the book. It was a tremendous success, selling 300,000 copies. Jacqueline Kennedy ordered a copy for the White House. He didn't have a royalty, but did wangle a paid year's sabbatical in Europe.

He knew I wanted to hear about Charles Burchfield and he had his book open to a passage he had written 55 years before, and 10 years before Burchfield died, that wasn't without eloquence or currency still. "In his latest work," Eliot read out loud to me, Burchfield has achieved "a masterpiece of imagination, organization, and daring. Nakedly elemental, the picture puts Burchfield in a class by himself among living water-colorists." Eliot was referring to a 1954 work, *Oncoming Spring*, that Burchfield had excitedly written about himself in his journals and Alexander Eliot quoted:

CHARLES BURCHFIELD, *ONCOMING SPRING*, 1954

It was a glorious few hours when I seemed to become part of the elements. When I was done at late afternoon, the picture was complete. It seemed as if it had materialized under its own power.

In his elegant book, *Landscape into Art,* Kenneth Clark hailed two artists (Turner and van Gogh) as both geniuses and "Northern artists," painters of "the midnight sun and aurora borealis." However you may want to rank them — as crazy and subjective, if entertaining, as such can be — Burchfield joins them. All three found in "the delirium of light... a release of their emotions." Burchfield literally painted the northern sky and named more than a few of his works "North" this and "North" that.

Before *Time,* Alexander Eliot had been a young painter himself with a wife and a child and he wasn't earning enough to support them. Couldn't even scratch out a living. The paintings were accumulating, crowding him out of his studio, and not selling. He got a job at the *March of Time,* then, after Pearl Harbor, at the Department of War Information. When

the war ended he went to *Time* magazine and applied for a job from Dana Tasker, whom he had met. Tack, as everyone called him, gruffly asked: "Yeah, what do you think you can do at this magazine?"

"I can make your art section sing," Eliot said. "I'll be the editor. I've been there, in the art world, and as a painter. You only run anything once or twice a month. I can do it every week."

"Really, okay, I'll tell you what," said Tack. "Go to the Sherry Netherland. Larry MacPhail of the New York Yankees is there. You ask him why he fired his manager Joe McCarthy. The sports editor's on vacation. Find out. Do a piece, and have it on my desk by seven, and if it's any good…" He let possibility dangle.

Of course what MacPhail, or the Yankees, had to do with art was anybody's guess. It was true that Tack, who owned horses and whose nickname came from when he played football, was no small sports buff. There was no arguing, so off Alexander Eliot went, certain MacPhail would have nothing to do with him. No one else had been able to get him to talk apparently, or get an answer.

Eliot unearthed MacPhail's room number, went up and hesitantly knocked. MacPhail threw open the door, taking Eliot aback, and not just that. MacPhail virtually yanked him into the room asking: "Do you favor Scotch in the morning?"

Dumbfounded, the young Alexander Eliot quickly improvised a lie: "Never too early, Sir."

The two had a drink and then a second, and Eliot baldly came out with it: "Why did you fire your manager?"

"Off the record," MacPhail responded. "He's an alcoholic."

Well in the wind, Eliot returned and told Tasker, "I failed. He told me, but off the record."

"That's okay," said Tack. "Weasel it."

So Eliot had his first lessons, not unimportant ones, to weasel and how to weasel. Tasker loved the piece Eliot wrote.

In the '40s, even into the '60s, *Time* didn't credit its writers or offer bylines. Its unrelenting hold on anonymity was infamous — and so it was only then that Eliot discovered that the art editor he would be replacing was Walker Evans, a man he greatly admired. In fact, was in awe of.

Eliot went upstairs to tell Evans, not knowing once more what to say or expect. Walker Evans stopped him before he hardly could get started and took him down to 3Gs Bar and told Eliot he hated Tasker. He had an offer again from *Fortune* magazine as a photographer, like the one that had spawned *Let Us Now Praise Famous Men*, and couldn't wait to get out of the office and away from writing and editing. Evans was elated to be relieved.

"I took delight in American painting," Alexander Eliot told me. "And it amazed me nobody cared. Art was very low on the totem pole in America. When Harry Truman jeered at ham-and-egg art, millions cheered and senators looked under the bed and saw Communists in what these artists were doing. I felt I had a mission to put American art on the map."

With savvy, he learned to ride piggyback on Henry Luce's belief, practically religious in its fervor, that this was "the American Century."

Eliot came to know the painters he wrote about. They became his acquaintances, sometimes his friends, and he surveyed a startling array. He followed their work and its evolution and they grew to be, he said, "his cast of characters," and Charles Burchfield was one of that cast of characters.

Time gave Eliot an expense account and he used it to take these artists to lunch at the Century Club or the Red Devil and, in Burchfield's case,

to the Barbizon-Plaza Hotel. Fifty years later, Eliot didn't remember much of what was said. Burchfield was direct, simple, and cogent; he had absolutely "no side whatsoever." He had assumed the painter of these startling works would be sophisticated, know all about art. Not at all. His opinion of Picasso, for example, was not high. "I just don't think he's sincere," Burchfield said.

Eliot asked him, "How long did you take to do one of the big paintings" he was now doing?

"Many years," said Burchfield, before he paused and then added: "Of course, if I knew what I was doing... "

One of the places in New York that Eliot frequented, even before his 15 years at *Time* magazine, was a gallery in a suite in a high-rise on Madison Avenue. It was called An American Place and very few people seemed to make their way up to it. Eliot was welcomed as "a fellow seeker" by the gallery owner he usually found alone there. This was Alfred Stieglitz, and Stieglitz became a mentor to the young man.

ALFRED STIEGLITZ, *GEORGIA O'KEEFFE — TORSO*, 1918

Eliot may have been lucky because he couldn't afford to buy any paintings. He was there to look, learn, and be inspired. If you wanted to buy from Stieglitz, Eliot said, there could be problems. He would want to know what kind of home you were going to give the painting. How did he know you really understood it? He turned away more people than not. He could be difficult, idiosyncratic, autocratic, or surprisingly vulnerable and open. It was unpredictable.

There were too many things to ask and I could see Alexander Eliot was tiring.

I had asked him about Georgia O'Keeffe when he was talking of Stieglitz, and before I left he said, "Let me tell you one more story." Not long before Stieglitz died, Eliot had arrived early one afternoon to An American Place. Stieglitz said, "I want to show you something precious to me. Don't get fingerprints on them. I'm going to take my nap. Just snap the door on your way out." Of course, they were the O'Keeffe nude photographs that Stieglitz had taken that would become so famous but had never yet been shown. It was an extraordinary aesthetic experience to see them. Eliot was enthralled, honored, and humbled.

"Would you mind my asking why you're not together," Eliot once had asked Stieglitz. "Of course, Dorothy Norman was the main reason," Eliot told me, referring to the married woman — protégé, writer, photographer, traveler, and equal champion of his artists — who was Stieglitz's mistress. Like O'Keeffe, Norman lived long past Stieglitz and into her 90s, and had a meritorious later life. "Stieglitz protected my innocence," said Eliot, "and said something about altitude and his trouble with the difference between New Mexico and New York. And nothing more."

After looking at the photographs, Eliot went to tell Stieglitz how he felt, how moved he was, at least say something. He found the aging man lying down, his cape over his face, one hand trailing to the floor, like a premonition of his death which was no more than months away. "I gulped," said Alexander Eliot, "snapped the door shut as I was told, and stole away."

That story crosses back 70 years and only now as I turn to look a final time at all Alex told me, checking it twice, do I learn last Monday he got up — still proud to be independent — walked to the Fig Tree Restaurant to write and have breakfast. He came home and was struck by an aneurysm and within 72 hours was gone just short of his 96th birthday.

The day before, Sunday, he had "finished" for the 100th time his latest manuscript. He called his son Jefferson and told him to "come and flash it," his phrase for backing it up on flash drive.

CHARLES BURCHFIELD, *SPRING RAIN IN THE WOODS*, 1950

After looking at it and "flashing it," Jeff said, "This is really the last time. It is done."

I write this now, like that other night, in once-again wet L.A. It has rained, and rained again, and now finally stopped. There's been a drought and it is said no matter how much it rains it will not be enough. But instantly, the hills turn green. The night has stars, Orion and his belt and Mars, and the moon, near full, is as big as a grapefruit. It is, however briefly, a stunning city.

On my wall near me is a Charles Burchfield painting, *Spring Rain in the Woods*, where it always rains, where there is no drought, and where windows (as Burchfield called them) of sun and spring slice into the woods to war with the remnants of winter. Burchfield wrote about it:

I decided to try to paint the roar of the wind in the woods. A fine afternoon — at times the wind ceased altogether and a great calm settled over the woods... Soon it changed and I began to improvise on other themes, such as wind-blown leaves dancing over the floor of the woods, and big rain-drops hitting them with a great clatter. Bits of sunlight entering into "windows" of the woods, great hemlocks bending before the force of the wind, the branches overhead clashing in anger at the menacing clouds.

Will I ever truly be able to express the elemental power and beauty of God's woods?

I haven't yet bought a cape to pull down over my face and eyes. I still yen for and look forward to such rainy days as Burchfield loved and painted and wrote about, and such rainy nights, however few and far between, that offered up Alexander Eliot, and the propinquity they can bring.

PROVENANCE

CHARLES BURCHFIELD,
THE RED WOODPECKER, 1955

THE PAINTING WAS SO FRESH and brilliant that when I saw it hanging I questioned whether it was true. Or could it be a fake?

But before that I saw its image online. The Internet changed collecting: it made images and information readily available. This was a twist for the art world where secrecy had traditionally been harbored and even cultivated. Hard facts were cloaked and not always easy to unearth. Mystery actually seemed to serve as an inducement. Dealers could be very sketchy, not to mention airy, about the provenance of a picture, where it came from and who had owned it. Twice early on I discovered paintings that I was interested in had recently come up at auction. In neither case was the fact disclosed.

The painting was a Charles Burchfield, and by then I had seen a lot of Burchfields and owned a few. I had not heard of this one. It was not in the Burchfield catalogue raisonné prepared in 1970 by Joseph Trovato. It was an industrious compilation using the records Burchfield and his wife Bertha kept and those of Frank Rehn, Burchfield's dealer for the last

35 years of his life. Still, no small number of works inevitably preceded any record or had slipped into the cracks, and weren't in the Trovato catalogue. There were also rumors of Burchfield forgeries. I had seen a picture of one.

I saw the image and e-mailed the gallery, asking about the picture and its price, and received a quick, curt reply. The price quoted was out of sight.

I responded: what is the realistic amount?

Immediately an answer volleyed back: the price was not negotiable.

Okay then I inquired how could the amount be paid? Over time?

There was another instant terse reply: You can pay by bank check or wire transfer.

My dander was up. I couldn't resist firing off my own volley: all this is very nice, but how about the fact that the image on the net is wrong.

What are you talking about? came back at me.

I wrote: The image is reversed.

Can't be, came back.

Oh, really, well Burchfield's monogram — the way he signed paintings the last 40 years of his life — is backwards on the picture.

That's ridiculous.

Well, you might want to check it out, I wrote not without some enjoyable attitude.

The next day came an apology and in spite of its acerbic beginning, it led to what became a surprising and significant relationship with a man, Bernard Goldberg — a New Yorker while I lived in Los Angeles now and a man a generation older — that I had nothing in common with

except for this passionate connection we shared, a love and enthusiasm for a certain period of American art. Bernard had gone to Horace Mann, become a real estate lawyer, then a real estate owner, five hotels that he sold in 1998, before he turned to art not only as a collector but also as a dealer. His taste was distinct, certain, and discriminating. The works he offered had exceptional quality. And prices. To the point where I came more than once to partner with him and piggyback on his discernment.

Bernard didn't travel any longer except to his house on Long Island, so I saw him infrequently, only when I went to New York. In a previous era, this surprising and richly enjoyed friendship would have been an epistolary one. Now it was via e-mail. Most often terse, but once in a while, especially from my side, it roamed into longer musings and meditations about this or that artist. And, of course, my wallet emptied and his filled up.

The painting first in question, *The Red Woodpecker*, that was so fresh and bold, was fair-sized, though not extremely large, less than 2 feet by a foot-and-a-half. Its size only accentuated its vibrancy. Burchfield had limned a woodpecker that wasn't still. The woodpecker was busy working and his red-capped head was in jabbing movement. In intimation Burchfield had created bright, sharp, rich echoes of its color. Not only that. The pecking put the tree into sway. Shapes, like quarter notes, rolled up and down the trunk. The other trees, flowers, and butterflies were alive as well; the very earth itself was animated. The whole woods were in musical motion.

In Bernard Goldberg's words, "the picture sang. It just popped."

The painting seemed to have little known recent history. There were a couple of gallery stickers on the reverse, and then the provenance stopped. It was a dead end. There was no further documentation and Bernard knew no more. I had met and exchanged notes with Nancy Weekly, a Burchfield expert, Head of Collections and Charles Cary Rumsey, curator at the Burchfield Penney Art Center in Buffalo, New

York. She kindly offered to dig into Burchfield's plenteous journals and notes. There was nothing there; the painting was absent, missing. There was no record of it.

But Nancy kept on digging and came upon an article sent at some later date to the museum. It was an interview in 1955 with Burchfield by a woman writer, Laverne George. The surprise and revelation was a grainy black-and-white photograph accompanying it. It was a bad copy, sort of dim and gray as if badly Xeroxed, but there was Burchfield and a woman, presumably Laverne George, and on the easel behind them was a painting. Even partially blocked and in soft focus, it looked dramatically like *The Red Woodpecker*.

CHARLES BURCHFIELD, *THE WOODPECKER*,
1955-1963

This was exciting but also misleading. It was known that Burchfield had painted a very large watercolor entitled *The Woodpecker*. It had landed finally in a North Carolina museum and was dated 1955-1963 and the subject was clearly the same. The picture was also clearly different than *The Red Woodpecker*. It had greater depth and solidity and was more

rounded and complete and yet had less vividness and explosive magic. It was less bold.

Burchfield, like most artists, did sketches and preliminary versions; even no small number of what I came to call look-alikes. They could be striking pint-size variations, signed, and completed works in themselves. Some were beauties; they seemed more original and less labored than the final incarnations. Nancy Weekly had even begun a list of them. Could this *The Red Woodpecker* be one?

Still there was another question, one more mystery. As I studied the photograph, I realized the work on the easel wasn't the same size as Bernard Goldberg's. It was substantially larger if still nowhere near the dimensions of *The Woodpecker* now in North Carolina. There was a partial possible answer. Burchfield not only did look-alikes. Starting in the 1940s, as I've written about, he worked and reworked his watercolors over time, sometimes decades, meticulously, remarkably and uniquely joining pieces of paper to his originals, enlarging them. His ideas and concepts would alter and change. That could explain the possible transformation of the painting on the easel in those eight years from 1955 to 1963 into the enormous work in the museum.

But what about Bernard's?

A next step was to find, if possible, Laverne George. That turned out to be not difficult but also unfortunately impossible. Her name turned up on Google, as did her husband Thomas George, a painter of no small consequence himself. They both were apparently still living. Within the past several years, he had had an exhibition at the Princeton University Art Museum.

I had given a painting to Princeton and had correspondence with its director then, Allen Rosenbaum, and its subsequent director, Susan Taylor. I called Susan and when I reached her I told her my story and about my quest.

Susan listened and laughed: "Are you coming to Princeton any time soon?"

"I wasn't planning to."

"Well, you should."

"Why?"

"Thomas George is very much alive and quite a character. Come. I'll call Tom, I'm sure he'll be interested, and I'll arrange a lunch."

Perhaps six weeks later, I flew east to do a book appearance and reading and detoured to Princeton and met Susan Taylor and Thomas George at the long-lasting, even heirloomesque, and now gone, Lahiere's restaurant. It was December, a chilly wintry day, an opposite season from the blooming spring Burchfield had seized in *The Red Woodpecker*. Thomas George was deep into his 80s, wore khakis, a button-down shirt and a tweed jacket, glasses, and moved with a spry crankiness.

Tom was excited, and I think amused, to hear about the painting and the bit of a tumult around it. It had been theirs. He had accompanied his wife to Gardensville, outside of Buffalo, to interview Burchfield. They — Laverne especially — had been excited by the recent watercolors they saw in Burchfield's studio, particularly the work in progress on the easel. Laverne thought the work was breakthrough. Burchfield was forging in an exciting new direction, less real and more expressionistic, even visionary. She believed they were looking at paintings that no one else had done or could do.

Laverne wanted to buy one. Instead, touched, Burchfield painted a new smaller version of the one she so admired and sold it to the Georges for next to nothing. Laverne's interview and subsequent article were written and published, entitled *A Day with Charles Burchfield*.

The Red Woodpecker had its provenance. It was true — it was real — and it had its story, its tale to tell.

The Georges had hung it, then put it into storage for decades as they moved from one place to another far and wide to live — Paris, Florence, China, Norway, Santa Fe, and Maine, and finally, downsizing, sold it to Hirschl & Adler.

After lunch, Thomas George took me for a ride in his station wagon past his old house and barnlike studio on Greenhouse Way. He had given the home up, sold it as well, but clearly it still held a place for him. As we drove in his car, I learned what I had not realized: Tom's father had been Rube Goldberg, the cartoonist and contraption icon, and his wife Laverne was still alive, but she was very deep into Alzheimer's disease and was now in a nursing home. I learned his opinion of certain American artists: he liked and admired Burchfield, though he felt more an affinity for Georgia O'Keeffe and he revered Arthur Dove.

Tom told me he still painted nearly every day. The works were smaller now, mostly watercolors. He was drawn to mountains and had painted them all over the world. For several years he had done studies of a pond over and over at the Institute for Advanced Study not far away. He was painting the sun now. His work crossed into abstraction so the suns were as much proof of his fascination with the circle, its beauty and simplicity.

By four o'clock the light was already failing. He drove me to where he now lived, a rambling guesthouse, and showed me where he presently worked. We weren't alone for long. Mary Bundy, the daughter of Harry Truman's brilliant but notorious Secretary of State Dean Acheson, and the widow of William Bundy, arrived. Her husband had been one of Kennedy's Best and Brightest, and the two had met and married during World War II when he was cracking enemy codes in England while she was working as a cryptanalyst at Arlington Hall, a secret army operation in Virginia.

Mary was smart-looking and sounding, circling 80 herself. The two were relaxed and quick with one another. They fenced with spirited enjoyment and intimate wit. At five o'clock cocktail hour was declared, what seemed to be an honored tradition and a daily celebration. With it came a discussion of the events of their day, ordinary or not, and touched

with that of the greater world. In no small and moving way it became clear they now shared a life.

I learned as I listened through the afternoon and into the evening that this painting I now owned had a thickness beyond the Bee Paper Burchfield favored with his brush. It had touched remarkable lives and histories and allowed me to do so as well.

This, too, was provenance.

A NEW JERSEY STORY

Whatever he painted, he was working outside time, outside movements, outside history, and we should be willing to look sideways and see who was painting solidly and confidently without regard to current trends.

— Steve Martin about John Koch

JOHN KOCH, *NIGHT*, 1964

WHEN I WAS YOUNG — and I imagine still — on certain summer nights when you walked into houses in New Jersey, the air hung heavy with humidity. It seemed to suck illumination out of rooms and swallow light. Floor lamps or desk lamps merely interrupted the dark. Surfaces, whether wood or metal, were tacky. Sticky. Touch them and residues lingered on fingers, clues left or clues taken, unnecessary evidence of the wilting heat and humidity that would attack 100 percent and for days threaten to never depart.

It was oppositely kin to the sense as snow fell and while it lay fresh on the ground. The world then was tucked into its cottony silence. On those summer nights the very air seemed to gather up its own silence. Stillness — except when broken by the stir, hum, or frenzy of insects. It was odd, this calm, this quiet touched with disquiet, with a note of eeriness, even a shadow of foreboding.

There were secrets in these New Jersey houses behind the closed front doors and heavily screened windows, events I never saw and only occasionally heard about and seldom understood as a child. There had to be good ones, the stickiness of flesh after love, the fresh quench of a gin and tonic, the tuck in of a child under just a sheet in the blessed whir of a fan. But it was the mysterious, the disturbing, and the sad ones that seem to stick like the humidity and be complicit with these saturated summer nights and their sensuous and adhesive torpor.

A June tale of hide-and-seek across backyards and a boy accidentally garroted by a clothesline, the one after another unexplained disappearance of cats one July, a man named John Cali who came home as darkness fell to find his wife and daughter dead and himself seized as the only suspect until he proved otherwise, and the story of a churchgoing man picking up hitchhikers on an August night only to be kidnapped and killed by them.

And on what was one such night in my 18th year, I decided to drink a fifth of gin. No tonic, no lime, no ice, no glass. Straight from the bottle. The brand selected, or rather available, was called Black Cat. The Black Cat smelled like some vile ether; it stank. Probably leaving the bottle open for evaporation would have been as swift as my drinking it. It was a delightfully stupid and lethal idea.

I had graduated from high school and had a job but was at loose ends, certainly psychologically, and ignoring it at all costs. I wasn't alone. We all felt it, the end of one era in our lives and the uncertainty of the next to come. It was there within us and shortly within the country itself. The halcyon '50s, if they were halcyon, were gone. Kennedy had been

assassinated and all that was to happen in the '60s in its aftermath was astir. We ran around in cars at night after work looking for something to do. Trouble could well be and was often not far away.

The vainglorious gin escapade was at a party — not much of a party, one more New Jersey summer night, a few guys trying to be rowdy, or at least combat summery boredom, hardly noticing at first a few girls stopping by. I started quickly, did well; I was going to make it, down it, finish the bottle, empty that Black Cat without a hassle. It was going to be a worthy achievement. I found a dirty book (who knows how dirty now?), started reading it aloud, and then somehow I lost recall until I couldn't stand any longer, or sit up on the couch, and I fell over and found my head in a girl's lap. Not just any girl as it happened. She had planned it that way, and we had some history.

Call her Shana, and our story began on one of those hugely hot humid nights, the night of baccalaureate two days before high school graduation, and not in the six years we went to school together before then. There was a party, this quite a different one, and different than any other we had had, and intentionally so. Our class' time together was all but over and inhibitions were set free. We offered ourselves up to each other for one night as we never had, especially to those we'd always wanted and never gotten the chance to know. It was sexual, but not only, and still with limits. Kissing yes, feeling up if at all possible, finger-fucking maybe, fucking no.

It was there that Shana fell down the steps to the basement recreation room, and I caught her. It's the stuff of legend and dream in me now, even immediately then, so young, so drunk, so long ago. I'm not sure what really happened, how much I've altered in my mind or made up. This is what we do after all. I don't know whether I'd even recognize whatever really happened if it replayed now. Perhaps it doesn't matter. Down she fell upon me, smashed and laughing. She looked at me with and without mockery at once and said, "Why there you are. I knew you'd be there. It's about time."

She'd apparently been sick and to replace the clothes she'd thrown up on I loaned her the shirt — a hockey jersey — that I'd brought, though I don't know now why. I have no memory of her vomit or of bad smell. I remember only when she stopped at our house some time later and returned it, laundered and folded and smelling clean and like her. She presented it to me. I can still see the motion of her arms and the way her lips set. They were fine and full and I would come to watch them and long for them, and recall them as vividly now closing in on 50 years later and it still amazes me: I don't know that I had ever noticed them until she handed me the folded hockey jersey.

Shana had bleached blonde hair then and was supposed to be racy, quiet but fast and very aloof. Many times sitting in alphabetical order, I found myself sitting a row behind her and slightly to the side of her, confounded by the reserve she seemed to have, a sort of disdain, and wanting the one and to shatter the other. Little of it was true. What I was to discover was how conservative and meticulous she was; drinking and smoking aside, she was a good, strict Catholic girl.

That sticky baccalaureate night we spent together, I cleaned Shana up; I took care of her. She talked a mile a minute, she laughed, we kissed, no more. I tried to con her out of her clothes and got nowhere. Amused hand blocks and batted down ideas. Once toward morning I ordered her to raise her arms and involuntarily she started to. Up the jersey went in my hands and down her elbows crashed, stopping me. "Oh, no, you don't," she said, not at all surprised or upset. She was remarkably beneficent.

That night, I thought, sat outside of time. We didn't know each other well before. We knew there was no likely after. We were dating others. So it was ironic we found ourselves next to each other at graduation rehearsal the next afternoon.

Who can say why or when you fall in love? The part of me that likes to think of itself as a higher being can talk about backgrounds, smarts, shared interests. The rest of me knows the potent corollary. Equally likely

are timing, chance, and the purest synchronicity. That and the most elemental of human instincts. Hormones.

I think I did, standing next to her in her long white dress, holding flowers and nursing a hangover and telling me to shut up as I whispered anything irreverent I could think of to try and impress her. I remember telling her I was going to kick her in the ass as we stood in front of everyone in the amphitheatre during the actual graduation. She told me I'd better not! The skirt of her dress subsequently offered me cover and she was suitably horrified.

Shana's father was a doctor. His parents were immigrants and he or they had changed their name. He kept two things on the living room mantel: a *No Smoking* sign and a sawed-off leg from the bed in which he was born. Once I took Shana to a hockey game at Madison Square Garden and — tape delayed — it aired on television later that same night after we had returned. We had sat low down near the ice and he asked exactly where. I scrunched down close in front of what for then was a big-inched set and pointed his daughter out as the action whizzed by. "Keep pointing," her father said. "I want to be able to tell everyone I know I've seen my daughter on television many times."

> *The picture becomes important at the moment*
> *that I conceive the light in it.*
>
> *— John Koch*

Long after I had left New Jersey, decades later and decades after I became interested in art, I was sent a transparency. I don't recall why. It was a painting by an artist I was only hazily aware of. His name was John Koch and he had little or no relationship with those I had come to know and buy. The painting was vastly alluring and "realist." The painting was painstakingly and radiantly so. A still life. A painter's palette board smeared with brilliant colors, a bed with rumpled sheets that seemed in themselves a living canvas, and as stunningly wrought and as sensuous as skin. It wasn't cheap; in fact it was startlingly expensive. Even if I could've

afforded it — and by begging or borrowing maybe I could have — I didn't buy it, which I regret.

I didn't know enough about the artist and I didn't understand then why it held me, and for some time, years even, I didn't think much more about it and barely recalled the name of the man who painted it.

JOHN KOCH, *CONVERSATION-NIGHTLIGHT*, 1954

It was in a bookstore in Santa Monica, California, in a remainder section where I came upon a catalog and again encountered John Koch. The catalog was old enough that most of the reproductions were in black and white. It didn't matter. I understood the power of the attraction like a revelation. This artist, beyond any single work, seemed to know those nights, that humidity, the secrets that I sensed. He captured them in his paintings, the small mysteries and enigmatic intimacies that are most and maybe all of our lives.

Sometimes quiet, sometimes elliptically charged, sometimes what could be dire, a silent breaking apart or rupture of a relationship. All without words the tearing of the fabric with those we might or may or should have loved. They felt right out of a certain time, a certain place, right out of what could be those summer nights I so remembered and that crucial, life-changing such moment in my own life.

It's taken me four decades and more to write about Shana, but I can still describe what she wore back on that hot Black Cat night: a sleeve-

less, yellow, summer-weight turtleneck. I can see some sort of knit. I can see her bare arms; see the design of her bra underneath the knit, and looking up from where I landed below in her lap, see the pushing shape of her breasts. They were not small, quite perfect, riding high, and framing her face.

The very next night we were at the same house again, and it was my turn to have a hangover. Shana wore a second sleeveless turtleneck only white this time, and I got my hands under it and wanted and didn't get more. The wanting and the slow dance toward sex was an important part of our time and our story. I was just 18; mature in ways but in many more a very young 18. We saw each other on and off for two adolescent, urgent, romantic, painful, doomed years. They were heavy-laden with emotion and wrong-headedness, sweetness and finally wreckage. What was true was we were different and not meant for each other. Which never stopped the wanting on my part. But for all the intense and charmed felicity, we were ill-timed. I wasn't ready; I wasn't up to it.

Our relationship was so very much tied to nights, and as I live longer and yet cast backwards, it's the summer ones I remember with their anticipation and excitement and yearning and rue, and there were such nights in those reproductions, even in black and white, in that catalog in Santa Monica.

> "*I love night pictures. I have great affection for people in bed by night light.*"
>
> — *John Koch*

Consider some titles of his works: *Nocturne, Lovers, Siesta, Night, The Insomniacs, The Departure.* And even if not explicitly so, nevertheless, such as the woman waking in *Telephone Call* or the man waking as a woman still sleeps with only the first fiery bar of day on a single wall in *Morning.*

There were great shadows and darkness in these works like Gordon

Willis' lighting in *The Godfather* and the chiaroscuro of film noir, and even more they led me on a journey back to the humid New Jersey nights of my childhood and adolescence and the emotional nights with Shana.

I felt them again in John Koch's work, scenes we had lived or I would have wanted to live, and ones I wished we hadn't lived, and I can remember Shana and our time as well and as specifically as any period in my life. It's tied to a longing and learning about sex, and a seductive laundry list of textures of skirt and glimpses of skin and qualities of night light dug deep into the loom. Nostalgia that, for years if I let it, could still gnaw or rabbit punch or run through me like an emotional electricity, make me long to live again my youth, and have a second chance to see what could have been, and apologize, or remedy mistakes. Do it better.

Who was this man who painted mostly interiors, often an artist's studio or his own New York apartment, and who repeatedly captured everyday and everynight scenes with such rigorous, delicate, realistic, charged, and uncommon intimacy?

There is talk about his hidden private life. I don't know; I don't care. This is what I know: John Koch had a stirring sense of space. He brushed to precise life rooms, doorways, and the details of the commonplace objects of our lives — a tipped-over lamp, a wall outlet, an ashtray, a telephone. His world could have been hermetic but there was a constancy of windows that ushered in the seasons. He was a subtle colorist who found salmon in a rug and the shade of tomato aspic in a robe. His use of white was vividly alive and extraordinary. It could be iridescent or incandescent, hard or soft, daylight or lamplight, and he made clear they weren't the same. They could be chalk white or white gold; they could glow and add depth and highlight — as slight as a speck of illumination on a glass, as widespread as the sheets in that first still life — to the human shapes alluringly apprehended in the ordinary and yet profound mystery of daily lives. These dramas were quiet but not necessarily small, and many, many at night, and offer what I think great art can: twine you for the first or *n*th time to what we remember, or wish we remember, and forever wonder at.

Twenty years later, and now coming on toward 30 years ago, I saw Shana at a high school reunion. She was finally the reason I went. It was to say I was sorry for much of the way I had been, so young and driven and lonely and stewing in my own juices. Often blaming her when I should've been blaming myself. I kept putting off approaching her, perhaps revenants of misbegotten cool. A kind of withholding and strut that's closer to cowardice than courageous. I heard she had had struggles, a truly troubled marriage to a Vietnam veteran and a second marriage that would fall away as well. A third was still to come.

Once she happened close by where I was. I had by now a small corner of success and someone was showing me the front page of the Sunday entertainment section of the *Newark Star-Ledger* where there was an article about me. "Have you seen this?" I asked her as she passed.

"Oh this, I know all about this," Shana said, dismissing it and scaling it across the table. The clipping fluttered in the air and kept on going, skittering off the table, landing on the floor, and she moved on.

Set back several feet, I stayed away from her some more. She could well bear a grudge; who was to say she didn't have cause? There was no denying the charge we still carried and that perhaps brought us both back to the reunion: what we yet required, and the surprise of the power it offered up to me, and may well have to her.

When it was late, dancing began and Shana came up to me. "Come on," she said.

As we danced, Shana didn't want me to pull her close; she wouldn't let me. There was an enormous tension. Our bodies beyond our hands didn't touch. I was there to respect it, whatever she needed or was right for her when with a shudder, a soft whoosh, she let go and the distance between us collapsed. We held each other. The clean sweet scent of her neck was unchanged. "There you are," I said. "It's about time."

I've never seen her since.

But time has added another dimension and recognition to those first days and those remembered nights. The original sensations and the pictures that go with them remain as fresh. Regrets still exist and yet a parcel of contentment has come. It is imperfect but it is full: we lived, we felt, we survived, and our lives have had shares of splendor. It reaches well past the initial hunger, the sexual impulse and need of then. It contains so much more now: all that we feared, all that we lost, all that we loved, and all that we are lucky to have.

And for me, amidst that luck is the small John Koch I have now, a night scene in that scalloped and sketchy illumination that "sits outside time, outside movements, outside history," and brings upon each glance or look the light and scent of youth and haunt and love of those times and those places and the things I have learned and carry.

It sustains me.

MORE

BRANDON STODDARD, *THROUGH A GLASS LIGHTLY*, 2010

*When I paint I think what would satisfy me is to express
what Bonnard said Renoir told him: make everything more
beautiful. This partly means that a painting should contain
a mystery, but not for mystery's sake: a mystery that is
essential to reality.*

— Fairfield Porter
(in a letter to Arthur Giardelli)

WE CAME TO CALL EACH OTHER BY INITIALS, Brandon Stoddard,
and me, JSY, two transported New Englanders, two men who
left bunches between the lines, in the time we knew each other, worked
together, challenged and supported each other, and then shared offices
for a decade.

BS came out of Southport, Connecticut, a family not without wherewithal, and fell from law school and then advertising, almost despite himself — and to his family's distress — into daytime television. Distress is actually too slight and an insignificant word. More rightly, it was a rich if largely unspoken WASP disapproval.

BS loved the world of television, and he moved up, advancing to nighttime programming and then to Movies of the Week and Mini-series. He didn't found them, but he was present at the creation, and then built the game-changing model that housed them.

In the decade that followed, BS put on the air ground-breaking stories and Emmy-winning television that shattered ratings history. Numbers that can't even be imagined today, or ever repeated outside of the Super Bowl. Now, a percentage share of the audience in the teens is estimable. Most fail to escape single digits. For BS, a 40 share of the audience was commonplace. Fifty not unheard of, and on successive nights through a week in 1977, 60 was surmounted and then an unheard of and unprecedented 70 assaulted.

After the first night of the mini-series *Roots*, BS was up at the crack of dawn because overnight ratings arrived three hours earlier on the East Coast. And then the phone rang. It was the report and a voice telling him the show had gotten a 40. Well, a 40 share was not bad for something so controversial. No, Brandon, he was told, not a 40 share. A 40 rating and a 64 share. When he got to his office, people were standing on chairs and desks applauding and cheering.

Go to the list of the highest ratings in TV history and there amongst the Top 25 are a dozen he was responsible for.

BS rose to be President of the ABC Entertainment Division, and took over series, launched a feature film unit, and Oscar nominations joined Emmys.

Nothing lasts. There is the top, and then there is after it.

When he left the network then, BS struggled to find what was next. Such a dilemma wasn't his alone: what do any of us make of the years we have left, however many or few? He was at that moment of life. There was golf and tennis. There was some teaching. Some were comic failures; others were successful, and not unsatisfying. None fulfilled him. What would he rather do? He was a bit of a Brahmin, but he was also a passionate man. Small, with a highly developed benign demeanor, he was rippled inside with his own complications and unfinished ambition.

As the sole boy with two sisters, BS was shipped up to the attic bedroom, as I had also been. It was one of several largely unexpressed things we shared and had in common that led to a crucial friendship. The banishment wasn't punishment, and BS didn't mind. To the contrary, it pleased him. He learned he could be alone, liked it. He devoured books and taught himself how to put together a hi-fi kit. He filled the attic with music and took in the changing sights at the window toward the water and Long Island Sound like paintings.

He discovered an intensity of curiosity and an interest in exploring his own mind.

So 40 and 50 years later, golf didn't cut it. He thought about painting, longed to have had the ability and training. Too late, far too late. Still he talked about it with his wife Mary Anne Dolan, who often joined us in initials. MAD was equally successful, on multiple boards, and the first woman editor-in-chief of a major newspaper in the country. They had first met with instant antithetic chemistry, neither on their first journey around the block. It began a several-year, topsy-turvy, back-and-forth dance that landed somehow perfectly in a marriage of magic.

Enough talk, MAD thought, and she went to work finding the best painting kit as a present for Christmas. It arrived in a fine wooden box with the finest tools and brushes, a stunning piece inside and out. Pleased

and proud, she wrapped it. Excited. She saved it as the best for last. She was sure he would be knocked out by it.

She was wrong.

For the only time in their marriage he lost his temper. He exploded. He slammed the gift shut. He wasn't going to paint, he said in deep fury. He would not be forced into attempting it. MAD was taken aback, shot down, and her own temper flared with equal force. Fine, she yelled, believe me it'll be in the mail first thing tomorrow, and out of here.

Not much more than a week later, he returned from a camera store with the simplest of spiral-bound books, *Watercolor for the Artistically Undiscovered*, by Thacher Hurd and John Cassidy, one of a series from Klutz Press. The level of a kid's book, it came with a palette of six quality watercolors and a brush and helpful tips and blank pages to paint. BS placed it down in front of MAD on the kitchen table purposefully, perhaps in an unstated apology, and he began to work.

In Los Angeles, recognizing how crude a beginner he was, BS signed up for classes at the Brentwood Art School and found a significant teacher, Barbara Ashton, there. Barbara insisted all students have lunch together. This man who was such a private person — one who had found solace and inspiration in an attic alone — was forever the only guy in the classes. He would sit and join them, and as soon as possible he'd retreat to his car and finish his sandwich.

In the beginning he was completely frustrated with both his skill — or lack of it — and his speed — and lack of it. He was very slow, hamstrung by his need of dexterity, woefully so, and was ready to give up. He contacted Barbara and asked for help, some private lessons, something Barbara didn't do. But BS was driven, competitive — competitive with himself — and he painted as much on his own as he did in class. He attacked the medium he was drawn to, watercolors, with the dedication of a job. An artist at work. He would bring a pile of paintings to Barbara

at her home, and she would critique and help in what turned into a series of private tutorials. Suddenly, BS went from novice to high quality with tremendous rapidity.

He turned his desk into a painter's place. Then he spilled onto other tables, and any other available surfaces until MAD jokingly — partly jokingly — exclaimed there was none left alone or untouched in the house. Then he established a mini-studio above the garage into what they came to call The Boathouse. It was finely and simply transformed, New England style, with its own entrance, shapeliness, and high clerestory. Winslow Homer never had it so good.

In the mornings, first thing every day, he was there. Seven days a week. Like a shot.

He did homework, gathered up books — oversized lead weights everywhere — went to exhibitions, did exercises — pencil sketches, gouache, and Japanese washes. He studied artists — Sargent, Nicolas de Staël, the Nova Scotian Tom Ward, Joachim Sorolla, Wyeth, and always Homer, Homer, Homer.

He could look at images of other artists with a more experienced and ever-keener eye, trying to figure out how he or she did that. He spent hours working gray, black, and brown tones, experimenting with neutrals. He sketched and drew rocks, working on their shapes and shadows. How to distinguish them. He loved architectural paintings, houses and especially barns. He played a lot with clouds.

And most of all there was the sea. He had lived near it, seen it from the attic, sailed boats on it off of Connecticut, and now he painted it. The sea, he learned, was infused with his main bent, light and color, color and light. How in a single wave there might be an extraordinary mix of 22 colors.

He learned materials, the variety and expense of brushes, his need of

rulers. He learned what paper worked best for him, and how difficult it was sometimes to obtain. He knew it was vulnerable, it could get too wet, it could wrinkle and crumple to the point where a car driving over it wouldn't level it out. He played with Kleenex® and Bounty® paper towels for rubbing and blotting, drying and flattening. He took to always having a hair dryer at the ready.

He came to know it was important to rehearse, practice the challenges and difficulties in the next watercolor he planned to do. He studied and snapped photographs, loved going to a site, however rugged, but he was not a plein air painter. He liked being alone with music in his studio. Most of all the score to the movie *Finding Neverland*, though once in a while he'd fall back to a football game in the background around him.

BS left his past lives behind. He turned the page into this new profound one. Art took him over. This wasn't a hobby. It was his new full-time, enjoyed, and passionate job. Eight hours a day. And at the end of each day began a ritual. BS would bring his latest work in progress, whatever its state, back to the house, and set it up on a stand and the bar was opened. With MAD then — and cocktails — it was to be talked about. BS seeking MAD's advice, not just her thoughts. She was his invaluable muse, her suggestions closely listened to and needed, whether taken or not.

In so many ways he was an easy-going man yet he pursued his watercolors with complete discipline. Absolute focus. Every day he felt he was learning, and every day he wanted that experience.

With the first painting he felt worthy — a watercolor of a single rose in 2004 — he began completing 40 pieces a year. When he traveled the work went with him. He would pack a minute bag with a couple of shirts and underwear, and place right next to it in the trunk of his car or carry with him onto a plane several portable portfolios that held his paintings. Anything else was shipped separately.

Then everything changed.

On a Friday afternoon in 2011, he left me a message, an unusual thing, and I unusually tracked him down at home. "Hold on," MAD said, "he wants to talk to you." He was taking down the flag that hung outside their house as dusk fell. After a minute he came on and told me he'd been diagnosed with cancer. There was little embroidery, no indulged emotion. Simple, direct, moving, without asking for an iota.

BS said, "I've been so lucky all my life. I've been waiting for the card to turn over. I guess now it has."

It was a rare, aggressive form of bladder cancer. Second and third opinions only confirmed the prognosis. Whatever treatment was attempted, the forecast was terminal.

With MAD, they searched for doctors, and started a program of daring and eventually experimental infusions. They were debilitating. They stopped much of the rest of his life; they didn't stop his painting. He kept on, even painted in the hospital. One, a still life, a white bowl with fruit. The bowl was in the room, MAD he sent to the cafeteria for the apples and bananas. This watercolor was different than any he had done before. It was a big, juicy, vivid explosion of color. It was so striking, MAD insisted he sign it — over his reluctance — not only with his signature, but where and when he painted it.

Every day as the cancer came and went — or rather attacked and retreated before attacking again — BS went to his studio above the garage and painted. What had become his full-time job became his life. He went on accomplishing still as many as 40 paintings a year and outliving any and all prognostications.

"When I paint," he said, "I don't have cancer."

BRANDON STODDARD, *APRÉS MIDI TO TANCOOK*, 2010

A year after his diagnosis, on a night he called the most vulnerable of his life — and maybe most satisfying — BS hosted a celebration of his work at a Bergamont Station gallery. He had to sit in a chair, but his paintings filled four rooms with his sense of color and command, humor and whimsy.

When the cancer seemed to pause or stall — in those "good" times — we had lunch. Sometimes they had to be postponed, and postponed again, but when we met he didn't talk about his illness. I would ask, and he would turn around my questions with masterful skill and ask about me. He wore a ball cap and would eat carefully and well, if not a lot, and the meal would be bright but quick, as if there was only a certain amount of energy he could summon — until the next call, the next re-schedule, the next sit down, the next quick bright meal, the next masterful turnaround of questions.

This was our ritual. Two New Englanders coming together and leaving so much between the lines.

There was an emotional surge to his watercolors even as he weakened. He still painted houses and barns and still lifes, especially flowers, but more and more there was a return to the sea. The sea the boy had seen and sailed. The sea that was alive. The sea that was fierce, surging in storm, a nor'easter ready to eat one alive.

As time passed, it became harder at the end of each day for BS, exhausted, to return from painting. He would call MAD now, and she would come and they would make their way back up the stairs to the house together, she holding him, he holding the day's or week's or month's work, in whatever state it was, to set on the stand to be talked about with a cocktail.

The hardest day came when they returned from treatment and realized BS could no longer walk. Within days he was bedridden. To take better care of him then, MAD moved him into his studio, The Boathouse, where he lay surrounded by his paintings. His final watercolor — white gardenias rich with roses, and daringly impressionistic — was close by.

And at the last, before coma came, BS pulled MAD down to him and looked around at his work and up to his wife, partner and muse and whispered:

"More."

A MONTANA STORY

BLACK BUTTE – FIRST LIGHT, 2014

Before his senior year in college, my son Jake decided to take his car back to school and drive it across the country from California. He had switched majors from pre-med to English and was gripped by a desire to teach and to become a writer. I suggested I join him — an adventure, a trek, a father and son together — he acceded, less than thrilled I suspect, but insisted he start alone. He set off, moving fast, and days later I flew to Hailey, Idaho, to meet and travel east with him.

It turned out to be among the most stirring experiences of my life, and led by the most salubrious providence to a profound change in how and where I lived.

Jake and I visited Ernest Hemingway's grave in Ketchum, Idaho, where he lay beneath two pines and under a broad, flat, smooth, life-size chunk of granite. A pitch of pennies scattered across it. We spent the night nearby and the next day drove through the lunar landscape of the Craters of the Moon National Monument. The shapes of the lava were crude and sinuous and the wind picked up and zithered through them.

We realized we were running out of gas and daylight as we climbed the switchbacking, and still snow-covered Beartooth Highway. After sputtering to the top, fearing and facing empty, we coasted down in the dark into Red Lodge, Montana and had dinner. I had a drink and fresh fish, and then at Jake's behest we kept going toward Billings, only to survive careening off the road at 80 miles an hour to avoid a deer. We ended up in a ditch, the engine savaged, and saved perhaps by a barbed wire fence that raked and tattooed the side of Jake's car and yet stopped us from having an intimate and fatal relationship with a tree. We were lucky.

We discovered we were by no means the first. Not more than a few miles from where we landed, Ernest Hemingway and John Dos Passos had experienced a similar fate on their way to Billings 70 years earlier in November 1930. With Hemingway driving, the two writers had spun off the road, their car overturning. The crash sent Hemingway with a compound spiral fracture of his right arm, his writing hand, into St. Vincent Hospital for more than six weeks. A Billings man, Earl Snook, befriended Hemingway while he was in the hospital, his arm bound with kangaroo tendon to heal, and provided the patient with pheasants and ducks to eat, and smuggled in (to quote a Hemingway inscription in a book he gave to Snook) "Red Lodge's finest product," otherwise known as bootleg booze.

Jake's car was in triage less than Hemingway's six weeks, but still four or five days. We spent them tooling about in a rental, circling back to Red Lodge, journeying south to Cody, east to Billings, north past some tiny town called Roscoe. We had lunch there at what seemed to be a landmark, the Grizzly Bar, on our way then northwest to Livingston

where one of the jokes about Montana might well be true: throw a rock and hit a writer. We returned to Red Lodge, which had been a mining center close to a century before. Lots of money and men and brothels then, but that time was over. There was skiing now, especially spring skiing, a large number of restaurants, and the proximity to Yellowstone National Park. And maybe 2,000 people.

It was after Labor Day in the year 2001, warm days and crisp nights, the leaves touched with the first nips of fall, the aspens scented with yellow like a touch of vermouth in a martini. For me it was a fine time.

When Jake's car was stitched back together and repaired — no small task — we began again. We left the mountains, skirted Little Big Horn, and started across the flattening plains that led to the Midwest and carried across five states toward the East Coast. Days later, sadly, on September 10th, I had to leave him and fly back west to California.

By that time I owned several paintings by Charles Burchfield. My inquiries about him had raised the attention of the Burchfield Penney Art Center in Buffalo, New York, and within a year or two they asked me to serve on an advisory board. Privileged to do so, I arrived to attend meetings, landing as rain ended and the skies cleared. It was the first time I had ever been in Buffalo, a city that a century before had been the tenth largest in the nation and now was struggling to remain among the top 100. Two assistants I had offered evidence of that plunge: their entire goal in life, successfully achieved, had been to get out of Buffalo. Escape.

It was hard to believe a desire to leave that day. A city famous for bad weather and long and frigid winters broke out its spring wardrobe. The hefty cumulus clouds were heaving, rolling and tumbling; they kept changing shapes as they separated, pulled apart and then slid away. The sun emerged. The sky converted to peerless blue. The grass lit up into an eye-popping shade and was bejeweled with dandelions as big as ping-pong balls right out of a late great Burchfield painting, *Dandelion Seed Heads and the Moon.*

At the end of the day there was a cocktail reception. The sun was falling and the light had softened. A yellow sheen lay across the world. The landscape was the shade of corn silk. I had a drink, a martini, and found myself talking to a tall handsome woman. Her name was Paula Joy; she lived in Buffalo, and was heading the drive to build a larger space for the Burchfield Center, a real museum.

I don't remember exactly how or why, but the conversation turned away from Burchfield and Buffalo. Paula began to talk about her family. Her father had retired and her mother wasn't well and they were downsizing. They were selling the jet.

By now I had incorporated a second martini into my life and I responded as we all would: "It's true. We all come to that place where we have to sell the jet. Or at least one of them. Are we talking here about the big jet or the little jet?"

Paula laughed, perhaps legitimately. "And we're selling our place in Montana."

"Where in Montana?" I asked.

"It's in a place no one's ever heard of," she said.

"Try me," I said.

"It's near the town called Red Lodge," she said.

"Really," I said, using the word for the first but by no means the last time. "I know Red Lodge. What is the house like?"

"Well, it's a hand-cut log cabin."

"Really," I said. "How big is it?"

"The living room is two stories high and has a two-story stone fireplace."

"Really," I said again, unable to stop repeating myself, seemingly

reduced to such a dazzling word — and I was supposed to make a living by, among other things, writing good dialogue. "Is there anything else?"

"The master bedroom is the original homesteader's cabin built in the 1880s."

"Really," I said pathetically, unable to help myself. "Is there anything else? Any land?"

"I think it's on like 35 acres."

"Really." It turned out to be in the range of 55.

"And protected by national forest and wildlife preserve."

"Okay, okay," I said at last coming up with a new phrase. "But it's not near a river and fishing, is it?"

"Actually, it's on a bend in a river," Paula said. "Seven kinds of trout."

So I said, as anyone would, "Can I buy it right here at the table?"

Paula laughed, thinking martinis, I'm sure, but jotted down her father's phone number.

A few days later, back in L.A., I couldn't resist. I called Paul Joy. He was refreshing to talk to, and forthright about the house, what he was proud of and what needed work or repair that he was going to do before any escrow might close. He seemed honest and honorable, a gentleman, an attraction in itself, and turned out to be exactly so, and an extraordinarily successful man. Los Angeles, where I lived, was infamous for craven and disreputable real estate behavior. Have a leak in the roof and, if it ever rained, the broker would likely herald it: "Look, for only an extra $500,000, a special added attraction — a waterfall in your living room!"

Not long after, checking the Internet, I found pictures, and a few weeks later on a Saturday morning I called the realtor handling the property in Red Lodge. I told him I was considering making an offer. The realtor, an exceptionally tall, lean, ex-hockey player named Jim Kadous, suggested I

come look at the house. A little difficult I said. When I told him where I lived, Jim Kadous wasn't particularly thrown. He also wasn't impressed. Anything but. He quickly added a caution: Hollywood had come before to Montana. Famous celebrities were splashed here and there, and right then there was a very hot and wealthy development in Big Sky. Red Lodge was different. It was off the beaten path; it was its own. Kadous felt the house was special and worth the price. Long term it would do well, but don't make an offer or buy to make a killing.

There was an offer already in, another was expected, and the next thing I knew I had also made one, and then I was in escrow without ever having been to the house.

I didn't know then that my offer might not have been the highest. When Jim Kadous called and presented the offers, Paul Joy responded, "Wait a minute, I spoke to that fellow. Liked him. Let's do that." For even longer, I didn't know that flattering version was incomplete. It wasn't so much me in fact that impressed Paul; rather it was that I had sent Jake, by now living in Missoula, Montana, the several hundred miles to check out the property and give me his opinion even before I could get there. That's what Paul Joy really liked: the fact that my son had come.

The closing was subject to my seeing it and approving, and I flew up to Billings and drove over to Red Lodge. It was a scorching hot afternoon, most unusual, and I was unsure. At Jim Kadous' suggestion, at dawn the next morning, I drove with him past the Grizzly Bar in Roscoe and down the dirt road to take another look, see the house a second time, and walk the roughly 55 acres of property.

The house was waiting for the sun. Vapor shimmied above the river. Across it stood Black Butte at 8,350 feet, a sharp, stark, beautiful brute. Even before the house, the sun found the crest of Black Butte with a pale rose blush. The color crept down the mountain, brightening and transforming as it did. The land and the river burnished into a deep, shining, and lustrous copper. And when the sun struck the house, its log sides bronzed.

I was taken neat.

BLACK BUTTE – COPPERTOP, 2004

We walked up onto a rise overlooking the river and Black Butte and the land that lay back to the east. Away from the mountain, it folded into the distance in levels and layers that seemed to come equally from Constable and Cézanne as Remington or Russell.

The house had a satellite dish that still remains idle, but I've taken to bringing DVDs to watch, including a selection of westerns. One was *Shane,* the movie George Stevens expanded from the barely 100-page, poetically-wrought, western novel I had gulped down when I was 10 years old, and shot it against the sharp, stark Grand Tetons in Wyoming as backdrop. Another was Sam Peckinpah's *Ride the High Country,* a man I had met and a film I had first seen 40 years before. It had moved me then and it did once again. It has an elegiac ending, Joel McCrea asking to go it alone, dying, sliding to final rest and leaving a sharp, stark mountain

lingering in the frame behind him. The last thing he and we see.

The image was in no small remarkable way like Black Butte. I realized that the location that I helped imagine and build for the television series the writer Bill Broyles and I created was set likewise against a sharp, stark mountain. I realized that a John Marin painting, *White Mountains, Dixville Notch #2*, I was to buy and hang in my offices one after another in Los Angeles was a further sharp, stark shape.

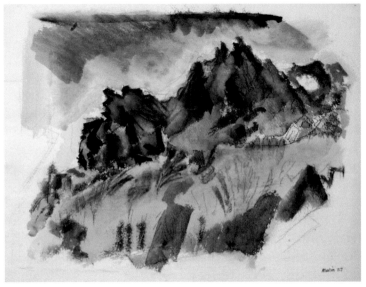

JOHN MARIN, *WHITE MOUNTAIN COUNTRY, SUMMER NO. 30, DIXVILLE NOTCH NO. 2*, 1927

I wondered if there were other such stark shapes lodged in other books or in my life, literal or not, and so deep that they were still yet unrecognized.

Beyond that, just in my interest in art, pieces I saw and loved or yearned to own early on earned a spot in the periodic table of my unconscious. They became hidden markers. As time went by — sometimes years and sometimes decades — a number came back into view. They appeared in exhibitions or they returned to the marketplace. Some had lost their luster. Others hadn't, and these seemed to shoulder an extra worthiness.

Some escaped again when they were for sale, but in two or three cases I found a way to capture them. Having them held an extra sweetness and even meaning.

These paintings bestow a lustrous connection across time, a deep tying-together triangulation of the walls of my house with the walls of my life.

I've come to know a significant thing about my and I suspect most of our lives. From childhood, or in the years shortly after, people, places and events we see and experience lodge in us and then we forget them. But we don't. Given the chance they find a way or place to revive and return, tie up one with another our hopes or dreams, our beginnings and our endings.

This may not be so deep or surprising, but it is true, and such offers an attempted shape and pattern to our existences. Even meaning. These are the tales we tell, our markers, these Montana stories, and the source and wellsprings of our mythologies.

WINDOWS

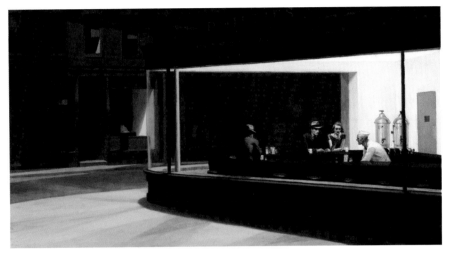

EDWARD HOPPER, *NIGHTHAWKS*, 1942

What one can see out in sunlight is always less
Interesting than what goes on behind a window pane.
In that black or luminous square life lives, life dreams,
Life suffers.

— Charles Baudelaire

IN THE SUMMERS WHEN I WAS YOUNG we played tennis. When we became teenagers and got better, it became competitive. Even more competitive. As we played then often to the edge of darkness and into it, we became aware of an even darker presence: my father through the screen in the dining room window where he could sit and watch. He still played golf then, but had largely given up tennis. He had not given up drink. He was there in a turned-around chair with glass after glass, and a low, marble-top side table that served as a bar only steps away.

We knew it when he was there, and we knew if he was, after we played, we would hear about what he had witnessed, good or bad. The more he drank, the more bad there was.

I don't remember now much of what he said, the specific criticisms, even invectives. What I remember is the sight of the window, the beat-up, patched screen that obscured him and made him a shadow, and perhaps a greater specter because of his all but invisibility.

When I think about tennis, when I infrequently step onto a court, when I think about then — I remember The Window.

I could probably say just that, those two words to my brothers and cousins, and they would know, and perhaps because of that, but not only that, I am drawn to paintings where there is exactly that. A window. Or windows.

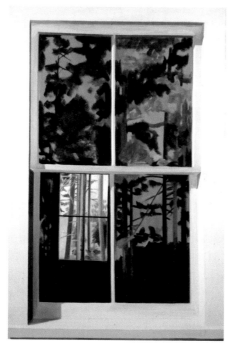

LOIS DODD, *VIEW THROUGH ELLIOT'S SHACK, LOOKING SOUTH*, 1971

Let me tell you what I do when I paint…
I draw a rectangle… which I consider an open window…

— Leon Battista Alberti

MARSDEN HARTLEY, *UNTITLED* (AKA *STILL LIFE*), 1919

There is no shortage of them in movies — just start with Hitchcock's *Rear Window*, such moving images as Barbara Stanwyck watching her daughter in *Stella Dallas*, Diane Keaton sighting snow in *The Family Stone* — and profoundly in art. Vermeer, of course, Matisse, Vuillard, Marsden Hartley, and Milton Avery to cherry-pick a few, and coming toward right now there's Roy Lichtenstein, Lois Dodd, Steve Mills, and Jack Vettriano. Again, these are no more than quick plucks out of a full hat.

Edward Hopper's paintings are rich with windows. They are intimately and intricately a part of his art. Unlike his friend Charles Burchfield, who could turn windows into facelike apparitions, the shapes touched with echoes of inviting or haunting emotions, Hopper did several things entirely else.

Amidst his most famous work — *Nighthawks*, *Chop Suey*, *Automat* — windows let us witness his isolated men and women, their silence and stillness. Windows are our way into their glassed worlds, and once in a while our only way out. Count the windows in Hopper houses and lighthouses. The numbers are not small or insignificant. In *Early Sunday Morning*, *House by the Railroad*, *Captain Upton's House* and *House at Dusk*,

the myriad windows are apprehended with considered fidelity. Clearly, they form a vital part of his planned composition; they are fundamental to the design.

EDWARD HOPPER, *AUTOMAT*, 1927

But study them and they begin to resist their own realism. Within their beauty is a sobriety that invites and forbids; they entice and repel. They conflate opposites, and ensnare uneasy sensations, a knottiness that won't untie. They remain, finally, what is a measure of the wonder of art, beyond complete explanation or decipher. Fathomless and inexplicable.

EDWARD HOPPER, *ROOM IN BROOKLYN*, 1932

In Hopper's late paintings, there is a severe consciousness of space. Windows increasingly reveal only a single figure, or none at all. A window, glaring light, and an empty room — the window the sole concession to a world stripped bare. They fulfill Hopper's confession, "Maybe I'm not very human... what I wanted was to paint sunlight on the side of a house."

EDWARD HOPPER, *SUN IN AN EMPTY ROOM*, 1963

Then there is Andrew Wyeth. Windows are even more his domain. They play plentifully and imperatively across his thousands of works. The rendering of houses in Maine or around Chadds Ford is critical to his art. In more than many — over 300 watercolors and temperas — there are windows, often multiple windows, some blank, some that reflect, some that you can see in, some you can see through to a second window and out.

Certainly his interest rose from the places where he lived and the places he knew, its Shaker style and clapboard architecture, a sense he shared with Hopper and his fellow Pennsylvanian Charles Sheeler — in both Sheeler's brilliantly chilly, precise photographs and paintings.

However, Wyeth's repeated use and invocation of the window burrows deeper.

They trace back by his own admission to his father N. C. Wyeth's death in a car stalled on the railroad tracks in 1945. The death has never been fully explained — a grandfather driving a grandson, both dying — did the car stall? Couldn't N. C. Wyeth have somehow escaped? At least saved the young boy? Could it have been a heart attack? A suicide? What finally and exactly happened? The accident remained a "terrible actuality" with questions never answered and ones that never will be.

ANDREW WYETH, *WIND FROM THE SEA*, 1947

A car, railroad tracks, a train coming — Wyeth never expressly painted the scene, but in the wake of the tragedy he was increasingly drawn to the poems of Robert Frost and Frost's own casualty list of grief and loss. The two men, though different generations, came to know each other, and Wyeth was asked to paint Frost's portrait. Haven't I done so already many times, he said, referring to his sense that there existed a profound kinship between his paintings and Frost's poems. Wyeth's sentiment was not one-sided. Frost befriended Charles Morgan, the owner of the Wyeth painting *Wind From the Sea*. The aging poet when invited to dinner would only sit where he was in front of the painting.

There is something of the splendid English painter John Constable in Wyeth's work, and how Constable rendered landscapes with extraordinary apparent fidelity. Wyeth admired Constable beyond his canvases. He believed, as Constable said, "that you never have to add life to a scene,

for if you quietly sit and wait, life will come — sort of an accident in the right spot."

Wyeth's unparalled representational skill turned into an achievement as often faulted as lauded in a time where modernism and then abstract expressionism shook the foundations of art far from realism. Still in certain Wyeth's paintings, as in telltale Frost poems, there is at play an additonal ingredient — what Wanda Corn called "metaphorical realism." Wyeth infused an emotional dimension into his superb rendering of the simplest of objects. Like Hemingway, in his early best short stories, he found the way to leave meanings in by leaving them out.

ANDREW WYETH, *GERANIUMS*, 1960

In *Geraniums*, a painting Wyeth kept while he was alive, a window allows us to see both a looking in and a looking out. It's laced with mystery. In the dark interior sits the shape of a woman, his model Christina, half turned away, not much more than a silhouette. Practically a wraith. Shadowy yet erotic. And is that a mirror she is looking into as we look into her? And beyond her lies the second window splashed with the light of the world beyond and outside, and as alluring and elliptical as she is in the dark.

Wyeth's paintings also offer the reverse. Our perspective is inside looking out, a man beside a window, or a woman laying on a bed, naked or not, with a window beyond her. Several are just windows, with a windblown curtain, or antlers or slickers above or beside. One painting

is set inside the window frame, the pane shoved open in Wyeth's words to the "tawny feel of winter" outside. Wyeth titled the picture, not without design, *Love in the Afternoon*.

In our lives as well as in art, windows offer a seeing in and a seeing out. An outsider looking in, wanting in; an insider looking out, wanting out. They join with voyeurism, and its coupling with fantasy and its flipside longing. For in such seeing is wrapped what we like and want, what we feel, and who we are. In the seeing can be the glimpse in all the weathered beauty of land, or leaves, or wind, or rain, or the sea.

What Robert Henri, mentor and influence to both Hopper and Wyeth, called "a look into time and space... and what we seek is not the moment alone."

What we seek is a window into our own lives, all that we have lived, what it means, and what we still have to live.

I realized then that I was not alone, and the paintings that drew me came not solely from my father behind the screen, and not only from a single memory or image. There were markers that cast colors across the crayon box of my life, light as well as dark. A full box laid deep with wish and wonder that tied back sharply, achingly or gratefully into the haves and have nots, and into a vision of what I once saw, or wanted or desired to see:

— the sight of the home I loved, arriving after dark, lamps aglow, the living room awash with amber light.
— the sight of my daughter Jacy as a child at play with her dolls and stuffed animals in the big window seat with drawers underneath we built for her.
— the sight of the girl at a beach house, brushing her hair, turning to see me watching her, and mockingly posing before sticking her tongue out at me.
— the sight of my son Jake as a boy perched atop the bluff overlooking Cape Cod Bay, mesmerized and memorizing by the comings and goings of boats.

— the sight of a woman I loved, and had now lost, driving away a final time, the allure still alive through the windshield and the glass and all that it reflected and obscured, offered and hid, already wired tight with grief's bankruptcy.

— the sight of a storm rolling in, the first pellets of rain pinging on the window, sitting up and splintering on the pane in the miniature shape of the stars in the Pleiades.

— the sight of my younger son Riley in the yard amidst a scatter of rocks, unknowingly in the footsteps of his older brother, walking and talking to himself, and spinning an "imagination."

And to one that rose out of fantasy and reality and joined them together, and changed my life.

A decade ago, my life in some disarray, I contributed to a book called *Doing It For Money*, 40-some writers carrying on about "the agony and ecstasy" of working in Hollywood. Among a few others, I was asked to come and read my piece on NPR and be interviewed. It was first thing in the morning in Santa Monica, and as I walked up to the front door I saw a shape through the tinted glass as shadowy as the woman in Andrew Wyeth's "Geraniums." Impossible to decipher much except for cowboy boots. Less murky somehow, red cowboy boots.

Minutes later, sequestered in a broadcast booth, reading my piece on air, there she and they were through a darker, smokier, shaded glass window. An even greater mystery, watching me, whatever she thought cloaked and hidden beyond seeing.

These red boots through The Window belonged to a tall — very tall in boots, and later in heels — woman with long auburn and mahogany hair, that day in a long skirt that hid impossibly long legs, and an age- and logic-defying figure. Afterwards, we met and talked on the way back to the parking lot and our cars, a conversation full of enjoyable disagreement and laughter that continues unabated.

Months later, together, the tables were turned. Claudia and I were glimpsed in embarrassing circumstances through a Window. The witnesses caught us in the midst of an argument that threatened to bear down and break wide open the new relationship. Unfairly, Claudia arrived to meet me in a short white dress made of some petroleum product that couldn't decide whether to retreat first from top down or bottom up. She said we needed to talk. We sat in two green leather chairs in a small room facing each other. Her charges, legitimate or not, set me bristling. The "talk" quickly grew into Virginia Woolf. Shivs drawn, rationality tossed, decibels trebling, sanity headed overboard.

There was a sound then on the wooden deck outside. It made little sense, it was a clatter. Not shoes, more like hooves. Exactly what it was. In mid-sentence and mid-shout, we stopped and turned to come upon two deer staring in the open Window at us. They cocked their heads in bafflement at the two squabbling humans, certainly wondering, *"What the hell are you two doing?"*

Claudia and I turned back, looked at each other, and could only laugh. They shut us up. The argument ceased to exist. It wasn't just over, it was gone. The deer moved on and we rose up from the two green chairs, and I took the woman in the desperately daring, wanting-to-shrink petroleum product out to a transcendentally pleasurable dinner.

STEVE MILLS, *THE OLD SHED*, 1998

I have looked through windows and been looked at through them. The windows that fascinate me in life and in art aren't, of course, only literal windows. They are about seeing into another place, another world — an artist's, a friend's, a lover's — their art and their lives, only to discover how it circles back upon me into what I love. And isn't that true for all of us?

The sight and story I see, and the chapters that unfold for me in the seeing, and the seeing, and the seeing.

Count the windows in the paintings I've been lucky enough to own and there are equally no few. I've stood in awe in a window in the dying light with the famous dealer John Gordon. I've told about the luminous and lovely, if sad connection with the little George L.K. Morris painting titled *New York Window, Number 2*. I've written about Charles Burchfield, his paintings that have kept me such company, if not about the windows they wear like badges, and often are as fundamental to his work as his left-handed brush. I look now at another joining them, magically snow blown, the houses and windows ghosts amidst the clash of sun and storm. I haven't even written about the terminally unhappy, brilliantly driven colorist Oscar Bluemner and his blank, black windows, or more about Davis Cone, the windows in his lustrously lit movie theatres, or the California post art deco painter R. Kenton Nelson, or a monumental work by the contemporary artist Christian Vincent, or the gold leaf on board surrounding Robert Ginder's bungalows and windows. I haven't...

More Windows.

Isn't that what all paintings are finally after all, on our walls or not, framed or not? Isn't that what art gifts?

Windows.

THE END OF SOMETHING

*There are moments in our lives, there are moments
in a day, when we seem to see beyond the usual. Such
are the moments of our greatest happiness. Such are
the moments of our greatest wisdom.*

— Robert Henri

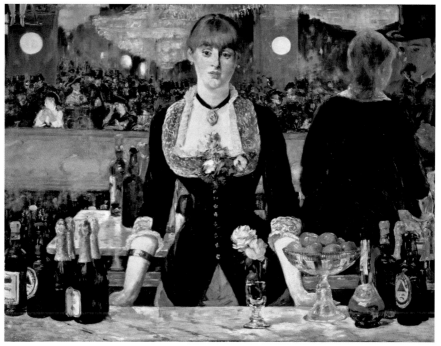

EDOUARD MANET, *A BAR AT THE FOLIES-BERGÈRE*, 1882

I THINK NOW AND AGAIN, IN FACT QUITE OFTEN, ABOUT BEAUTY. The word itself and the way it is configured, a long first syllable and a short sharp second. It can be snapped out (consider Cary Grant delivering "Beauty, beauty, beauty!" à la "Judy, Judy, Judy"), or it can roll from the tongue with languor (say Orson Welles or John Huston saying it, not to mention Everett Dirksen or William F. Buckley). The thesaurus comes

up with "loveliness" and "splendor." They are synonyms of a sort and fine words, but not what it is or what makes it or what it does to us.

I am at a loss finally.

I know it is about a specific subjective response to a woman, a painting, a leaf, a hamburger. I know it is tied up in our wiring to our eye and connected to our taste and I suspect our loins and in the best and deepest instances to the experiences or expectations of our hearts.

I know it can be in the instantaneous moment — a human face I saw last night, a black woman in profile at sunset, hair tied back, the lines of her face, the colors of the haloed light — and then it is gone. I know too, it can be an infinite moment — a sight or scene that will remain with me all my life, as alive now as then, as alive as if painted on canvas by Robert Henri or Goya or Velázquez, paintings still alive a hundred years or a thousand.

In searching and falling short of a definition, I turn sometimes finally to another word.

In an old movie, a western, the actor Cliff Robertson, playing Cole Younger, gets sidetracked on his way to rob the infamous Northfield, Minnesota bank. He happens upon a baseball game. He is witness to a contest in its earliest days, this time played amidst gobs of mud. The first baseball he has ever seen. The only baseball. He ganders at the spectacle, wide-eyed. If more playful, his gaze is not unlike F. Scott Fitzgerald's incantation as Jay Gatsby peers across the Long Island Sound from West to East Egg and Daisy Fay's house, a glimpse like the first sighting of the:

> *fresh, green breast of the new world… [that] for a transitory enchanted moment man must have held his breath in the presence of this continent, compelled into an aesthetic contemplation, he neither understood nor desired, face to face for the last time in history with something commensurate to his capacity for wonder.*

In awe Robertson bequeaths: *"It's a wonderment. A wonderment!"*

For me perhaps that word captures as well as any that feeling, that first and lasting magic, and serves as good a definition for beauty as any fancy or elaborate one I've read or could attempt to spin.

I'm older now, and more settled down than once. My most robust collecting days are behind me, largely over. Along that peripatetic journey I've made mistakes. Errors. Foolish, stupid, and bewildering ones. I've bargained well and I've bargained badly. I've bid too high, bid too low, not bid at all when no else did because no one else did.

But I've been lucky. No Turners or Homers or van Goghs. No Vermeers. Still, I have borrowed for a time for my walls, my home, and my life the paintings of artists whom I admire and they have never stopped exciting or feeding me with their enduring and ongoing challenge to capture the magic of the world — abstract or not — in all its weather and wildness in nature or in the human face and form.

I will sell them. More accurately, they will leave me, like moving on from a long or short sojourn at one more hotel that began before and will continue beyond me. I was a blessed way station.

When they are gone I will be left with their images in my memory. As I gain years, memory gets more forgetful yet simultaneously oddly and oxymoronically deeper and richer. It scratches out and uncovers small and large tidbits that I thought were gone. That I didn't even know I ever had. I possess their revenants, or perhaps they possess me. They will come and go, not unlike how my daughter Jacy described Mark Rothko's paintings: an ongoing force of my infinite moments changing weather even in their absence.

I think now about a most recent day when I happened to be in London. I had little time, had been wickedly sick — whether from food poisoning or some 24-hour bout of flu — but with my adored second wife Claudia,

still weak, I rushed through the rain and oncoming night to reach the Courtauld Institute before closing. We just made it. It was a bookending return for me, close to 40 years after my original visit.

So there I was again with what a single man a century ago had gathered around him. The Seurats, Renoirs, van Gogh's bandaged ear, and especially the exceptional collection of Cézannes.

But I found myself finally, as the guards warned us of waning minutes with Edouard Manet's *A Bar at the Folies-Bergère*. It is, of course, famous, justifiably so: the barmaid serving, her expression as enigmatic as the Mona Lisa, with the great long widescreen mirror behind her, and the man she must be but seems not to be serving. The more you study it, the more it unveils a dislocation and distortion of experience, our normal and perceived reality. It's endlessly captivating and mysterious in its details, its particulars and perspective, and in the unanswered questions it insists. To look at it is to see and see anew. I could study it forever and still marvel. It is a monumental work of art.

A Wonderment.

I realize in this moment, standing in the light of its elusive allure and brilliance, that for all I've learned I am as fresh and new as the young man who wandered likewise — closing in on five decades ago — into the basement of the Montclair Art Museum. I'm in thrall beyond whatever I've bought or sold, wanted or gained, or lost.

It hasn't ended, won't. In whatever time I have left, and less and less and finally nothing to do with such as collecting, I've just begun.

ACKNOWLEDGMENTS

To the artists mentioned and not who so graciously allowed me into their studios and their lives to see and to learn, and especially to those who permitted me to talk about and illustrate their works.

To those in the art world who have offered me an education, advice, counsel, and friendship through years and decades, including Warren and Jan Adelson, Meredith Ward, Debra Wieder, Bob and Cheryl Fishko, Katherine Degn, Bridget Moore, Martha Fleischman, Liz Sterling, Margot Chvatal, Peter Kloman, Chloe Richfield Heins, Lou Salerno, Lauren Bender, Terry Martin, and Bernard Goldberg.

To Johnny Jensen for his camera and his eye, and always the sharing of spirits.

To Melissa and Carole Fitzgerald and the Pennsylvania Academy of Fine Arts, the Frelinghuysen Morris House and Studio, the Andrew Wyeth Foundation, the Alexandre Gallery, and Peter, Jennifer, Fernanda, Anita, Aimee, Sonia, Barbara, Kyle, Steve and Rafael for their assistance and permissions.

To the Burchfield Penney Center, the invaluable Nancy Weekly, Tullis Johnson, Scott Propeack, Carol Kociela, and all those who work there and champion American Art and that of Western New York.

To John Robb, Kitty Robinson, James Young, and the members of my family always for their love, support, and forbearance for my many journeys that took me to places and people often away from home.

To Jeannette Penick, and her father, Sydnor Barksdale Penick, Jr., for their loving sharing of their own interest in art that allowed me to discover and nourish the beginning of my own — and to put up with such an obsession.

To Shea Farrell, Dave Shulman, Lisa Helms, Kara Kenna, the challenged designers and proofreaders, and all those at Tallfellow Press, so much wrapped in so few.

And to Jonathan Galassi, for his words, and much more.

Frontispiece	Charles E. Burchfield (1893–1967). *Moonlight in the Flower Garden*, 1961, watercolor and charcoal on joined paper, 48 x 30 in., Private Collection, Courtesy of the Charles E. Burchfield Foundation
Prologue	Cézanne, Paul (1839–1906). *The Pipe Smoker*, 1890, oil on canvas, 35.4 x 28.3 in. (90 x 72 cm), Hermitage, St. Petersburg, Russia, Photo Credit: Scala/Art Resource, NY
The Beginning	Margaret Young (1943–2005). *Portrait of JSY*, 1955, Pastel, 18 x 14 in., Photo Credit: Jake Young
Paterson	*The Great Falls in Paterson, New Jersey,* Photo Credit: ©gary718/123RF
	The Great Falls of the Passaic River and Hydro Power Station in HDR, Photo Credit: ©Christopher Fell/123RF
	The Great Falls of the Passaic River, Photo Credit: ©Mihai Andritoiu/123RF
	Demuth, Charles (1883–1935). *The Figure 5 in Gold*, 1928, Oil on cardboard, 35 1/2 x 30 in. (90.2 x 76.2 cm), Alfred Stieglitz Collection, 1949 (49.59.1), The Metropolitan Museum of Art, New York, NY, USA, Image copyright ©The Metropolitan Museum of Art, Image source: Art Resource, NY
Mentors	Cézanne, Paul (1839–1906). *Still Life with pots and fruit*, 1890-4, Private Collection, Photo Credit: The Art Archive at Art Resource, NY
	JR Meeker. *Adirondacks*, 1873, Oil on Burlap canvas, 10 3/4 x 24 in., Photo Credit: Johnny Jensen
	Atelier Cézanne, Courtesy of AUCP-Leblog.com, France
	Cézanne, Paul (1839–1906). *Mont Sainte-Victoire, seen from Les Lauves*, 1902–1906, Oil on canvas, 25 1/8 x 32 1/8 in. (63.82 x 81.6 cm), Nelson Atkins Museum of Art, Kansas City, MS, U.S.A., Erich Lessing/Art Resource, NY
The Trunk Sale	George L. K. Morris. *New York Window #2*, 1935, Watercolor on paper, 16 3/4 x 13 1/4 in., ©Frelinghuysen Morris Foundation, Lenox, Massachusetts
Hal, the Artist	Gogh, Vincent van (1853–1890). *Letter to John Peter Russell*, Late June 1888, Reed pen and ink on wove paper, 8 x 10 3/8 in. (20.3 x 26.3 cm), Thannhauser Collection, Gift, Justin K. Thannhauser, 1978. 78.2514.19, The Solomon R. Guggenheim Museum, New York, NY, U.S.A., Photo Credit: The Solomon R. Guggenheim Foundation/Art Resource, NY
A California Story	Diebenkorn, Richard (1922–1993). *Ocean Park #79*, 1975, Oil and charcoal on canvas, 93 x 81 in. (236.2 x 205.7 cm), Estate #1495, ©The Richard Diebenkorn Foundation
	Diebenkorn, Richard (1922–1993). *Ocean Park #70*, 1974, Oil and charcoal on canvas, 93 x 81 3/8 in. (236.2 x 206.7 cm) Estate #1486, ©The Richard Diebenkorn Foundation
	Diebenkorn, Richard (1922–1993). *Ocean Park #140*, 1985, Oil on canvas, 100 x 81 in. (254 x 205.7 cm), Estate #1570, ©The Richard Diebenkorn Foundation

ILLUSTRATION CREDITS

The Weatherman *Gordon's World*, Photo credit: Johnny Jensen

Gertrude Gertrude Young (1862–1930). *Afternoon Clouds*, 1929, oil on canvas, 31 x 23 1/2 in., from the collection of John Robb, Photo Credit: Justin Hyde

Gertrude Young (1862–1930). *Desert Bloom*, 1927, oil on canvas, 20 x 16 in., Photo Credit: Johnny Jensen

Photo of Gertrude Young painting, Original photographer unknown, Photo Credit: Johnny Jensen

Storytelling Norman Rockwell. *Shuffleton's Barbershop*, 1950, oil on canvas, 46 1/4 x 43 in., Norman Rockwell Museum Digital Collections, Printed by permission of the Norman Rockwell Family Agency Copyright ©the Norman Rockwell Family Entities

Norman Rockwell. *Breaking Home Ties* (final), 1954, oil on canvas, 44 x 44 in. (H 111.8 W 111.8cm), Norman Rockwell Museum Digital Collections, Printed by permission of the Norman Rockwell Family Agency Copyright ©the Norman Rockwell Family Entities

Norman Rockwell. *Breaking Home Ties* (study), 1954, oil on photograph laid down on board, 11 1/4 x 10 1/4, Norman Rockwell Museum Digital Collections, Printed by permission of the Norman Rockwell Family Agency Copyright ©the Norman Rockwell Family Entities

Realism Robert Cottingham. *ART*, 1992, color lithograph on paper, 45 3/4 x 45 3/4 in., ©Robert Cottingham, courtesy of Forum Gallery, New York, NY, Edition of 15 Artist Proofs

Davis Cone. *The Glen*, 1988, Acrylic on Canvas, 12 x 18 in., ©Davis Cone, Photo Credit: Johnny Jenson

Thomas Eakins. *Walt Whitman*, 1887–88, Oil on canvas, 30 1/8 x 24 1/4 in. (76.5 x 61.6 cm.), Acc. No.: 1917.1, Courtesy of the Pennsylvania Academy of the Fine Arts, Philadelphia, General Fund

Winslow Homer. *Fox Hunt*, 1893, Oil on Canvas, 38 x 68 1/2 in. (96.5 x 174.0 cm), Acc. No.: 1894.4, Courtesy of the Pennsylvania Academy of the Fine Arts, Philadelphia, Joseph E. Temple Fund

Johannes Vermeer. Dutch, (1632–1675). *A Lady at the Virginal with a Gentleman (The Music Lesson)*, c. 1662, Oil on canvas, 29.4 × 25.2 in. (74.6 cm × 64.1 cm), The Royal Collection, London, Photo Credit: The Royal Collection/HIP/Art Resource, NY

Light Carl Holsoe (1863–1935). *A Lady Reading in an Interior*, 1910, oil on canvas, 25 1/4 x 23 1/2 in., Private Collection

Johannes Vermeer. Dutch, (1632–1675). *Girl with the Red Hat*, c. 1665/1666, oil on panel, painted surface: 22.8 x 18 cm (9 x 7 1/16 in.), support: 23.2 x 18.1 cm (9 1/8 x 7 1/8 in.), framed: 40.3 x 35.6 x 4.4 cm (15 7/8 x 14 x 1 3/4 in.), Credit Andrew W. Mellon Collection, Courtesy National Gallery of Art, Washington

JSY. *Ash Fork, Arizona*, 1971, 6 1/2 x 9 1/2 in., Taken with Nikkormat camera using Kodak tri-x film, Photo Credit: Johnny Jensen

Museums and Women	*Tall*, Photo Credit: Tullis Johnson Elsie Driggs (1895–1992). *Pittsburgh*, 1927, Oil on canvas, 34 1/4 x 40 1/4 in. (87 x 102.2 cm), Whitney Museum of American Art, New York, gift of Gertrude Vanderbilt, Whitney 31.177, Digital Image ©Whitney Museum, N.Y. *Liz in the Dark*, Photo Credit: Tullis Johnson
Pieces of Glass	Charles E. Burchfield (1893–1967). *Sun and Snowstorm,* 1917, watercolor and gouache on joined paper laid down on board, 19 1/2 x 27 in., Private Collection, Courtesy of the Charles E. Burchfield Foundation John Marin (1870–1953). *Deer Isle, Stonington, Maine, No. 10*, 1924, watercolor, charcoal and pencil, 15 1/4 x 17 7/8 in., © 2015 Estate of John Marin/Artists Rights Society (ARS), New York Charles E. Burchfield (1893–1967). *Diamonds in the Snow, Christmas card variation of Winter Diamonds*, c. 1950-54, watercolor, 18 x 21 3/4 in., Dubuque Museum of Art, Cora Gordon Memorial Purchase, 50.00.01 [Trovato no. 1342, undated], Made into a Christmas card by American Artists Group, N.Y., E403-61V, folded: 5 x 6 1/2 in., Burchfield Penney Art Center, Charles E. Burchfield Archives, Gift of Francis B. Valentine, c. 1975, (Mr. Valentine wrote that the card was received for Christmas 1954; It is signed "Bertha and Charles Burchfield," and Valentine wrote in pencil beneath that "Save among my special greetings mail") Charles E. Burchfield (1893–1967). *Winter Diamonds,* 1950–60, watercolor, gouache, charcoal, chalk, pencil, and crystalline on joined paper and laid down on board, 36 x 46 in., Private Collection, Courtesy of the Charles E. Burchfield Foundation Charles E. Burchfield (1893–1967). *Sketch for Sun and Snowstorm*, 1917, graphite on paper, 6 x 9 in., Burchfield Penney Art Center, Charles E. Burchfield Foundation Archives, Gift of the Charles E. Burchfield Foundation, 2006 Charles E. Burchfield (1893–1967). *Sunshine During a Blizzard,* 1947–1959, watercolor on paper, 30 1/2 x 44 1/2, Private Collection, Courtesy of the Charles E. Burchfield Foundation
Andrew	Pippin, Horace (1888–1946). *The End of the War: Starting Home*, 1930–33, Oil on canvas, 26 x 30 1/16 in. (66 x 76.4 cm), Gift of Robert Carlen, 1941(1941-2-1), Philadelphia Museum of Art, Philadelphia, Pennsylvania, U.S.A., © Copyright, Photo Credit: The Philadelphia Museum of Art/Art Resource, NY
A New England Story	Homer, Winslow (1836–1910). *Northeaster*, 1895, Oil on canvas, 34 1/2 x 50 in. (87.6 x 127 cm), Gift of George A. Hearn, 1910 (10.64.5), The Metropolitan Museum of Art, New York, NY, U.S.A., Image copyright © The Metropolitan Museum of Art, Image source: Art Resource, NY Homer, Winslow (1836–1910). *A Summer Night*, 1890, Oil on canvas, 30.2 x 40.2 in. (76.7 x 102.0 cm), Inv. RF1977-427, Photo: Hervé Lewandowski, Musee d'Orsay, © RMN-Grand Palais/Art Resource, NY

Homer, Winslow (1836–1910). *The Life Line*, 1884, Oil on canvas, 28 5/8 x 44 3/4 inches (72.7 x 113.7 cm), The George W. Elkins Collection, 1924, Philadelphia Museum of Art, Photo Credit: The Philadelphia Museum of Art/Art Resource, NY

John Marin (1870–1953). *Schooner and Sea*, 1924, Watercolor on paper, 16 1/2 x 20 in., ©2015 Estate of John Marin/Artists Rights Society (ARS), New York

Petals on a Bough Andrew Stevovich. *Local/Switch*, 1997–1998, oil on linen, 56 x 72 in.

Andrew Stevovich. *Night Scene with Neon*, 2003, oil on linen, 8 x 8 in.

Andrew Stevovich. *Flora*, 1984, oil on linen, 6 1/4 x 10 in.
Used courtesy of the artist

Noir Robert McGinnis. *Deadly Welcome* and *The Scrambled Yeggs* artwork used with permission from artist Robert E. McGinnis, master painter and Society of Illustrators Hall of Famer (inducted in 1993)

Strong Poison Cover of the Avon Reprint Edition [©1951 by Avon Publishing Co., Inc.] from *STRONG POISON* by DOROTHY L. SAYERS, Copyright ©1930 by Dorothy L. Sayers Fleming, Copyright renewed ©1958 by Lloyd's Bank Ltd., Executor of the Estate of Dorothy L. Sayers, Reprinted by permission of HarperCollins Publishers

Rafael DeSoto. *Dime Detective Cover*, 1944, oil on canvas, 19 1/2 x 13 1/2 in., Original Pulp Illustration by Rafael M. DeSoto, Courtesy of the DeSoto Studio Archives

The Wheelchair Tour Charles E. Burchfield (1893–1967). *September Road*, 1957–1959, Tour Watercolor on paper, 29 3/4 x 39 1/4 in., Private Collection, Courtesy of the Charles E. Burchfield Foundation

Rothko, Mark (1903–1970). © ARS, NY, *Orange and Yellow*, 1956, Oil on canvas, framed: 93 1/2 73 1/2 x 2 3/4" (237.5 x 186.7x 7 cm.), support: 91 x 71" (231.14 x 180.34 cm.), Gift of Seymour H. Knox, Jr., 1956, Albright-Knox Art Gallery, Photo Credit: Albright-Knox Art Gallery/Art Resource, NY

Matisse, Henri (1869–1954). *The Red Studio*, Issy-les-Moulineaux, fall 1911, Oil on canvas, 71 1/4" x 7' 2 1/4" (181 x 219.1 cm), Mrs. Simon Guggenheim Fund, The Museum of Modern Art, © Succession H. Matisse/ARS, NY, Digital Image © The Museum of Modern Art/Licensed by SCALA/Art Resource,

Turner, Joseph Mallord William (1775–1851). *Snow Storm - Steam-Boat off a Harbour's Mouth*, Exhibited 1842, Oil on canvas, 91.4 x 121.9 cm. (101 × 89 in.), Tate Gallery, Photo Credit: Tate, London/Art Resource, NY

The Rainy Night *LACMA Lights*, Photo Credit: Chris Cunningham

Charles E. Burchfield (1893–1967). *Oncoming Spring*, 1954, Watercolor on paper mounted on board, 30 x 40 in., Burchfield Penney Art Center, Purchased in part with support from the Western New York Foundation and the Olmsted Family in Memory of Harold L. Olmsted, 1990, Courtesy of the Charles E. Burchfield Foundation

Stieglitz, Alfred (1864–1946). *Georgia O'Keeffe-Torso*, 1918, Gelatin silver print. 23.6 x 18.8 cm (9 5/16 x 7 3/8 in.), The Metropolitan Museum of Art, Gift of Mrs. Alma Wertheim, 1928 (28.130.2), The Metropolitan Museum of Art, New York, NY, U.S.A., Image copyright © The Metropolitan Museum of Art, Image source: Art Resource, NY, © 2015 Georgia O'Keeffe Museum/Artists Rights Society (ARS), New York

Charles E. Burchfield (1893–1967). *Spring Rain in the Woods*, 1950, Watercolor, gouache, and charcoal on joined paper and laid down on board, 30 x 40 in., Private Collection, Courtesy of the Charles E. Burchfield Foundation

Provenance Charles E. Burchfield (1893–1967). *The Red Woodpecker*, 1955, Watercolor, Gouache, and pencil on paper, 21 1/2 x 15 1/2 in., Private Collection, Courtesy of the Charles E. Burchfield Foundation

Charles E. Burchfield (1893–1967). *The Woodpecker*, 1955–1963, Watercolor on paper, 50 x 38 in., Reynolda House Museum of American Art, Winston-Salem, North Carolina, Courtesy of the Charles E. Burchfield Foundation

A New Jersey Story John Koch (1909–1978). *Night*, 1964, oil on canvas, 26 x 40 in. (66 x 101.6 cm), Private Collection, Courtesy Kraushaar Galleries, New York

John Koch (1909–1978). *Conversation - Nightlight*, 1954, Oil on canvas, 20 x 12 in., Private Collection

More Brandon Stoddard (1937–2015). *Through A Glass Lightly*, 2010, Watercolor on paper, 19 x 19 1/2 in., From the Collection of William and Reva Tooley

Brandon Stoddard (1937–2015). *Après Midi to Tancook*, 2010, Watercolor on paper, 12 x 16 in., Owned by MAD

A Montana Story JSY. *Black Butte – First Light*, 2014, Photo Credit: JSY

JSY. *Black Butte – Coppertop*, 2004, Photo Credit: JSY

John Marin (1870–1953). *White Mountain Country, Summer No. 30, Dixville Notch No. 2*, 1927, watercolor and pencil, 15 x 19 1/4 in., © 2015 Estate of John Marin/Artists Rights Society (ARS), New York

Windows Edward Hopper, American, (1882–1967). *Nighthawks*, 1942, Oil on canvas, 84.1 x 152.4 cm (33 1/8 x 60 in.), Friends of American Art Collection, 1942.51, The Art Institute of Chicago

Lois Dodd. *View Through Elliot's Shack, Looking South*, 1971, oil on linen, 53 x 36 in., ©Lois Dodd, Courtesy Alexandre Gallery, New York

Marsden Hartley. *Untitled (aka Still Life)*, 1919, Oil on board, 32 x 25.75 in.

Hopper, Edward (1882–1967). *Automat*, 1927, Oil on canvas, 28 x 36 in. (71 x 91 cm), Des Moines Art Center, Des Moines, Iowa, U.S.A., © DeA Picture Library/Art Resource, NY

Hopper, Edward (1882–1967). *Room in Brooklyn*, 1932, Oil on canvas, 73.98 x 86.36 cm (29 1/8 x 34 in.), Museum of Fine Arts, Boston, MA, U.S.A., Photo Credit: Erich Lessing/Art Resource, NY

Hopper, Edward (1882–1967). *Sun in an Empty Room*, 1963, Oil on canvas, 28 3/4 x 39 1/2 in., Private collection, Photograph by Alex Jamison

Andrew Wyeth, American, (1917–2009). *Wind from the Sea*, 1947, tempera on panel, overall: 47 x 70 cm (18 1/2 x 27 9/16 in.), framed: 66.4 x 89.5 x 7 cm (26 1/8 x 35 1/4 x 2 3/4 in.), Gift of Charles H. Morgan 2009.13.1, © Andrew Wyeth

Andrew Wyeth (1917–2009). *Geraniums*, 1960, drybrush watercolor on paper, 20.75 x 15.5 in., © Andrew Wyeth

Steve Mills. *The Old Shed*, 1998, oil on board, 32 x 46 in. Used courtesy of the artist

The End of Something Manet, Edouard (1832–1883). *A Bar at the Folies-Bergère*, French, 1882, oil on canvas, 37.8 x 51.2 in., Courtauld Institute Galleries, Photo Credit: bpk, Berlin/Courtauld Institute Galleries/Lutz Braun/lisa Art Resource, NY

JOHN MARIN: THE EDGE OF ABSTRACTION

"… the first strokes of the brush. How lovely the stuff is when you've just put it down. While it's still all alive… Paint. Lovely paint. Why, I could rub my nose in it or lick it up for breakfast… The spiritual substance. The pure innocent song of some damn fool angel that doesn't know even the name of God."

– The painter Gully Jimson in The Horse's Mouth *by Joyce Cary*

There are these stories – or perhaps tales – of how Marin painted. This "waggish, unassuming, boylike and curiously dignified"[1] man, whose "face was all puckered up with smiles and frowns,"[2] spotted sitting in a tree, or hunkered in the stern of a dory, or standing knee deep in Casco Bay painting with both hands, and using an easel that swiveled round three hundred sixty degrees like a great plate or a lazy Susan.

Whatever the exact truth, one thing is abundantly clear about John Marin: he loved to paint – and he did it originally, and with equal the fervor and industry of van Gogh, Turner, or Pollock. His love of what he did is in and jumps off the work, whether early or late, watercolor or oil, as a kind of joy and undeniable force as sharp as the scent of paint itself, and bestrides his imagination and invention from the teens to his last days working in bed in 1953. He returned to the same themes and the same places, but they were not few and never with a loss of vigor, investigation, or innovation.

So often Marin is compared to Cézanne. The one resemblance these two men most had was what they did with their days and their lives in achieving masterworks. Like Cézanne, John Marin went out again and again, and forever in groundbreaking search and finding of his own bathers and Mont Sainte-Victoire.

Futurism, Fauvism, Cubism, Expressionism, et cetera – all of which he's been tagged or associated with and all of which have certain smidgens of validity – are finally irrelevant. To keep it simple – a person looking at a picture on a wall – there's a dynamic in Marin that's beyond art critics or art classes or professors or scholars that feels essentially American. "It is America and nowhere else. We are made to experience something which is our own," wrote Paul Strand.[3] And very much of its time: that second American Revolution in the aftermath of World War I that played through the Roaring Twenties into the Depression, and brought with it a remarkable outburst of creativity in the arts. He was fecund, perhaps too much so; yet much of his work feels remarkably alive today, freshly ripped from his pads of paper, or unveiled canvasses peppered with surprise.

Marin had a passion for place that has carried beyond his time. It's ripe with his essential concerns and real locales, and yet lies beyond easy or exact categorization.

There is nothing but realism.

This is the only (ist or ism) left to the artist — for if the work is not real what is it what are you?…

The imaginative storyteller has given you nothing gives you <u>sawdust</u> for bread…

A copied sea is not real — The artist having seen the sea — gives us his own seas which are real.

And these symbols of his creation give him in their own right even a greater pleasure than the object seen — he reforms them he rearranges he focuses to his own satisfied inner seeings and longings.[4]

Marin is so often thought of as a rugged individualist, a man alone, and there's a truth to it – he went his own way, clearly. But he was a schooled architect, a part of the remarkable Stieglitz circle, and his crusty, plentiful, Whitman-like writings are seasoned with the mention of artists (Tintoretto, Boudin, Goya), writers (Walton, Chekhov, Twain, Bergson, Lawrence, Wilde), and most of all composers. Among the too many to mention are Beethoven and Mozart, Copland, Stravinsky, Debussy, and most of all Haydn.

Critics throughout his life invoked the relationship of his work to music ("As abstract and as universal as the music of Bach," Duncan Phillips said).[5] Still, perhaps no one captured this essence in words better than Marin himself. In a famous evocation of New York he concluded, "While these powers are at work pushing, pulling, sideways, downwards, upwards, I can hear the sound of their strife and there is great music being played."[6] His love of and feeling for music though, whether symphony or jazz or requiem, is finally and best found in his paintings. At times, like Charles Burchfield, there are what appear to be musical shapes in the placement and pulsing energy of his lines.

His finest work didn't happen in a single year or in a single medium. His finest work very often is vitally stirred and rife with movement; it often includes his exploration of the frame around or within a painting that offers at once "the impression of looking through a window" and "breaking through this imagined barrier."[7] His finest work carries his rough-hewn lyricism and quivers of emotion; it is full of feeling. His finest work most of all finds the shoals and beauty and surprise of that territory that is real and not real and that dances movingly and elastically along the edge of abstraction.

These works carry both what he called "an understanding of accidentals"[8] and "the beautiful lonesomeness of a work of art" that "can stand many seeings – revealing anew at each seeing."[9] Take for example his major oil, Related to St. Paul's, New York, 1928. This city, these ripping diagonals, these great buildings alive and living out his very definition of "great music being played." But what is that yellow, that splotch, that broken yolk in the midst of a masterpiece? And there it is again in several of his tremendous oils of New York, both large and small, done in the Thirties. Is it some reflection, a revenant? Is it what Fairfield Porter called "a yellow splash of sun on the ground, like a suicide"?[10]

Such questions cross into his watercolors equally. In his painting, The Sea, 1923, what seems simple and representative in each looking again becomes less concrete, evermore bottomless and mysterious. And in the great watercolor, Schooner and Sea, 1924, is that the land? Is that the waves, even the sail? Is that smear of remarkable red the setting sun, a jutting rock, an errant buoy? What? Schooner and Sea is a painting where there is a "painted boat in a painted sea,"[11] and yet it's one where each brush stroke seems to harbor its own color and unique and separate intention. Yet again, is each touch of paint in fact a piece of a dynamic abstraction, a purely action painting decades ahead of its time? And does it finally matter? No.

As Martha Davidson wrote, Marin could paint "with a tumultuous and pantheistic ardor," capturing in watercolor or oil "all the powers of the sea, its terrible beauty, titanic movement and treacherous calm [with] a swift magnificently coordinated calligraphy [that] seems to spring from a source in nature common to the scene itself"[12].

In the best of his work, Marin was "no longer dictated by idea, limited by its obstinate propensity for abstraction from reality but rather by an acute perception into the complete and continuous actuality – what William James called 'the stubborn irreducible facts'…" wrote Louis Finkelstein in linking Willem de Kooning to Marin, plumbing what he felt to be a deep kinship between the two artists, where "a belief in a structure of reality too rich and too complex to be knowable by any preconceptions – a structure of which we being a part, can know only a part, but that in knowing we are a part, we know more truly" ties them together.[13]

In that "reality" remain the paintings themselves, still fresh with discovery and vibrant life – the smell of the sea, the stench of exhaust and cacophonous excitement of Manhattan, the arid hues of New Mexico, the scrubbed washes yet jagged punch of the White Mountains at Dixville Notch, *the rhythm of rain and wind and weather around these places, and the lives they know and hold – apprehended in the instant and touched with a measure of infinity.*

(Endnotes)

1 *Paul Rosenfeld, "John Marin's Career,"* The New Republic, *90 (Apr. 14, 1937), p. 290; quoted by Ruth E. Fine in* Modern Art & America: Alfred Stieglitz & His New York Galleries *(2001), Sarah Greenough, ed., p. 341.*

2 *Cleve Gray, ed.,* John Marin by John Marin *(1977), p. 8.*

3 *Paul Strand, "American Watercolors at the Brooklyn Museum,"* The Arts, *2 (Dec. 1921), p. 152.*

4 *Gray, p. 132.*

5 *Duncan Phillips, "7 Americans" (1950), p. 21; quoted in* The Eye of Duncan Phillips: A Collection in the Making, *(1999) Erika D. Passantino, ed., p. 388.*

6 *Gray, p. 105.*

7 *Leigh Bullard Weisblat in* The Eye of Duncan Phillips, *p. 382.*

8 *George L.K. Morris letter to the author, quoting Marin.*

9 *Gray, pp. 126, 130.*

10 *Fairfield Porter,* Art In Its Own Terms: Selected Criticism, 1935-1975 *(1979), p. 210.*

11 *Gray, p. 96.*

12 *Martha Davidson, ArtNews (Dec. 10, 1938), p. 17; quoted in* Modern Art & America: Alfred Stieglitz & His New York Galleries, *p. 348.*

13 *Louis Finkelstein, "Marin and de Kooning," in* Magazine of Art *(Oct. 1950), p. 204.*

ANDREW STEVOVICH: IN A STATION OF THE METRO

In a Station of the Metro

The apparition of these faces in the crowd;

Petals on a wet, black bough.

— Ezra Pound

1

There are people — there are always people — in Andrew Stevovich's paintings and they all pose a question that's often a riddle. Who are these men and women? What are they up to, and what exactly is going on?

Here is an artist who sets the table, puts into play with remarkable polish the situations and players of his unique dreamscapes. We find ourselves at a carnival, a nightclub, a racetrack, a card game, a movie

theatre, a coffeehouse, or we come upon a woman alone with a butterfly, a tulip, a cat, or a drink. We arrive at some unknown chapter in their stories as witnesses, if not voyeurs, and are tugged upon to join these specimens in their strangely sealed worlds.

Reaction to Andrew Stevovich's world is seldom mild, and often fierce. He is not for everyone. Once lured, however, it's difficult to take your eyes off his people, their worlds, the painterly surfaces and the spell that he casts over them. His paintings are full of windows and glass, shades and screens that accent only further that these men and women, and we with them, have been apprehended in this artist's poetic and particular dioramas.

The sidelong looks of the almond-shaped eyes of his people have become fabled — the furtive glances are frequently and trenchantly mentioned in reviews and essays about this artist's work. The faces hold a stylized host of feelings. In them can be reflection or worry, fear or caution, suspicion or boredom, anger or what sometimes seems to mock the very possibility of nothing at all; or rather, not nothing, but some further closely held, cloaked emotion. Their very faces seem another veil or screen to successfully hide behind.

These faces are seldom without the company of their hands — hands that have such prominence that they become beings of their own. They can be languid and cumbrous, or they can be busy and extremely specific in the gestures they make — whether smoking a cigarette, rubbing a chin, sneaking into a pocket, or touching another's cheek. Inanimate or animate, they perform an accompanying ballet and manifest the personalities of the faces they belong to.

All this occurs as Stevovich's people wait in these scenes for what is about to happen — or has just happened, or might have happened, or should have happened — in the ordinary places of our days and the darker dens of our nights. They wait, along with us, suspended in these charged instants.

> *…(his) precisely-focused canvasses with their linear*
>
> *abstractions and rich glazes cause one to look at them as*
>
> *one would look at the painting of a Flemish master…*
>
> — *Robert Taylor, Boston Globe*

2

The influences and antecedents upon which Andrew Stevovich's work have been well charted by critics and by himself from Giotto to Gauguin, Botticelli to Beckmann. In a book about his work, Carol Diehl and Anita Shreve offer others, and there are more to be wondered at in their play with abstraction, like Stuart Davis or even Patrick Henry Bruce. While clearly aware of such a laundry list, Stevovich most of all — and most pleasingly of all — is staking out and charting very much his own territory.

He reaches beyond the people into his successful fusion of the classism of the Flemish and Italian Renaissance painters to his contemporary subject matter. In the richness of his palette and the sheen of his canvas, Stevovich lifts his human creatures out of the frozen movements and gifts them with a remarkable glow. His paintings carry an inner light.

It's easy with the incandescent finish of Stevovich's paintings and the gravity of his work to neglect the humor and what one critic described as the "delectable sense of visual wit" that rides along with astonishing confluence in the paintings. There's a deadpan tweak to his world, a sly emotional crackle. Just an example — consider the advertisements and posters that populate his work: how often they have people portrayed in them; how often these faces seem larger and livelier than the "real" faces in front of

them; how these faces can dominate those "real" faces with their alluring edge and beckoning visions, both ordinary and mythic.

The degree of darkness or irony in Stevovich's wit is difficult to decipher exactly, perhaps intentionally so, but it calls up mention of a wide range of literary bedfellows. They range from Carl Jung to the cartoonist Peter Arno. Nabokov has been invoked; the Canadian author Robertson Davies should be. Kafka lies in wait, and perhaps most on point in tone and tilt would be Gogol.

It's the combination of "old-master formality and the ironies of the present tense" that mark and complete the true originality of his vision.

> *Stevovich transformed each vignette into a theater of*
>
> *appearances. The main players in this theater are men*
>
> *and women… who possesses a gravity more proper to the*
>
> *realm of ceremony than to the everyday.*

> — *Ronny Cohen, Artforum*

3

A sense of "theater" comes easily in relationship to Stevovich's paintings because they carry such narrative weight. He is a storyteller, and the frozen moments he seizes upon could be frames of film while giving hint, like Edward Hopper's paintings "at a large drama beyond the limitations of the picture's frame" (Gail Levin). Call up a screenplay description—wide shot, two-shot and close-up—it suits Stevovich's work, and he finds and fits the drama to the size and scope of them.

Wide shot? Paint a subway — he's taken it on several times, getting on, getting off, riding one. Crowd scenes, jams of people. The most ambitious, Local/Switch, is an intricate, dense cram of enduring passengers, both real and surreal. Where is the drama? It's in their composure and their clothes and hats, in the very composition itself. The painting lifts out of the most mundane and everyday intricate, dense , and beautiful radiance.

Close Up? Paint a woman, woman alone — Stevovich's done it many times. Pick Flora as an example: The spare presence of objects, such caring and lapidary attention to a certain few details — the wave of her hair, the single flower, the stillness of her glass, the jewel of a reflection in it. In the perfection and luminous finish around her gathers a beauty, but the beauty is mysterious; it seems as much camouflage as revelation. Looking at Flora — or Lola or Nadine or the many women without names — she and they seem so clean and fresh. A number are recumbent, quietly erotic, lying with grapes or amongst leaves. It makes you want to sit or lie or go with them. It makes you wish life was like that, but why then is Flora, for example, so pained? Or is she? Is she?

The questions that haunt Andrew Stevovich's paintings rise again with the riddles, and the elusive glimpses of an answer. What is the story? Who are these people? Deny it, fight it, or embrace it — they are a piece of us.

Petals on the bough.

CHARLES BURCHFIELD: A WALK IN THE WOODS

"How good it was to be out again, to be 'going out painting'…

I decided to try to paint the roar of the wind in the woods… the trees about me clashing and swaying majestically… wind-blown leaves dancing over the floor of the woods, and big rain-drops hitting them with a great clatter. Bits of sunlight entering into 'windows' of the woods…

Will I ever truly be able to express the elemental power & beauty of God's woods?"

— *Charles Burchfield*[1]

In his lifetime Charles Burchfield liked little better than to walk in the woods. He would tromp beyond where paths were broken, carrying his umbrella in case of rain. Where the woods were complete, cocooned in Nature's reverie, he would set up his easel, get out his brushes and paint.

In his lifetime, and even after, Burchfield was lauded but often in a minor key because of his chosen medium, watercolor. Yet what he did with watercolor was groundbreaking, eventually creating "large scale watercolor paintings with more complex surfaces than have ever been achieved before or since."[2]

There were myriad attempts to classify Burchfield's work. He was linked because of subject matter to 19th-Century landscape painters such as Thomas Moran and George Inness, and because of his astonishing and eloquent journals to 19th-Century writers like Emerson, Thoreau and John Burroughs. He was even labeled for a while the "Sinclair Lewis of the Paint Brush."[3]

He was called a Realist, a Regionalist, a Romantic Realist, an Expressionist and the last Pantheist – and while each holds a certain validity, none finally captures the ongoing breakthroughs and individuality of his art which stretched across a career of more than fifty years.

"All weather is beautiful and full of powerful emotion".

— *Burchfield*[4]

Charles Burchfield painted the weather. He painted the seasons. He sometimes remarkably apprehended the violence and beauty of their changes in a single work. He seldom painted people. His people were in his houses, in the doors and windows, in the shapes of eyes that spill or shine out from his trees. These shapes can possess an anthropomorphic pathos and wonderment or seem to ignite like flames.

Burchfield painted the times of day and night, piecing together sheets of paper as he got older, to make greater room for the brilliant cadmium yellow of what Burchfield expert Nancy Weekly calls his "liquid sunshine," or to gather up the hallowed monumentality of an impending storm, or to toss stars and constellations into the sky.[5]

He was an acute observer of even the shifts of wind and light, and seemed to understand the importance in Nature of the subtle variations of plant and animal life and how "the epic forces of great seasonal cycles are given prelude in the stirrings of minutiae."[6]

Early on, Burchfield created posters and then earned a living designing wallpaper, talents that can be seen in his work of that period and that echo across his several thousand works after he resigned from H. M. Birge and Sons to devote full time to painting in 1929.

In those years Burchfield limned the sun and trees, birds and butterflies in delicate and accurate detail.

Certain subjects absorbed him. He painted, for example, at least fifteen watercolors with sunflowers as a prominent subject.[7]

Some are literal depictions, others tweaked in all manner, mood, and configuration, with perhaps more still to be unearthed like in the recently found brooding yet glowing work entitled Sunflowers at Late Dusk.

In the late 1920s, extending into the '30s, he was linked with some accuracy to Edward Hopper. The two artists came together in the stark and iconic portraits of town and cityscapes and then separated again in their subject matter and approach, an intersection and divergence not unlike Braque and Picasso a decade earlier. Burchfield and Hopper even wrote stirringly about each other's work.[8]

In 1943, famously, Burchfield decided his work had lost its vitality and originality. From that year until the end of his life, he reached back as early as 1915 and 1917 for inspiration and transformed his work, never losing touch with reality and never being restrained by it.[9]

In that same groundbreaking era, he painted such masterworks as Sweet Pea Mood. It is so complete a work, so fully and brilliantly Burchfield, that despite its signed date, 1917 (what he and others have called his "golden year"), it's hard not to wonder if perhaps, even for certain, if he didn't come back at a later time as he often was to do, join its added section of paper and alter it.

The pentimenti of his workings and re-workings are often visible in strata upon strata of pigment. Every stroke filled with emotional content. He could scrub with sponge and cloth, too, until places on the paper were roughened and abraded and yet fit his new conception. "Sometimes the better ones have to evolve over a period of years," Burchfield wrote to the avid collector Theodor Braasch.[10]

> "The real artist is never at rest — he is always painting, if not actually, with his eye or in his mind. His problems accompany him wherever he goes — to the dining table, the concert, the theater, among friends, to his bed. He does not design this.
>
> He cannot help it."
>
> — Charles Burchfield[11]

Burchfield jotted what he called "idea" notes on many of his drawings, such as the song of a bird, or heat, or wind, or cold, or even the adaptation of a sketch as an abstract motif.[12]

He never stopped doodling, drawing, or drafting on pads of paper and used envelopes, grocery lists and probably on napkins and menus, whatever was at hand. Even when his health was questionable he went to the woods or to the tiny studio with the skylight that lay at the back of his yard and put brush to paper.

He just never stopped.

His most profound relationship to other artists from van Gogh to Picasso, from Marin to Rockwell, whether similar or not, may have been exactly this: his invention and industry never wavered. Into the final days of his life he was at work. He sketched, he painted, inspiration coming from ideas and works old and new.

> "You will see, in the future I will live by my watercolors."
>
> — Winslow Homer[13]

This quote of Homer's — whose works are beyond remarkable — apply equally to Burchfield. What's increasingly true is that even as he stands on his own, Burchfield calls to mind even more far reaching benchmarks for comparison, be it from painting, music, or literature.

Burchfield's journals are peppered with the mention of composers — Mozart, Haydn, Dvorak, Copland and most of all Beethoven and Sibelius. He had a profound love and connection to music. He listened while he was painting and while he wasn't. The very shapes of musical notes insinuate through his paintings, sometimes literally in the lines he drew. There lives a rhapsodic vibrancy.

Burchfield also read widely as well through English and American authors. Yet his work seems most evocative of the extraordinary Russian writers of the 19th and early 20th Centuries. They feel emotionally akin, especially to Ivan Turgenev's A Sportsman's Notebook, the volume that Sherwood Anderson called "the sweetest thing in all literature." The redolent prose in Turgenev's stories has a startling similar allure to the subjects that so engrossed Burchfield in his journals and his watercolors — the delicacy of a summer afternoon, the damp yet holy melancholy of the woods, the spiritual essence of sudden rain.[14]

For all this, whatever possible sources he drew from, it remains clear Charles Burchfield doesn't fit into any single movement. He stands alone.

And now the impact of his work is reaching across time: a new generation has discovered him. Young artists mention him and search out his work. Their interest isn't in labeling him; it's in the world he takes them to.

Today animation is no longer a sidebar. With such as Pixar and Dreamworks, it has cornered a key station in our culture in one significantly successful film after another. In Ice Age 3, for example, the conjuring of outsized plants and insects and the lives they lead could well have shaken directly out of Burchfield's most far reaching and sometimes criticized fantasies.

Cementing Burchfield's reputation is a major retrospective exhibition that opened in Los Angeles and then traveled to the Whitney Museum. It has been curated not by a museum director, but by the renowned contemporary artist Robert Gober.

Charles Burchfield stands, it seems, no longer alone.

His work is alive today on the Bee Paper he favored, still fresh and full of wonder with the hues of spring and autumn — ochre and salmon, cerulean and cobalt, butterscotch and tobacco brown — and the color of the winter sky "like the interior of a vast pearl" that flowed out of his left-handed brush and that he forged into a vision.

> "...Once again I belong to nature... the rain beats in my face, my feet sink in the mire...
> A great happiness comes over me... It seemed as if this was the first walk I had ever
> taken—like the first created man coming into a new land..."
>
> — Charles Burchfield[15]

Charles Burchfield walked in the woods around Salem, Ohio in his youth and then for several decades out Zimmerman Road toward Gowanda, not far from Buffalo, New York. He made these walks his own. He walked in the woods finally of his own imagination, writing and painting with a fierce and poetic passion. In his wake and in his luminous, visionary and unique work, he left us the forever pleasure of walking with him.

FOOTNOTES

[1] *Benjamin Townsend, editor,* Charles Burchfield's Journals, The Poetry of Place, *SUNY Press 1993, p. 524*

[2] *Nancy Weekly, "Ecstatic Light", DC Moore Gallery, 2007*

[3] *Quoted by David W. Steadman in* The Preston Morton Collection of Art, *Katherine Harper Mead, editor, Santa Barbara Museum of Art, 1981, p. 230*

[4] *Quoted by John I.H. Baur,* Burchfield's Seasons, *Kennedy Galleries, 1982, unpaginated.*

[5] *For a remarkable discussion of Burchfield's astronomical accuracy, see "The Moon, the Stars, and the Artist, Astronomy in the Works of Charles E. Burchfield" by J. Patrick Harrington,* American Art Journal, *Volume XXII, No. 2, 1990, p. 33-59*

[6] *Bruce W. Chambers,* Charles Burchfield, the Charles Rand Penney Collection, *Sites Press, 1978, p. 15*

[7] *Townsend, p. 691*

[8] *"Burchfield has used (gouache and watercolor) with such frankness and daring that he has overturned our old notions of it," Hopper wrote, for example, in 1928 in American Artists Group, p. 9*

[9] *"1965 finds me going back more and more to that rhapsodic visionary year of 1915 for inspiration and subject matter, which in turn, becomes absorbed into the further probing into the secrets of life, nature and the world of the spirit."*

 – Charles Burchfield, quoted in Charles Burchfield, The Charles Rand Penney Collection, *p. 39, drawn from John I. H. Baur, Charles Burchfield, Macmillan, 1956, p. 58*

[10] *Charles Burchfield in a letter in 1959, quoted by Nancy Weekly, "Ecstatic Light," DC Moore Galleries, 2007*

[11] *Townsend, p. 589*

[12] *Edith H. Jones, editor, quoting Burchfield in* The Place of Drawings in an Artist's Work, The Drawings of Charles Burchfield, *Praeger, 1968, p. 8*

[13] *Helen A. Cooper,* Winslow Homer Watercolors, *Yale University Press, 1986, frontispiece.*

[14] *See for example, (one of many) this passage in Ivan Turgenev's,* A Sportman's Notebook, *translated by Charles and Natasha Hepburn, Viking Press, 1950, Compass Books, 1957 from the story "The Rendezvous", page 266:*

 "It was fluky weather. One moment the sky would be overcast with puffy white clouds, at another it would suddenly clear in places for a moment, and, through the rift, the azure would appear, like the glare of a brilliant eye... the leaves were whispering faintly over my head: you could have told the time of the year from their whisper alone... the interior of the wood drenched with rain, kept changing its appearance as the sun shone out or went in behind the clouds: sometimes it was all ablaze..."

[15] *Quoted by John I. H. Baur in* Burchfield's Seasons, *un-paginated*

LOIS SLOAN: A PASSION FOR STONE

"I'd be walking home from school

and I'd reach the corner of Crescent

Heights, and I could hear the hammer

and chisel a block away…"

— *Amy Harrison*

Paint a picture of an extraordinary life. Rather sculpt it from stone.

Lois Sloan was a single mother, a high-beam headlight woman, and a life long working artist, first in pastel, then ceramics, then lastingly and most transcendently stone. Born in Minnesota, then from Texas with two young children, Scott and Amy, her first marriage broken, Lois struck out for California. For the next thirty-five years she lived in and through a remarkable time — the Sixties, Seventies and Eighties — in West Hollywood.

In a family that came to include her younger daughter, Claudia, Lois struggled out a living doing many things — ceramic hors d'oeurve dishes, earrings and cufflinks that were advertised for a spell in Esquire, and interior decorating. To quote Claudia, "She had a remarkable sense of space and aesthetics."

No slouch in beauty, Lois put together a portfolio, a series of black and white photographs. Mock model poses, one holding a can of Adorn hair spray. She took them to the legendary Hollywood agent Paul Kohner. Kohner asked her, "What do you want to do this for? This business will eat you up and you've got kids. What do you really want to be?"

"An artist," answered Lois.

"Go home and do it then," Kohner said.

And so she did.

Lois studied books, she took classes, she found mentors like Richard Guy Walton, a noted San Francisco and Tahoe artist who wrote her a vital, trenchant, five-page single-spaced letter that prescribed the way of an artist, a letter she kept the rest of her life.

> *Embryonic painter: What have you done?… Don't dishonor yourself with talk of paint and no doing; have you man guts and do you have white lead? Remember, some place in any house is something to paint on and something to paint with…*
>
> *1. Time is the first ingredient.*
>
> *Your days are taken with your young… (but)*
>
> *2. Paint three nights a week.*
>
> *3. Your palette is black, burnt umber, burnt sienna, yellow ochre, ultramarine blue… (etc). Your white is a separate thing, it is to be thought of as one thinks of plaster or as one thinks of flour in a cake.*
>
> *4. Masonite or Upson Board.*

5. Tools: palette knife, large bristle brush, med. sized flat sable, at least two enamel brushes, one package dime store sandpaper…

6. Medium — Linseed Oil, one pint. Small can of good varnish. Pint or quart of turpentine…

7. Texolite or Luminol: thin slightly with water but leave it as thick as toothpaste…

8. Prime edges in all stages…

9. Men to study: Picasso, Cézanne, Modigliani, Henry Moore, Paul Klee, and Michelangelo.

Don't fail to start painting because you have no idea. Most artists have no idea when they do their best work. When they have an idea they do their worst work…. Ideas only encumber the great opportunist and that is the world of invention.

Do not impose yourself. Do not force. Painting is a search and you will find the world of being and the world of beauty or whatever world you are subconsciously seeking by doing, not by invocation…

Walton's specific, by no means easy counsel reached deeply into Lois's work and across her life.

To help earn a living then, Lois became a teacher and a mentor as well. The backyard of Lois' house on Norton Avenue metamorphosized into an outdoor studio. Under the cover of five avocado trees, she set up shop for herself and her students. The otherwise bare space transformed. She sought and found old barber chairs and stripped the backs off. With their hydraulics, they became sculpture stands that could rise and fall and spin three hundred and sixty degrees. A brilliant conception. The classes grew until the backyard had a cover of marble dust rather than grass, a little like snow, and was festooned with works in progress, covered by plastic as they waited for the next class.

While the classes were fundamental to earning a living, Lois' encouragement, faith, and life force led those who came to not want to leave. That reluctance led the wealth of avocados to become "the birthplace to the greatest guacamole in the world." On a table in the house resided a lazy Susan. It was one more creation, an outsized phenomenon that could feed a multitude with guacamole, tacos and chips, and libations of strong natures.

Around it friends, students, and families gathered to argue and laugh about art, their work and their lives. It was a chock full circle, a fervent and eclectic array of talent that spanned the arts beyond her classes — such as writer Sydney Carroll, comedy writers Sheldon Keller and Howard Albrecht, producers and directors Melvin Frank and Norman Panama, composer David Raksin, newsman Bill Stout, comedian Louis Nye, actor Richard Basehart, entertainers Bobby Van and Elaine Joyce, and the iconic Saul Bass. Gossip was also not neglected. "She was called the tarantula of Hollywood," according to her son Scott. "She knew the lowdown on everybody."

It was a unique backyard. It was a unique salon — through a time that was tumultuous in and out of art with Lois at its luminous center. As Elaine Joyce said, "Secretly everyone wanted to go to bed with her, men, women, cats, dogs… Seriously, butterflies would land on her outstretched arms!"

When she was alone under the umbrella of avocados, Lois did her own work, did it in sweats when women didn't wear sweats. As she turned to sculpture, Henry Moore and especially Michelangelo remained profound inspirations. She discovered others to admire as well, Hans Arp, Jacob Epstein, and Jules Engel.

Lois' knowledge was wide, and not just about art. "She knew things, all kinds of eclectic things," says Claudia. "Butterflies, plants, music, cooking." Both Amy and Claudia learned this as they practiced piano. From her mother's bedroom would come the commanding yell, "Right hand, third finger, wrong note!"

Stone drew Lois first cautiously and then into a relationship only equaled by her bond with her three children, and more profound than with men — and she was significant catnip: she had style, and could rise from her sweats, like Venus from the half-shell.

She loved stone. The look of it to the eye, the touch of it, the very feel of it. It was a passion. She made stone come alive. Granite, travertine, Carrara and black Belgian marble. She found some in Italy. She found some south of downtown Los Angeles.

In the industrial section there, railroad cars brought imported stone for such as kitchen counters. They would pull up and dump all the loose and broken pieces. With Hy Fink, a big, husky man and the owner of the Akron stores, and dragging her son Scott along as well, Lois would load up and bring the stone to the backyard.

Lois said she always knew she wanted to carve, but women didn't, and she initially didn't have the tools, literally or figuratively. Her hands and head weren't yet ready. She learned through still trying to "impose" and through mistakes that "the stone tells you what it wants to be."

Working, Lois often lost sense of time. Hours would pass. Day would fade. Darkness would fall. Still she would toil, labor, except those words are opposite of what she felt, what consumed her. Her daughter Amy would try to call her in futilely. She would only finally have success in extricating her mother with the offer of a finely spun martini.

In 1990, Lois left the house on Norton Avenue. The backyard and the salon. She felt Hollywood had changed, her children were grown. She missed the change of seasons. She missed the lakes of her childhood in Minnesota. So again she struck out, one more adventure, this time alone. She moved back to water and Snag Island on Lake Tapps outside of Seattle.

But Lois wasn't finished. She set up a studio in her big garage. Now with compressor and power tools, she carved works of art into increasingly abstract and extraordinary shapes. "The work has to speak for itself," she said to me after I met her years later, her high beam life force still intact, vivid and passionate. "Either you get it or you don't. If you have to name it you've missed the mark." And then she said: "I just love the beauty of light when it plays upon form."

Her own light never left her.

Through the four seasons, surrounded by water, this ruggedly individualistic artist continued to carve her beloved stone unabated for the next twenty-two years into the very last months of her life.

INDEX